JOHN SHAW'S
LANDSCAPE
PHOTOGRAPHY

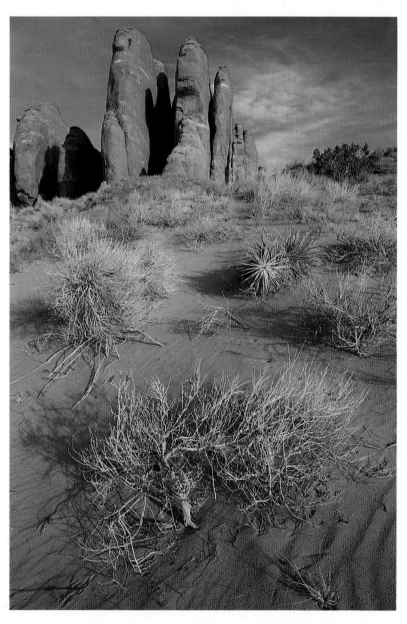

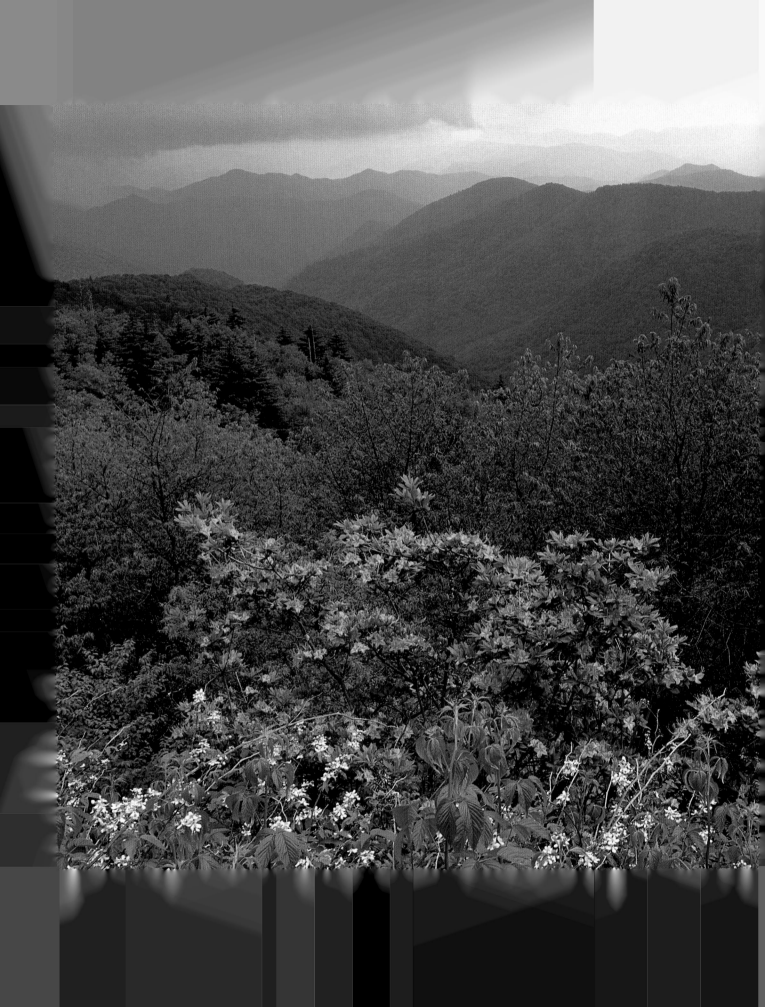

John Shaw's
LANDSCAPE
PHOTOGRAPHY

AMPHOTO
an imprint of Watson-Guptill Publications
New York

With all my love to my wife, Andrea, for her encouragement, support,
and patience throughout my photographic endeavors.

John Shaw is an internationally acclaimed nature photographer whose work has been extensively published in a variety of magazines, including *Outdoor Photographer, National Wildlife, Natural History, Sierra,* and *Audubon.* Shaw's photographs can also be seen in numerous calendars, books, and advertisements. He is the author of three best-selling Amphoto books, *The Nature Photographer's Complete Guide to Professional Field Techniques* (1984), *John Shaw's Closeups in Nature* (1987), and *John Shaw's Focus on Nature* (1991). Shaw conducts workshops and tours at selected locations. He lives with his wife, Andrea, in Colorado Springs, Colorado.

Half-title page:
SANDSTONE FINS IN THE FIERY FURNACE, Arches National Park, Utah.
Nikon F4, Nikon 24mm lens, Fuji Velvia, polarizer.

Title page:
FLAME AZALEA AND MOUNTAINS, Blue Ridge Parkway, North Carolina.
Nikon F4, Nikon 35mm lens, Fuji Velvia.

Copyright © 1994 by John Shaw

First published 1994 in New York by AMPHOTO, an imprint of Watson-Guptill Publications, Inc., a division of BPI Communications, Inc., 1515 Broadway, New York, NY 10036.

Library of Congress Cataloging-in-Publication Data

Shaw, John, 1944–
 [Landscape Photography]
 John Shaw's landscape photography / by John Shaw.
 Includes index.
 ISBN 0-8174-3710-X : $22.50
 1. Landscape photography. I. Title.
TR660.S445 1994 93–41703
778.9'36—dc20 CIP

Manufactured in Hong Kong

1 2 3 4 5 6 7 8 9 / 02 01 00 99 98 97 96 95 94

Edited by Robin Simmen
Designed by Jay Anning
Graphic production by Hector Campbell

PREFACE

This book is about possibilities, about various methods and techniques you can use to expand your visual horizons, and ways to record on film the emotive landscapes you see with your mind's eye. I want to open a dialogue with the reader about how we perceive these landscapes, and the photographic choices we make to record them. I trust you will continue this dialogue as an internal discussion every time you go into the field. This exchange could, perhaps, be thought of best as a private question-and-answer session, which functions both as a precursor and an aid to the creative process.

There certainly is no single right way to photograph a landscape, and it would be highly presumptuous on my part to imply as much. This book doesn't present any formulaic procedures for taking landscape pictures, a "step-one, step-two, step-three" by-the-numbers approach to photography. I encourage you to develop your own way of working, your own vision, and your own response to the world around us. Don't copy my photographs, but rather use them as suggestions and starting points for your work.

While this book is primarily aimed at the 35mm camera user, many of the technical discussions—for example, the sections on exposure, foreground/background relationship, or lens choices and perspective—apply to all formats. Good photographic technique is identical regardless of the camera used. I do stress the importance of technical competence in this book, as I believe it is the absolute foundation for quality photography. Control of the technical side of photography frees you to focus your energy and drive on your unique vision. For a more concentrated discussion of how you go about actually finding a subject, and the mental process you go through in taking a photograph, I would refer you to my previous book, *John Shaw's Focus on Nature.*

And finally, as you photograph landscapes, I hope that you develop a deeper compassion for the land itself. As a result of our efforts to record the natural world, I hope that a natural ethic develops, an ethic of respect, concern, and love for the subject.

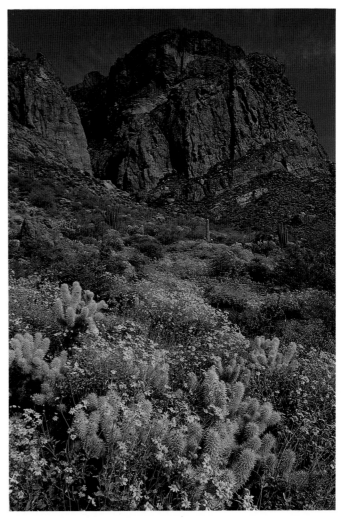

CHOLLA AND BRITTLE BUSH, Organ Pipe Cactus National Monument, Arizona. Nikon F4, Nikon 24mm lens, Fuji Velvia.

CONTENTS

INTRODUCTION 8

EXPOSURE 14
Basic Theory of Exposure 16
Fine-Tuning an Exposure Meter 22
Using a Camera's TTL Exposure Meter 25
Depth of Field and the Hyperfocal Scale 29

EQUIPMENT AND FILM 32
Camera Systems 34
Film 38
Tripods and Heads 41
Polarizing Filters 45
Graduated Neutral-Density Filters 48

LENSES 52
What Lenses Do 54
Wide-Angle Lenses 57
Normal Lenses 60
Short Telephoto Lenses 62
300–600mm Lenses 63
Tilting Lenses 67

LIGHT UPON THE LANDSCAPE 72
Seeing the Light 74
The Changing Light 76
The Edge of Light 80
Bad Weather is Good Weather 84

THE LANDSCAPE AS DESIGN 86

Designing a Photograph 88
Photo-Graphics 90
Vertical or Horizontal? 94
Foreground Drama Adds Depth 96
Aerial Perspective 98
View Camera Techniques for 35mm Composition 100
The Seasons 102

PROBLEMS AND SOLUTIONS 106

Sunrises and Sunsets 108
Merges, Converges, and Apparitions 110
White Skies 112
Contrails 113
Tilting Horizons 114
Environmental Problems 115
Preventing Flare 116
Viewfinder Coverage 117
Two Lights in the Sky 118

ON LOCATION 120

Photographing a Theme 122
Focusing on One Area 126
Being in the Right Place at the Right Time 130
The Animate Landscape 134
Deciding Where and When to Go, and What to Bring 138

INDEX 143

INTRODUCTION

What is a landscape? Well, a landscape photograph encompasses the scene around us. It could be a picture of a "grand landscape," a great, majestic sweep to a far distant horizon; or it could be an "intimate landscape," a picture taken at close range featuring the foreground immediately in front of the camera. It could even be a series of photographs of the myriad and minute details which, seen as a whole, make up both of these views. Landscapes are everywhere around us; we move through a constantly changing kaleidoscope of scenic images.

A good landscape photograph is more than a mere record of a location you once visited, because it always involves your individual perspective. There is no such thing as a purely objective landscape photograph. Taking a picture should entail a series of conscious decisions on your part, because the many photographic choices you make control the viewer's perception of the scene. You choose exactly what to photograph and how much of that subject to include in the frame; in effect, you are telling the viewer what is important about the scene by limiting what he or she can see.

Actually recording these scenes on film, however, is another story. All too often our visual experience of a scene and the images we make of it have little in common. We lose the vitality and immediacy of our experience; the pictures are flat, dull, and unexciting. Generally speaking, this is a technical problem. Seeing a potential picture and then translating it in its fullest potential to film are two separate acts.

Too many would-be landscape photographers overlook technical mastery; they believe that if they could travel to fantastic locations, they would make fantastic pictures. Not true. Being in exotic locales leaves you with only fleeting memories if you're fumbling with your camera. Producing good photographs means knowing how to control the tools of photography: lenses, films, light, and exposure. Technical proficiency must become second nature, something so automatic that it doesn't intrude when you need to focus on aesthetics.

Good photography combines two ways of processing the constant inflow of images and sensations: a simultaneous filtering of material through emotion as well as logic. On the one hand, you must be an artist, paying attention to the intuitive and mystical world of your inner vision. Unless you bring your own intensely personal emotions about a scene to your photography, your pictures will be flat and lifeless. On the other hand, you must be a precise craftsman, able to make informed choices about lenses, apertures, shutter speeds, and tripod locations.

When art and craft are united in photography, the very best pictures are produced, images that affect us not only visually but also deeply in our minds and memories. We look at these pictures...and we feel the soft desert air on our faces, hear the waterfall, or feel the chill of the autumn morning. The purpose of this book is to help you achieve this kind of artistry in your landscape photographs by helping you understand the tools and techniques at your disposal and how you can use them most creatively.

THE CASTLE, Capitol Reef National Park, Utah. Nikon F4, Nikon 35mm lens, Fuji Velvia, polarizer.

This type of picture is commonly tagged a "grand landscape," a big scenic view of a dramatic area; yet this is in no way an arbitrary composition. I carefully chose my shooting location, the lens I used, my tripod height, and the framing of the picture. The large black rocks in the foreground corner (their size was exaggerated by my wide-angle lens) introduce you to a slope of layered textures, brown and tan earth tones, and leading lines culminating in the hard-edged vertical rocks at the very top. I cropped tightly at the top of the frame, as this is a picture of hard rock, not the open sky.

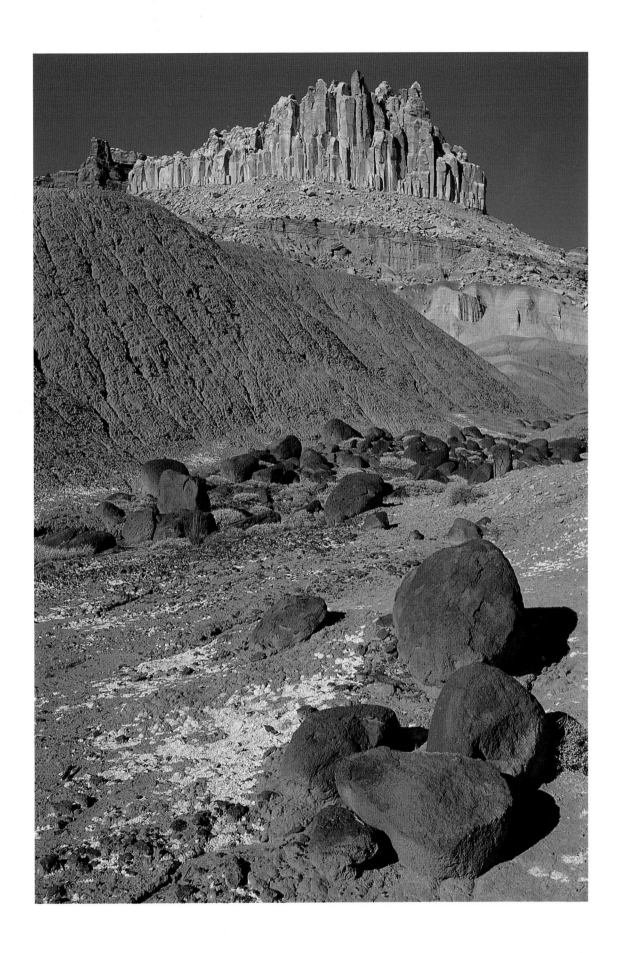

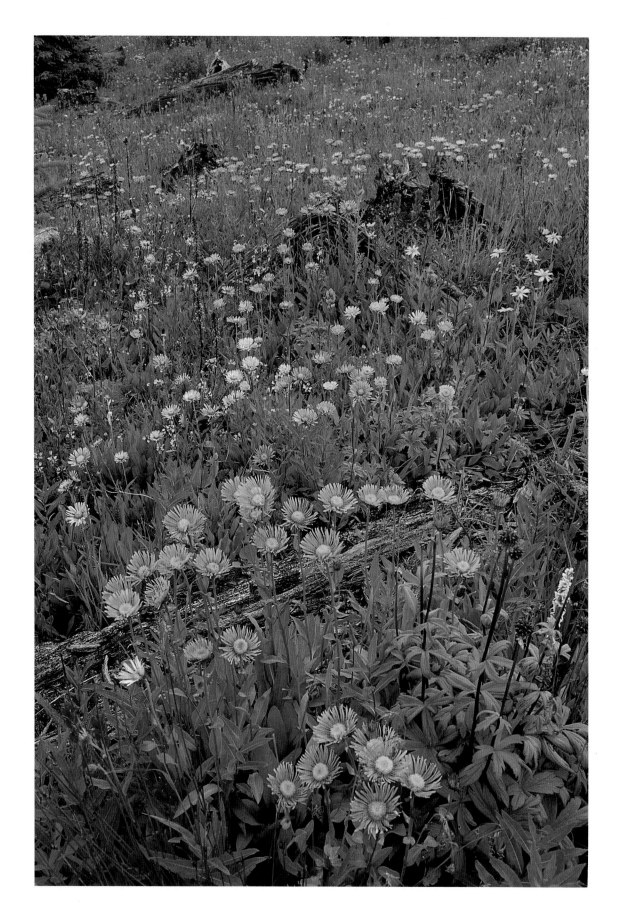

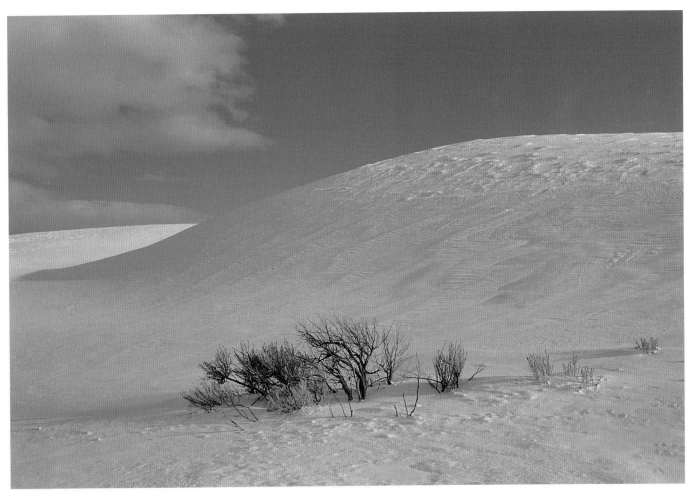

SNOW-COVERED HILLS AND SAGEBRUSH,
Yellowstone National Park. Nikon F4,
Nikon 50–135mm zoom lens, Fuji Velvia.

This is a deceptive photograph. Is that a snow-covered hill, or a white sand dune? There really are not that many visual clues; the viewer has to be actively involved with the picture to realize the answer. Look at the contrasts within this shot. Compare the texture of the snowy hill to the texture of the clouds, the soft line of the hill with the hard edges of the sagebrush, the even tonality of the sky and the subtle tonal changes of the snow.

ALPINE WILDFLOWERS, Colorado. Nikon F4,
Nikon 24mm lens, Fuji Velvia.

Here was an alpine meadow so exploding with color, so laden with patterns, so diverse with plants—that I was completely overwhelmed when I first saw it. I had to decide what to do; should I shoot tight single blossoms or overall views? I posed a question to myself: what did I consider most exciting about this place? The answer—the vast colors of the meadow falling into patterns— dictated what to do. I used my 24mm wide-angle lens to frame several different variations.

RIPPLES ON A LAKE. Nikon F4, Nikon 50–135mm zoom lens, Fuji Velvia.

This landscape was rendered as a photographic abstraction. All the normal visual indicators—a horizon line, recognizable objects, a point of view—are gone. What is left are the most basic elements of design: line and color.

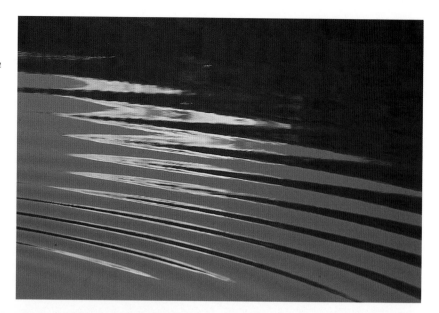

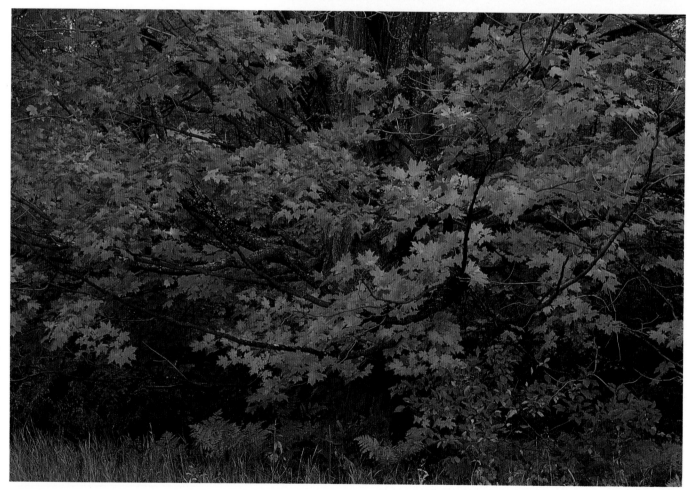

SUGAR MAPLE TREE IN AUTUMN, Michigan. Nikon F4, Nikon 105mm macro lens, Fuji Velvia.

The strength and age of this sugar maple are readily apparent, reinforced by the horizontal composition. I like the way the bare gray branches contrast with the orange and red leaves, while tucked at the tree's base are bracken ferns already turning color. Overcast light lets the film see into the woods (harsh direct sunlight, with its blocked-up contrasts, would have destroyed the quiet mood of this photograph).

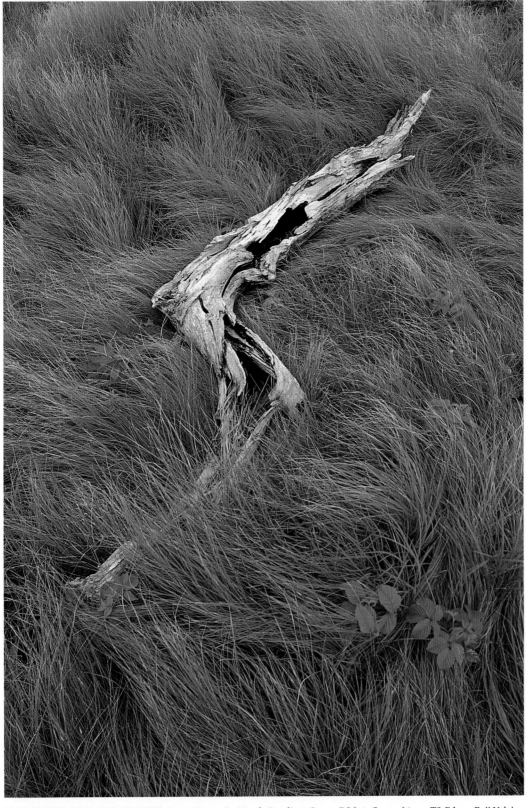

A single detail—the lightning-flash zigzag of an old dead branch—tells a story that carries beyond the borders of the picture, a story of weather and harsh conditions. Here the hollow and rotting wood is a counterpoint to tussocks of thick grass. A blackberry vine anchors the lower corner of the frame.

FALLEN TREE LIMB AND GRASSES, Roan Mountain, North Carolina. Canon EOS-1, Canon 24mm TS-E lens, Fuji Velvia.

EXPOSURE

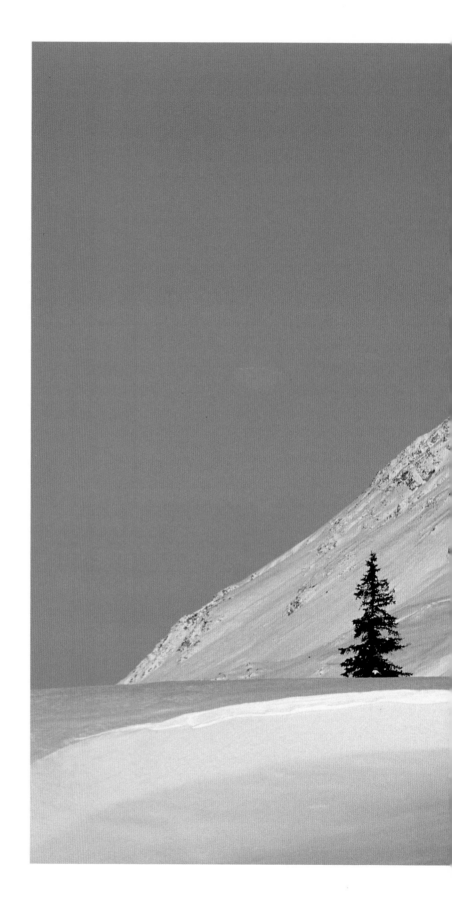

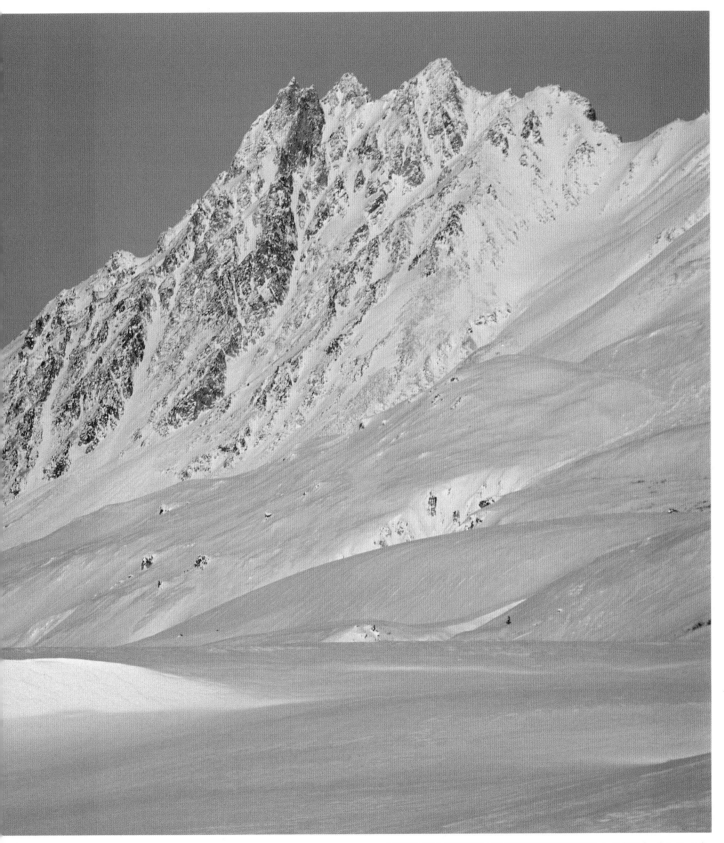

THREE GUARDSMEN MOUNTAIN IN WINTER, British Columbia, Canada.
Nikon F4, Nikon 80–200mm zoom lens, Fujichrome 100.

BASIC THEORY OF EXPOSURE

One of the keys to good landscape photography is properly exposing the film. But for too many photographers, proper exposure tends to mean shooting at whatever exposure the camera happens to set. I would suggest—in fact, I would argue quite strongly—that if you want to take better landscape photographs, the place to start is with a thorough understanding of exposure. After all, if your pictures are important to you, and if you want to take credit for making good pictures, then you should be in control of the exposure process. This doesn't mean shooting all pictures with manually set exposure values; you can take great photographs with a camera set on "autoexposure" or "programmed exposure" as long as you are aware of what choices the camera is making, can evaluate them to see if they are what you want, and know how to override them if necessary. You should be in control of what the camera is doing, not the other way around.

Let me define some commonly misunderstood terms: First, *correct exposure* means getting your pictures back exposed the way you wanted them to be exposed. That is, if you wanted the sky to be light blue in your photo and, sure enough it *is* light blue, then you've achieved correct exposure. You produced exactly what you wanted. When what you consider the subject's most important tone appears in your slide just the way you wanted, you've done a good job.

But if that tone is lighter than you wanted it to be, then you've made a mistake. You've *overexposed* the film. For example, suppose you wanted that sky to be light blue, but instead it comes - out as a pale, whitish-blue, even lighter in tonality than what you had imagined. If the results are lighter than what you wanted, the exposure is incorrect.

The opposite problem occurs when a tone appears darker than what you had in mind; for example, if your light-blue sky shows up in your finished slide as a rich, medium-blue sky or an even darker navy blue. Now you have *underexposed* the film. However, if a dark tone in the subject, which you wanted to be a dark tone in the slide, turns out that way, then the film has been correctly exposed.

Maybe you've noticed that I haven't yet mentioned the exposure meter in your camera. Achieving correct exposure has nothing to do *per se* with the meter reading or the values set by an automatic exposure system. If you simply shoot at the setting the camera suggests, you may or may not get back a photograph exposed the way you wanted it to be. Why leave it to chance? If you let the camera make all the exposure judgements without your reviewing those decisions, then when someone says they like your pictures you can respond, "Yes, my camera takes great pictures, but I'm just the person who happens to carry it. I hope my camera doesn't grow legs and walk away with my job as a photographer."

In reality, what makes someone a good photographer is not a special lens, or a limited-production film, or a rare filter known to no one else; it is the use of good photographic technique and a thorough knowledge of exposure control. Your goal is to achieve correct exposures repeatedly, regardless of the lighting conditions or the location problems. You want to be able to produce technical quality whenever you want and never leave the photographic process to chance.

Controlling exposure—always rendering the exposure on the film exactly the way you want it—is, in my opinion, the most important part of photography. After all, you can own the best equipment available, travel to the most exotic locales imaginable, be at the perfect spot at the perfect time in the perfect light, but if you make a mistake in exposing the film, then what have you produced?—photographs destined for the wastebasket. Granted that there is a learning curve involved—for example, one person's photographic successes might be another's discards —you still need control of the exposure process at all levels of photographic skill. Your skill level will grow as your control increases in precision.

I'm not suggesting that everyone become technocrats, slavishly following a set of step-by-step rules. But I do think that a thorough understanding of exposure basics is vital if you want to grow as a photographer. Before I discuss how to use an exposure meter to decide what *you* think the correct exposure should be, let me review some basic exposure theory for you so that we are working with a common vocabulary.

All aspects of the photographic process connected with exposure are measured in values called *stops*. The more you can think and work in stop increments, the easier exposure control will become. In simplest terms, a stop is always relative, defined as a doubling or halving of any value; you have twice as much, or half as much, of any given value.

The actual exposure you shoot at depends on three things: the shutter speed set on the camera body, the aperture set on the lens, and the type of film being used. *Shutter speed* is a time value, the length of time a camera's shutter is open, permitting light to fall on the film. Shutter speed controls the duration of any exposure. *Aperture* is the size of the lens opening, the hole through which light passes to strike the film when the shutter is opened. Aperture is measured in *f-stops,* and controls the intensity of light during any exposure. *Film sensitivity*, expressed as an ISO rating, indicates how any film will chemically react to a certain light level. All three of these variables work in stop increments.

Shutter speeds are normally expressed as seconds and fractions of seconds in a progression of times. Different cameras have various beginning and ending points; indeed there currently seems to be a manufacturers' contest to see which company can make the fastest shutter. But all 35mm single-lens-reflex (SLR) cameras have the following speeds: 1, 1/2, 1/4, 1/8, 1/15, 1/30, 1/60, 1/125, 1/250, 1/500, and 1/1000 sec. Most cameras don't display the fractions but instead abbreviate the shutter speeds, showing "1/60" as "60," for example, or color coding full seconds and fractions of a second differently.

Using the standard shutter-speed sequence, each time value is either half the preceding speed or double the following speed, depending on how you look at this progression of numbers. For example, a speed of 1/60 sec. is half the time of 1/30 sec., but twice the time of 1/125 sec. Each of these jumps is a one-stop change; as stated above, a stop is defined as a doubling or halving. From 1/30 to 1/60 is a one-stop change (one halving), to 1/125 is another stop (another halving), to 1/250 sec. another. So changing shutter speed from 1/60 to 1/1000 sec. is a four-stop total shift in time value. Going from 1/60 to 1/4 sec. is also a four-stop shift, but going in the other direction.

Changing shutter speed in either direction affects the way motion is recorded on film. The faster the slice of time—for example, going from 1/500 to 1/1000 to 1/2000 sec.—the more an image will progressively seem to be frozen. Conversely, going to ever slower shutter speeds—such as from 1/15 to 1/8 to 1/4 sec.—will record motion as a blur. The slower the speed, the more blurred the image becomes.

When set in certain exposure modes, many autoexposure cameras have so-called "stepless" shutter speeds. This simply means that the shutter can be electronically set in-between the marked speeds. A few camera models also are able to display

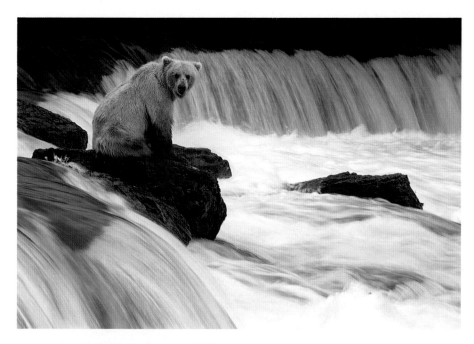

BROWN BEAR IN STREAM, Alaska. Nikon F4, Nikon 300mm lens, Fujichrome 100.

These two photographs were taken at equivalent exposure values, which is confirmed by the bear remaining the same color in both shots. But the difference in shutter speed—one photo was taken at 1/8 and the other at 1/250 sec.—recorded the rushing stream in extremely different ways, either blurring the water or freezing it, and hence the pictures have vastly different moods. Both are correctly exposed. Is one version "better" than the other? That depends on your individual taste. By the way, the "frozen" shot was taken at 1/250 second at f/4. What was the exposure setting for the other photograph?

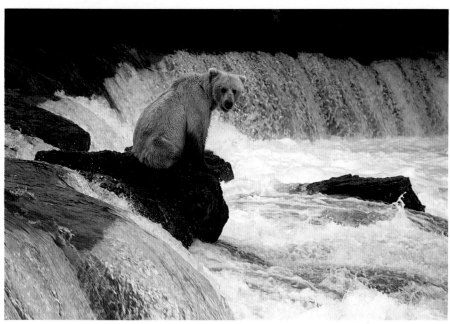

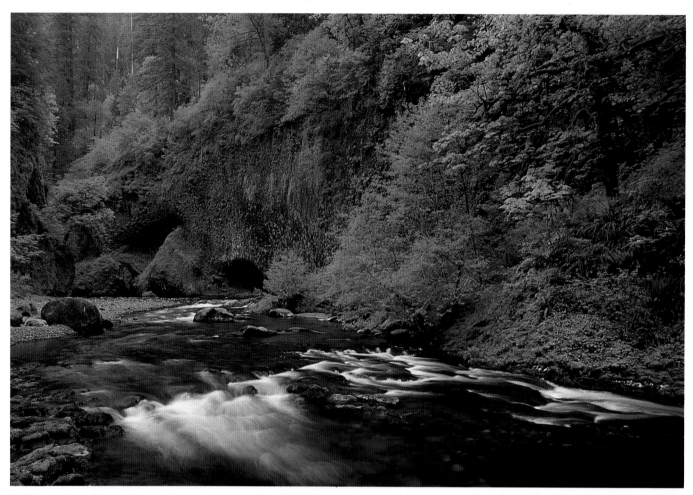

EAGLE CREEK, Columbia Gorge Scenic Area, Oregon. Nikon F4, Nikon 50–135mm zoom lens, Fuji Velvia, polarizer.

With my polarizer mounted on the lens, I metered the greenery on the right side of the picture. My meter said 1/15 sec. at f/5.6 for this slow film in the overcast light. Now I had a starting exposure value, but I knew I didn't actually want to use these settings. I wanted a slower shutter speed to blur the water into a silken effect, and I needed a smaller f-stop to give more depth of field or foreground-to-background sharpness. A four-stop change in shutter speed to 1 second equaled a four-stop change in aperture to f/22. As long as I know one correct starting point, I can change the camera settings to end up at a correct equivalent exposure.

ROCKY MOUNTAIN JUNIPER AND SANDSTONE WALL, Colorado. Nikon F4, Nikon 105mm macro lens, Fuji Velvia.

Even before taking a meter reading, I realized that a medium aperture—about f/11—would suffice for this picture. I preset my lens to this f-stop, metered the scene to find the appropriate shutter speed, and took the picture.

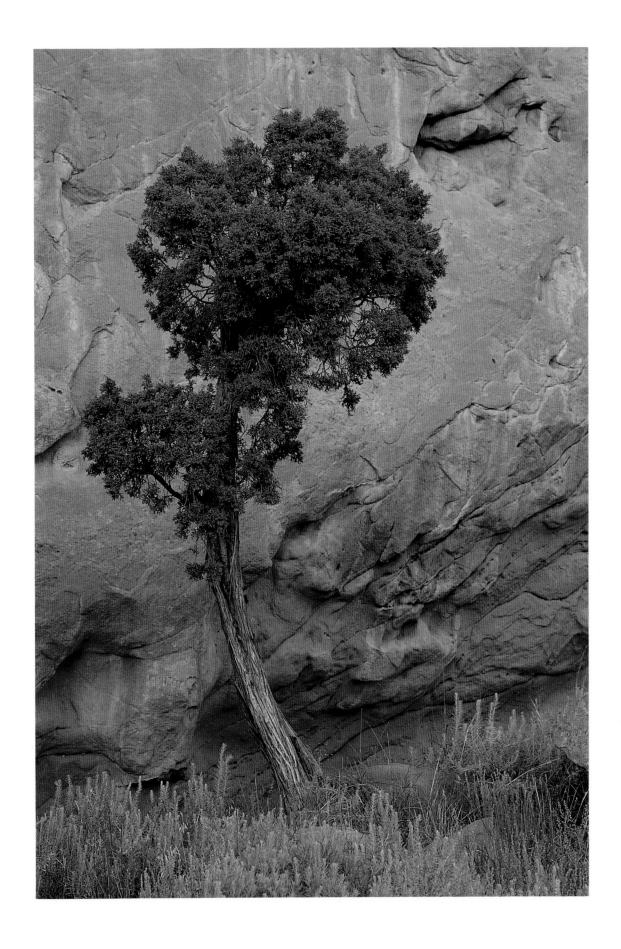

these in-between speeds; 1/45 is halfway in-between 1/30 and 1/60, as 1/90 is halfway in-between 1/60 and 1/125 sec. When most cameras are in their "manual exposure" mode, the shutter speeds must be set at distinct increments, usually in full one-stop steps. Check your camera's instruction manual to determine how your particular camera body works.

The *f*-stops marked on a lens, which are its apertures, also represent a progression of doubles and halves, although the numbers used are not themselves doubles and halves. The standard sequence of *f*-stop numbers includes *f*/1, *f*/1.4, *f*/2, *f*/2.8, *f*/4, *f*/5.6, *f*/8, *f*/11, *f*/16, *f*/22, and *f*/32. As with shutter speeds, not all lenses have all these numbers; plus some, especially lenses for film formats larger than 35mm, have additional ones. Each of these numbers indicates the size of the lens opening through which light passes. This *f*-stop sequence is listed in one-stop increments. Each opening admits half as much light as the previous number, or twice as much light as the following *f*-stop. For example, *f*/11 lets in half the light of *f*/8 (a one-stop difference) or twice the light of *f*/16 (a one-stop change in the other direction).

Note that *f*-stop numbers are really fractions, although they are normally not written as such; consequently, the larger the *f*-stop number, the smaller the hole actually is. Thus *f*/2 represents a large opening that admits a lot of light, while *f*/32 is quite a small opening, admitting only a sliver of light. Considered as fractions, this makes sense: 1/2 is a lot larger than 1/32.

If a lens has an aperture ring that can be manually moved, you can set the ring anywhere. The "click-stops" on an aperture ring are there only for convenience and have no other meaning. Some lenses have "clicks" at every marked, full, *f*-stop increment; other lenses have "clicks" at the half stops also. A one-stop change is a one-stop change, regardless of where you start. From *f*/8 to *f*/11 is a one-stop difference; from halfway between *f*/8 and *f*/11 (*f*/9.5) to halfway between *f*/11 and *f*/16 (*f*/13) is a one-stop difference; from just a smidgen past *f*/8 to just a smidgen past *f*/11 is one stop.

Two terms are traditionally used regarding a change in aperture. *Opening up* means going to a larger aperture—a wider hole or opening in the lens—and thus admitting more light to hit the film. *Stopping down* is just the opposite and means going to a smaller aperture, which consequently reduces the amount of light hitting the film.

Because shutter speed and aperture both affect the amount of light striking the film, they must be thought of as a pair. They both work in stop values, using the same doubles and halves progression, and they are related to each other by what is called *reciprocity*. After a necessary amount of light is established for a correct exposure, then either the shutter speed or aperture can be adjusted, as long as the other value in the pair is changed reciprocally. A one-stop change in shutter speed equals a one-stop change in aperture in the other direction in terms of the actual amount of light hitting the film.

Another way to think of this is that doubling the duration of the shutter speed and halving the intensity of light admitted by the aperture is the same thing as halving the duration and doubling the intensity. To illustrate this concept, imagine that you needed to earn twenty dollars. You could work for four hours at five dollars per hour, or you could work for five hours at four dollars per hour. Either way you end up with twenty dollars, and this final result is what counts.

Because shutter speed and aperture exhibit reciprocity, you can use a slow shutter speed and a small aperture, or a fast shutter speed and a large aperture. Either way, the amount of light hitting the film is the same; however, depending on your choices, the effects you obtain on film are different, as will be explained later in terms of depth of field and how motion is recorded.

In practical terms, reciprocity means that after you've decided upon an exposure level, you are free to pick and choose shutter speeds and apertures while maintaining correct exposure. Suppose that 1/8 sec. at *f*/11 is the proper exposure. If you increase time to 1/4 sec. (a one-stop change, double the time) and decrease the aperture to *f*/16 (a one-stop change, half the light), you'll end up with exactly the same amount of light hitting the film. So 1/8 sec. at *f*/11, and 1/4 sec. at *f*/16 are equivalent exposures. So are 1/2 sec. at *f*/22, 1/15 sec. at *f*/8, 1 second at *f*/32, and 1/30 sec. at *f*/5.6. These combinations all admit the same amount of light to hit the film, and all would be proper exposure. Knowing the correct exposure, you can then pick any *f*-stop you want to use, or any shutter speed you want to use, and make reciprocity adjustments.

Pick up a camera to see how easy this is—just count off the number of stops as you change either the shutter speed or aperture. Then change the other setting by the same number of stops, and you'll end up at the same equivalent exposure. For example, assuming that 1/250 sec. at *f*/4 is the correct exposure, a five-stop change to 1/8 sec. (longer shutter speed) requires the same five-stop change in aperture to *f*/22 (smaller hole) to maintain correct exposure.

Whatever shutter speed and aperture you select will largely depend on the film you're using. A film's degree of sensitivity to light is expressed by its film-speed rating, or ISO number. Low ISO number films are called "slow" films because they need a lot of light to record images, while films with high ISO numbers are called "fast" films as they need less light. Examples of slow films are Kodachrome 25 at ISO 25 and Fuji Velvia at ISO 50, while typical fast films include the ISO 400 Ektachrome and Fujichrome films. Both Kodak and Fuji offer very fast films at ISO 1600.

Film-speed ratings also work in stop values, the same doubles-and-halves concept as shutter speed and aperture. Each numerical doubling of the ISO number is a one-stop change. Shifting from ISO 25 to ISO 50 is a one-stop difference. Going to ISO 100 is another stop, and to ISO 200 one more stop. It is easy to count stops as you double the number. For example, how many stops are there between ISO 25 and ISO 1600? Starting at 25, we get 50, 100, 200, 400, 800, 1600—a total of six stops.

If you know the correct exposure for a particular film, you know the correct exposure for any other film so long as you know the ISO ratings for both and you work in stop increments.

Start with your known exposure, and simply change it by the number of stops between the two film speeds. For example, assume that Fujichrome 50, rated at ISO 50, is properly exposed at 1/8 sec. at *f*/8. What is the correct exposure for Fujichrome 400 (ISO 400) in the exact same light? There are three stops between these two films' ISO ratings, so take the Fuji 50 exposure and change it by three stops to 1/60 sec. at *f*/8 (or any equivalent exposure: 1/30 sec. at *f*/11 is the same as 1/15 sec. at *f*/16, which is the same as 1/8 at *f*/22, and so on).

Here is the progression of ISO film speeds in one-third stop increments. Films are not available at all these numbers, but just remember that doubling or halving the ISO number means a one-stop change. For example, ISO 12 is one stop below ISO 25, and two stops below ISO 50.

12 16 20 **25** 32 40 **50** 64 80 **100** 125 160 **200** 250 320 **400** 500 640 **800**

From this sequence you can see that Kodachrome 64 (ISO 64) is 1/3 stop faster than Fuji Velvia, or 2/3 stop slower than Ektachrome 100. If you set the ISO on your camera on a dial rather than on an electronic display, you probably won't see all these numbers. There isn't enough room for them all, so many intermediate numbers are represented by dots. For example:

12 • • 25 • • 50 • • 100 • • 200 • • 400 • • 800

The concept of stops, and the ability to think in stop values, is basic to any understanding of photography. My work as a photographer, and this entire book, is based upon a comprehension of stops. If you're not fully comfortable with this idea, please take the time to reread this section. I guarantee that understanding the fundamentals of exposure, and of stops, will make you a better photographer.

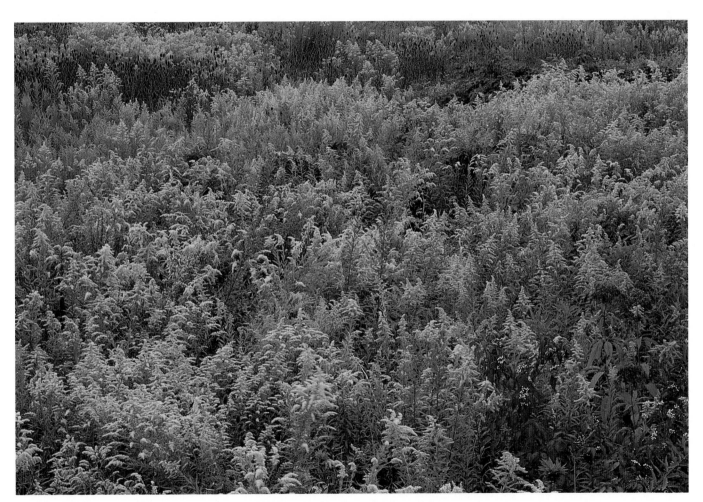

GOLDENROD FIELD, Pennsylvania. Nikon F4, Nikon 105mm macro lens, Fuji Velvia.

Here a compromise was necessary: a slight breeze was blowing, causing the tall goldenrod to sway. The light was even and unchanging, so getting a meter reading was easy. But what to do about that breeze? This common field situation typifies the need always to think about shooting conditions and about what you're trying to accomplish. Rarely can you just "point and shoot," letting the camera make all the exposure decisions. The camera meter may suggest a starting point for exposure values, but you must decide how to control the situation.

FINE-TUNING AN EXPOSURE METER

Because today's cameras have built-in exposure meters, and most offer several different metering patterns, it is easy to think we can just turn on the camera, point and shoot, and make great exposures. I once heard a photographer say that the "P" on his camera's exposure-mode selection meant that that was what he should use if he always wanted **P**erfect exposures. Well, the truth is that letting the camera make all the decisions about shutter speed and aperture, as in that person's **P**rogrammed exposure mode, only guarantees getting an exposure, but not necessarily the correct one. Of course, getting some sort of an exposure is simplicity itself—open the back of the camera before you rewind the film and you've made an exposure!

Cameras can't think. They don't know what you're photographing nor do they know how you want your picture to appear. Always shooting at the exposure suggested by the camera's exposure meter, or always shooting in an autoexposure mode without considering what is happening, is a quick way to produce bad exposures. But before I discuss how to control exposure by controlling your exposure meter, you must do one more thing: establish a starting point at which to set the ISO number on your camera's film-speed dial so that you can measure light consistently.

Correct exposure is determined either by estimating the light or by taking a meter reading and working from there. The problem with estimating the lighting is obvious: out-of-doors, the light level keeps changing. Even if it were consistent, you would have to run some tests to first determine correct exposure. You could shoot every f-stop/shutter-speed combination possible and arrive at correct exposure by a process of trial and error, but that isn't practical.

The only estimated exposure system that works is based on a known, consistent, light level: bright sunlight. From about two hours after sunrise until two hours before sunset, proper exposure for any film on a clear, bright day (no haze, no dust in the air, no pollution) for a frontlit subject bigger than a camera bag, and of average tonality, is expressed by the *sunny f/16* principle. It only works in bright sunlight on a clear day with the sun up above the horizon, not at dawn or dusk, and it doesn't work for closeups. The light must be coming over your shoulder and striking the front of the subject. And your subject has to be of average tonality. A subject of average tonality is called a *medium-toned* subject; it is neither light nor dark but halfway in between. If all these conditions are met, sunny *f/16* says that the correct exposure is the shutter-speed number closest to the film's ISO number at *f/16*, or any equivalent exposure value. Sunny *f/16* = 1/ISO at *f/16*.

Suppose you're shooting Kodachrome 25 (ISO 25). Correct exposure for this film in bright sunlight would be 1/30 sec. (the shutter speed closest to the film's ISO number of 25) at *f/16* or any equivalent. An exposure of 1/30 sec. at *f/16* is the same as 1/60 sec. at *f/11*, which is the same as 1/125 sec. at *f/8*, or 1/250

sec. at *f/5.6*, and so on. If you were shooting Fujichrome 50, sunny *f/16* starts at 1/60 sec. at *f/16*; for Fujichrome 100, it starts at 1/125 sec. at *f/16*; for Ektachrome 200, 1/250 sec. at *f/16*.

Remember that these exposures are for frontlit, medium-toned subjects. What is the exposure when you're faced with shooting a white, backlit subject? To preserve detail in any extremely light-toned subject, stop down one stop from your sunny *f/16* exposure. To show detail in an extremely dark subject, open up one stop from sunny *f/16*. For a sidelit subject, open up one stop, and for backlight, open up two stops. Remember that in all these cases you're *estimating* the exposure—you're not metering—and you're working in bright sun. One way to make correctly exposed photographs would be to always shoot in bright sunlight, use the sunny *f/16* principle, and forget about ever taking a meter reading. But that would certainly limit what you could photograph.

Usually, it is a good idea to take a meter reading and work from it; however, you need to determine a starting point for your camera's metering. You must learn what your exposure meter does in order to control exposure. The way to do this is to verify what ISO setting on the camera's meter makes a medium-toned subject appear as a medium-toned image on slide film, which means checking your meter's calibration.

For some reason, people tend to believe that just because they own expensive cameras, their exposure meters will always give the correct exposure settings. Not so. Your camera can suggest an exposure, but it isn't necessarily appropriate for what you want to see on film. Nothing is wrong with your camera; you just need to determine a starting point for its exposure meter. And the place you want to begin is with medium tone.

Tonal values range from black to white, from very dark to very light. Right in the middle, halfway between these extremes, is medium. This is often called "middletone," but I hate to use that word. Too many photographers always add another word to it, saying "middletone gray." Because I'm working in a color system, I'm talking not only about gray, but also about green, blue, red, brown, and so on. Greens range from an extremely dark, blackish-green to an extremely light, whitish-green. Right in the middle is medium green. There are also medium blue, medium red, and medium brown. The reason I want to calibrate a meter's ISO dial to this medium tonality is that there are many more average-toned natural subjects than those that fall into the extreme range.

One way of checking a meter's calibration—a quick and dirty method, I must admit—is to use the one correct exposure you already know: sunny *f/16*. Go outside and meter a medium-toned subject under sunny *f/16* conditions (clear day, not a closeup reading, frontlit). Do this with your camera set on its manual exposure mode, and preset the shutter speed and *f/*stop to the sunny *f/16* settings for the film you are using. Use a normal focal-length or longer lens, and avoid using a variable-aperture zoom

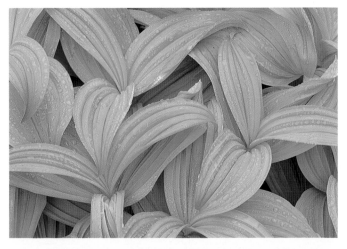

Here is an example of an exposure-meter calibration test. First I chose a subject—false hellebore and dew—that I considered to be medium-toned. Then, with my camera mounted on a tripod, I shot five frames of it in even, unchanging light, only changing the ISO settings on my through-the-lens (TTL) camera meter. Now I can pick whatever setting I like best, the setting that renders what I call a medium-toned subject as a medium-toned image on film. In this particular case, the meter ISO setting I would choose happens to be the same as the film manufacturer's ISO rating. That is the ISO number I set on this particular camera when I use this particular film.

lens if possible, because it will shift *f*-stops except at either end of its zoom range. Set your camera so that it doesn't automatically read the ISO speed through the DX coding on the film canister. Now adjust the ISO setting until you get the meter to say that your preselected sunny *f*/16 values are indeed correct. You know what the right answer should be; just get the meter to agree with you.

A more precise way of doing this, and one that circumvents the problem of waiting for a perfectly clear day, is to run a test with the slide film you want to use. Find a subject that you consider to be medium-toned, illuminated by even, unchanging light. Use any lens you want (a zoom is fine as long as you set it at one focal length and leave it there), but be sure to meter *only* the subject and nothing else. Pick a medium shutter speed and aperture, using any exposure mode, manual, automatic, or programmed. Set the ISO number for whatever film you're using, then manipulate the meter until it indicates the proper exposure, and shoot one frame. Keep notes on what you're doing or, better yet, write the ISO number on a tiny scrap of paper and stick it in the picture.

Reset the ISO number to the next mark over, again make the meter indicate proper exposure, and shoot another frame. Shift the ISO another mark in the same direction, shoot again, and then shift the ISO again and shoot one last frame. Now do exactly the same procedure, but change the ISO setting in the other direction.

You'll end up with a series of seven slides, varying by 1/3-stop intervals from one stop under the manufacturer's rating to one stop over. View these however you normally critique your work, and simply pick one exposure that you like best. The ISO you used to shoot it is the ISO number to set with that camera and that film. If you have several cameras, you can now simply compare meter readings to make them agree.

Either way you check your exposure meter, it doesn't matter in the least what ISO number you end up with on your camera. These numbers are just reference marks, not engraved in stone. Your only purpose in calibrating your meter is to find out at which number the meter makes a medium-toned subject appear medium-toned on the film. The numbers themselves are meaningless. I've often said that I wish camera ISO settings were labeled A, B, C, and D, and that camera instructions read "Pick the setting that gives you the results you like."

You're not changing the film in any manner, you're not "pushing" the processing, you're not deviating from your normal procedures. You are simply finding the correct starting point for metering. I own four camera bodies. When I shoot the same type of film in all of them, I set the same ISO number on only two cameras. For example, suppose I'm using Fuji Velvia, rated by Fuji as an ISO 50 film. To make four cameras' meters give me exactly the same shutter speed and aperture and to get the results I like, I've learned to set two of my cameras at ISO 50, one of them at ISO 32, and the fourth body at ISO 80. This doesn't mean that you should set any camera you own at one of these numbers. You need to run your own test.

By the way, when you decide to run this test and pick a subject that you considered to be medium toned, it is very important for you alone to make this decision. It doesn't matter what anyone else calls that tone. The point is to establish consistency for yourself. As long as you are consistent in picking tonal values—in other words, as long as whatever you choose as medium toned you would normally call medium toned—everything will be fine. You will calibrate your meter for the way you work. Don't ask anyone else; they're busy taking their photographs while you're shooting yours.

USING A CAMERA'S TTL EXPOSURE METER

Now that you've determined the right set point for your camera's built-in exposure meter, or which ISO number yields a medium-toned placement for a given film type, you must learn how to use the meter so that you're in control of exposure. You've bought an expensive, high-quality camera, so you should learn how to use it to the fullest.

All through-the-lens (TTL) meters are reflected-light meters. They measure the light reflected from any subject at which they are pointed, and they assign a tonality to this subject: the tonality for which they've been calibrated. In other words, if you calibrate your meter to a medium tone and then take a picture at whatever exposure the meter suggests, then whatever you've metered will be rendered as a medium tone in the final slide. This is true regardless of the subject's tonality in reality. When you follow the meter's advice, whatever you point it at becomes medium toned on film.

This happens with all exposure modes and all metering patterns. Current cameras typically employ several metering patterns built-in: generally a center-weighted pattern, a matrix or multi-segment pattern, and a spot pattern. But if you meter exactly the same area with each of them, they will produce exactly the same answer. All reflected-light meters do only one thing: they tell you what exposure to shoot at if you want the results according to the way the meter is calibrated. Because you've already calibrated your meter to medium tone, your meter is programmed to say only one thing, "here is medium, here is medium, here is medium."

If the subject you want to photograph is indeed medium toned, you are all set. Simply meter it and shoot, and you'll have a correct exposure. If the subject is not medium toned, an intermediate step is necessary before you can photograph. One solution would be to meter something else, something medium

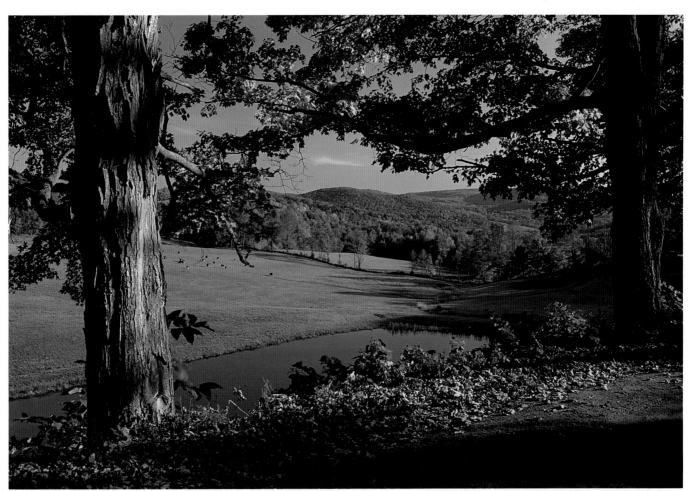

FIELD AND AUTUMN TREES, Vermont. Nikon F4, Nikon 24mm lens, Fuji Velvia, polarizer.

This scene has a broad contrast range from deep shadows to the light sky just above the horizon. An averaging meter, or a multiple-segment meter, would have been overly influenced by the scene's many dark areas and would have tried to lighten the entire frame. Aware of this, I walked up between the trees, spotmetered the medium-green hillside, walked back to my tripod position, and shot at my metered values.

toned. Find any medium-toned area illuminated by the same light as your subject, and meter it. Then swing back to your original subject and recompose the picture, but use the exposure settings derived from the medium-toned area to take the picture. As long as the light falling on your subject remains the same as the light falling on the area you've metered, this is the easiest way to obtain proper exposure.

If there is no medium-toned area to meter, you could carry one with you specifically for this purpose. An 18-percent gray card that, by definition, reflects a photographic middletone can be purchased at any good photography store. However, it is easy to imagine some of the problems posed by this solution to metering landscapes. As has been shown, any substitute metering area has to be illuminated by the same light as the subject you want to photograph. What happens if you're standing in the shadow of one mountain trying to shoot a sunlit mountain range across a valley? Your gray card would be in the wrong light. And what about photographing a sunset?

Even a top-quality gray card usually has a sheen, plus it must be held at a precise angle for an accurate meter reading. My advice is to buy one for use as a visual reference scale when you need it, but don't meter from it. There is a better way to work. (If you do want a gray card, I recommend a brand called "The Last Gray Card." It is hard plastic and has a suede finish on its gray side.)

In my opinion, the best procedure is to meter any part of the scene you're actually shooting, and then work in stop values on either side of middletone. This is what I do with all my photography. You can meter anything as long as you know what its tonality is; in other words, how many stops it is from medium tone.

An individual frame of color-slide film has a total exposure range of about five stops, from textureless white to solid black. Medium tonality falls right in the middle, halfway between these two extremes. One stop open from medium tone—or one stop open from your meter reading—makes a color appear *light*, while two stops open from medium makes a color *extremely light*. One stop down makes a color appear *dark*, while two stops below the meter reading yields *extremely dark*. The half stops fall in-between these tones. Of course, you can add or subtract stops by using either shutter speeds or aperture; you're just adding light to lighten an area, or taking away light to darken an area.

Take some time to familiarize yourself with the exposure system set forth in the chart below. To work in the field, look at your subject and pick one tonality. Now decide how you want it to appear in your slide. Do you want it to be "light," "dark," or perhaps "extremely light"? Notice that I didn't ask what tone that area is in reality. You're concerned with how you want an area to appear in the slide; it can be a literal rendition of what you see, or it can be lighter or darker than what nature offers. How it looks on film is your choice.

This exposure system works whether you are shooting in the manual mode or any autoexposure mode. In fact, if you own an autoexposure camera (and almost no cameras are manufactured anymore without at least one autoexposure mode), you'll discover an equivalent to the chart right on your camera. It is the autoexposure compensation control, and it is marked in the same stop increments. All autoexposure cameras automatically expose their subjects as medium tones. Changing the *f*-stops or shutter speeds in an autoexposure mode has no effect on the final exposure; the camera automatically compensates in the other direction.

To override autoexposure's automatic "medium," first you must decide in stop values what tone you want an area to appear on film; then meter that area, and dial in the compensation factor; finally, lock in this exposure until you take the picture. If you don't lock in the exposure, you may make some dreadful

I urge you to memorize this little chart. To use it to expose for any color you want, just fill in the color at the end of a line. For example, if you meter a blue area and shoot at the meter reading, it will be "medium blue" in your slide. Open up one stop from the meter reading, and the area will appear "light blue" in the picture. Stop down one stop from the meter reading, and the area will be "dark blue". Open up 1½ stops from the meter reading, and it will be "light light-blue." Stop down ½ stop to make it "light dark-blue." Get the idea? You're determining whether your blue area will be lighter or darker than the medium blue that your meter shows how to expose. Remember, however, that you have to meter that one area and only that area to control its tone.

HOW TO ASSIGN TONALITY TO ANY COLOR AND EXPOSE FOR IT

+2½ stops open	textureless white
+2 stops open	extremely light
+1½ stops open	light light
+1 stop open	light
+½ stop open	dark light
Meter reading	medium
-½ stop down	light dark
-1 stop down	dark
-1½ stops down	dark dark
-2 stops down	extremely dark
-2½ stops down	detailless black

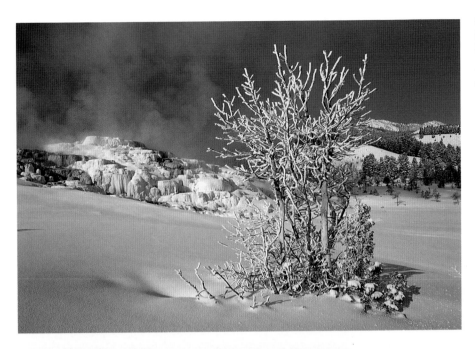

WINTER TREES AT MAMMOTH HOT SPRINGS, Yellowstone National Park. Nikon F4, Nikon 24mm lens, Fuji Velvia.

For proper exposure I metered the snow, then opened up two stops.

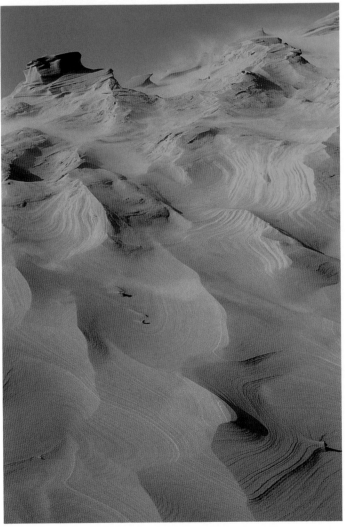

WIND-BLOWN PATTERNS IN SAND DUNE, Outer Banks, North Carolina. Nikon F4, Nikon 105mm macro lens, Fuji Velvia.

Here I metered one specific area, the sand, then opened up one stop from the meter reading, which rendered the sand as a light tone.

mistakes. Suppose you want to make an area "extremely light." Meter it on automatic, and dial in +2 stops compensation. If you then recompose to take the picture without locking the exposure, you'll end up exposing whatever the meter is finally pointed at for two stops lighter than medium. Be careful.

Regardless of whether you work with manually adjusted shutter speeds and apertures, or whether you let the camera set them automatically, you need to know precisely what area of the picture the TTL meter is actually reading. Does your camera meter the entire area shown on the viewfinder screen and give you an averaged reading? Is spot metering or partial-area metering available? Exactly how much of the picture area does the spot meter cover? How does shifting a camera's metering patterns affect the area covered by the TTL meter? Your camera's instruction booklet provides this information, generally under the headline "metering sensitivity patterns." The instructions should illustrate exactly what sections of the frame are covered by each metering pattern and should explain how this coverage is denoted in the viewfinder. Make sure you know and understand this information.

AUTUMN SUGAR-MAPLE LEAVES. Nikon F4, Nikon 35mm lens, Fuji Velvia, polarizer.

While this rainy scene had some light and some dark areas, I metered the entire scene with my Nikon set on its matrix pattern metering, then photographed at the suggested exposure setting with no additional compensation.

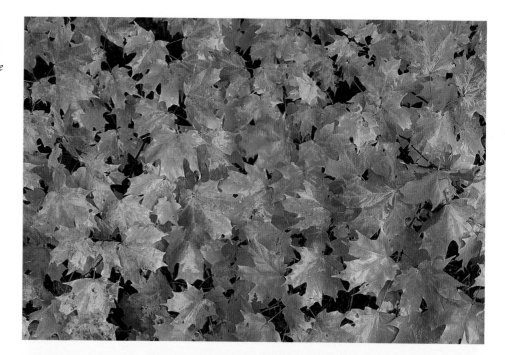

CRESCENT MOON OVER RIDGE TOP, Saguaro National Monument, Arizona. Nikon F4, Nikon 300mm lens, Fujichrome 50.

In this pre-dawn photograph, I wanted the sky to appear dark blue, so I metered it and closed down one stop. With landscape photography, as opposed to closeup details, I rarely close down more than one stop from my initial meter reading because I'm usually more worried about burning out the highlights than about creating an extremely dark tone.

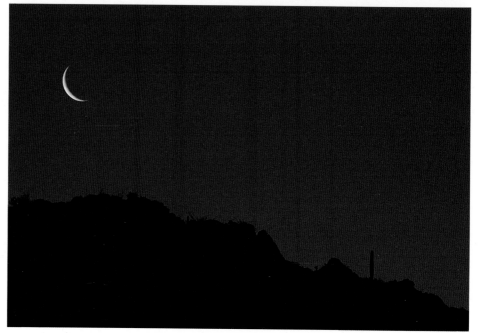

DEPTH OF FIELD AND THE HYPERFOCAL SCALE

When you're shooting in the field, a given exposure is generally a compromise between several factors: the shutter speed you would like to use to freeze any motion—for example, the wind blowing plants, or vibration problems magnified by long lenses and slow shutter speeds—and the *f*-stop necessary for your chosen depth of field. Basically, *depth of field* refers to the section of a photograph, from the nearest to the furthermost points from the camera, which appears to be in sharp focus.

In theory, only one plane of any subject can be in perfect focus: the plane on which the lens is focused. But in reality, things on either side of this plane of sharpness appear to be in focus, too. Outside this zone of relative sharpness, on either side of it both near and far, the image is definitely not sharp. The size of this zone of sharpness, called the depth of field, is controlled by four factors: the actual *f*-stop at which the picture is taken, the focal length of the lens being used, the size of the subject being photographed, and the distance between the camera and the subject.

On any lens, as you stop down to a smaller aperture, you increase the depth of field; as you open up to a larger aperture, you decrease the depth of field. Apertures of *f*/22 and *f*/32 yield greater depth of field compared to those of *f*/2 and *f*/2.8 on the same lens. The smaller the hole, the more the depth of field.

With any given lens set at any given *f*-stop, depth of field decreases as you decrease lens-to-subject distance. If you're photographing an entire mountain range with a 105mm lens, depth of field at *f*/16 is measured in hundreds of yards; shoot a single tree with the same lens still set at *f*/16 and now depth of field is measured in feet; work a single flower blossom with that 105mm lens, and depth of field at *f*/16 is measured in fractions of an inch.

If you're photographing the same subject from one location, depth of field decreases as you increase the focal length of the lens you're using. For example, if you're shooting with a 24mm lens and switch to a 200mm lens, you'll have much less depth of field even though you use the same *f*-stop on both lenses. What

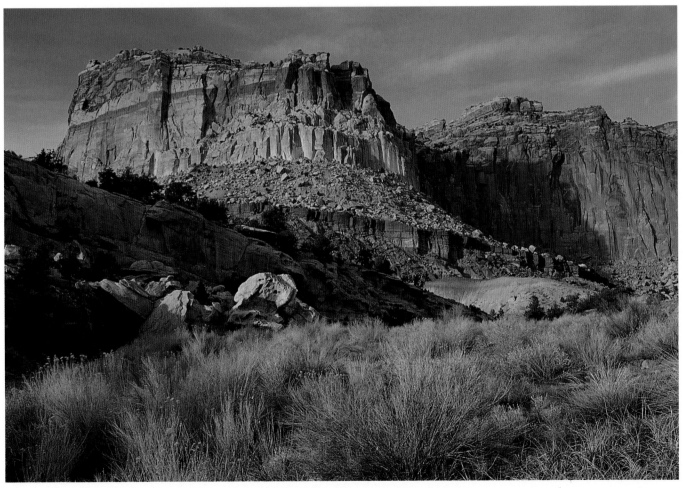

ROCK FORMATIONS ALONG WATERPOCKET FIELD, Capitol Reef National Park, Utah. Nikon F4, Nikon 35mm lens, Fuji Velvia.

By using the depth-of-field preview and the hyperfocal scale on my lens, I knew that I needed an aperture at least as small as f/16 in order to have both the foreground plants and the distant rock formation in sharp focus.

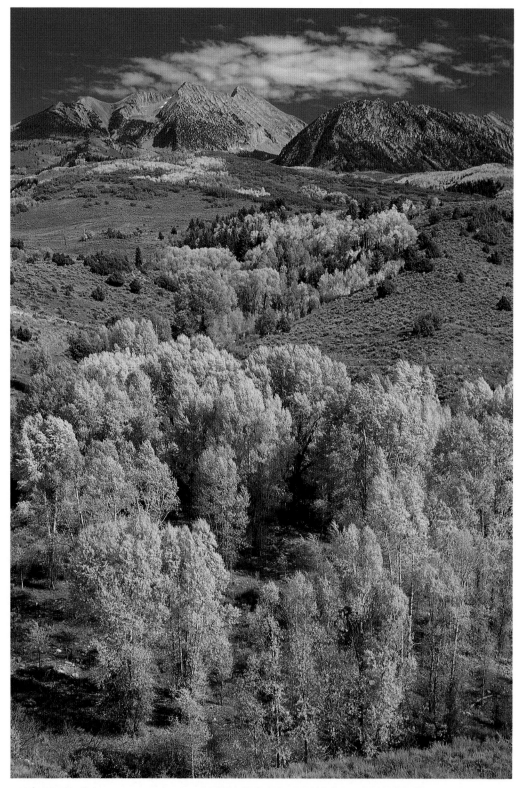

ASPEN TREES, Chair Mountain, Colorado. Nikon F4, Nikon 55mm macro lens, Fuji Velvia, polarizer.

Although the wind was really blowing, I didn't want to pass up this spectacular scene. Luckily, the foreground trees, the nearest subject area in the picture, weren't really very close, so I didn't have to stop my lens down very far; f/5.6 gave me all the depth of field I needed and let me shoot at the fastest shutter speed possible.

you've done by going to the longer lens is increased the image size, or decreased the coverage of the subject; and whenever you cover less of a subject, you lose depth of field. In other words, as you gain magnification you lose depth of field.

But if you keep image size the same, then all the lenses you use at the same *f*-stop will yield pictures with the same depth of field. Shoot a photo with your 50mm lens, then back off so that you're four times as far from the subject, and you'll be shooting an identical image size with your 200mm lens. If both lenses are used at the same *f*-stop, depth of field will be the same in both resulting photographs. The background will look different in the two pictures due to the lenses' angles of view, and the perspective will be different, but depth of field will be the same.

Is there a single correct *f*-stop to use for landscape photography? I've heard some photographers advocate always shooting landscapes at the smallest *f*-stop on a lens, but I strongly disagree with this philosophy. Simply pick whatever *f*-stop gives you the depth of field you need. There is no valid reason to stop down any more than necessary for this depth of field. If an exposure of 1/30 sec. at *f*/11 produces the depth of field you want, shooting at an equivalent exposure of 1/4 sec. at *f*/32 only increases the possibility of fuzziness due to subject or camera movement. Why bother?

I'm certainly not suggesting that you always shoot landscapes at the fastest shutter speeds possible. One good reason to use a slow speed is when you intentionally want to show movement within the frame by creating a blurred image, for example, of wind moving across a field or flowing water. You must decide what is most important for your photo, depth of field or shutter speed. Choosing one will dictate the other.

Some lenses (primarily fixed-focal-length wide-angles) incorporate a depth-of-field scale that usually appears as a series of *f*-stop numbers written on either side of the focus-indicator mark on the lens barrel. Directly across from this series of numbers are distance markings. When the lens is focused, you can read off the depth of field falling on either side of the focus point.

The depth-of-field scale is used for presetting the lens to the *hyperfocal distance* for any given *f*-stop. The hyperfocal distance is the point of focus where everything from half that distance to infinity falls within the depth of field. To find this distance for any *f*-stop, just prefocus your lens by placing the infinity mark on the focusing collar over the *f*-stop mark for the aperture you're using. In other words, you're making sure that depth of field extends infinitely far away. The nearest point covered by depth of field will be directly opposite the *f*-stop mark on the other end of the scale. The point of actual focus on the lens is the hyperfocal distance; you might be surprised to notice that it is always twice the minimum depth-of-field distance.

To use this information to maximize depth-of-field when you're shooting, suppose that you read from the scale that depth of field extends from 4 feet to infinity. Your focusing point will be at 8 feet. Now just make sure that the nearest foreground object is at 4 feet. It will look out of focus through the viewfinder because you're viewing with the lens wide open; but when you press the shutter release, the lens will stop down to your chosen shooting aperture and all will be in focus.

When I'm working, I don't quite trust the depth-of-field scales on my lenses as being accurate enough. When I use them to determine the hyperfocal distance, I always preset the scale one *f*-stop wider than the one I'm shooting in order to cover any discrepancies. For example, I'll use the *f*/11 marks to preset my lens, but I'll shoot at *f*/16. Most of the time, however, I use the depth-of-field preview device on my camera body visually to judge through the viewfinder what *f*-stop I want to use.

For serious landscape work, I wouldn't buy any camera that didn't offer a means of viewing through a lens while it is stopped down. This feature is usually called a "preview button" or "depth-of-field button," and when activated, it stops the lens down, allowing you to preview the depth of field. Normally you're viewing through a lens wide open, seeing the depth of field of that wide-open *f*-stop. But if you shoot at any other *f*-stop, the results on film will be vastly different. I want to see what the film is going to see, to view what is in focus and what is not, and to pick the best *f*-stop for yielding exactly the depth of field I want. I want control of the photographic process.

Here is how to use a depth-of-field preview. Keep your eye to the viewfinder as you *slowly* stop down the aperture of the lens until you like the result. That is the *f*-stop to use. If you shift instantly from *f*/2 to *f*/22, there won't be enough time for your eye to adjust to the different light levels. By gradually making this change, you can view what is really happening to the image. Take your time. The viewfinder will get darker because you are viewing at progressively smaller *f*-stops, letting less light through, but this darkening will have no effect on your final exposure. After all, you will pick the appropriate shutter speed for whatever *f*-stop you decide to use.

If the ambient light level is quite high, it can be very difficult to see through the viewfinder with a lens stopped down. Here is a tip to make this easier. Have you ever watched someone using a view camera? In order to see an image on the groundglass, the photographer must block out all extraneous light with a dark cloth, so that the only light striking the eye comes through the lens. You can do the same with a 35mm camera. Consider carrying a dark cloth into the field. Even easier, just pull your jacket up over your head and around the viewfinder. It works!

EQUIPMENT AND FILM

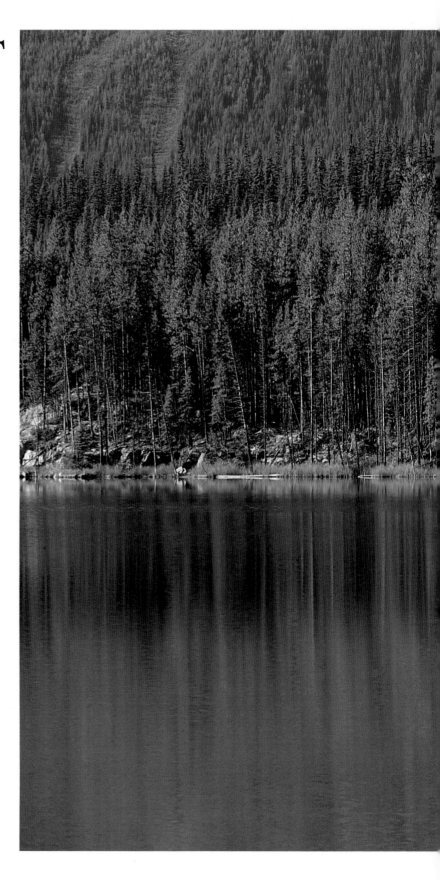

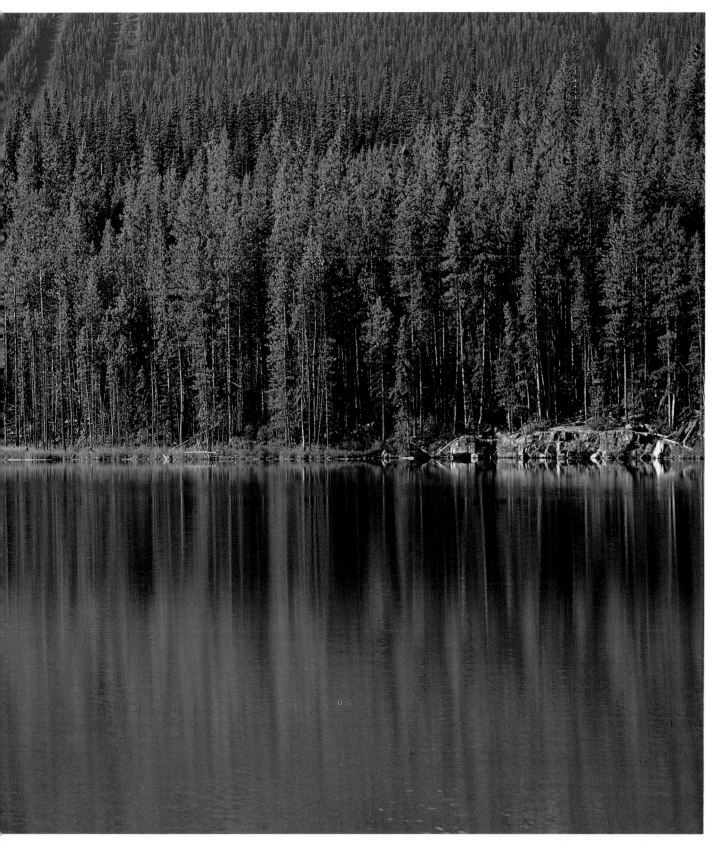

LODGEPOLE PINES AND REFLECTIONS, Banff National Park, Canada.
Nikon F4, Nikon 300mm lens, Fuji Velvia, polarizer.

Camera Systems

You can produce great landscape photographs with any 35mm SLR camera; however, I encourage you to buy the best equipment you can afford. This is especially true regarding the lenses you use, because one thing that limits the quality of any photograph is the quality of the lens. An image on film can be only as good as the image projected by the lens.

On the other hand, the best lenses can't produce pictures by themselves. People often say to me, "Gee you must own some good lenses." True, I do own some good lenses, but owning a quality lens just means that you could afford to buy the lens. Equipment alone doesn't make photographs. You may need certain equipment to shoot specific pictures; however, good technique, or how you use that equipment in the field, is far more important. Used haphazardly, the very best equipment will produce sloppy photographs; yet mediocre equipment, wielded with fanatical attention to technique, is capable of producing exquisite images.

Many photographers—myself included, at times—fall into the trap of believing that if only we could buy another lens or another accessory, our pictures would show a vast improvement in quality. Photographers tend to be gadget addicts. The truth is that most of those gadgets just weigh down our camera bags or sit unused on a shelf at home. Using the equipment you already own to its fullest potential is what really makes a difference, not buying more equipment.

Great pictures can be made with any brand of camera; the manufacturer's name is immaterial. I would be more concerned with the reliability and ruggedness of a camera than with its brand name. One way to find out about a brand's track record is to call a local camera-repair shop and ask how often they work on a given camera. Or better yet, go to a location favored by professional nature photographers, and ask them why they're working with the equipment they have with them. For this exercise, I suggest going to such places as Yellowstone National Park in the winter, or Vermont at the height of autumn's color, or the chain of national parks across southern Utah in early spring. At least this method of camera research is fun!

However, there are some specific features I would want on any camera I planned to use for landscape photography. Below is a list of camera features that I consider essential:

Full exposure control. Personally, I like a camera that offers total manual control of exposure settings as well as other autoexposure options. And in any autoexposure mode, I want a complete override option available; that is, a full autoexposure compensation system should exist. At a minimum, it should provide two full stops on either side of the metered value and should function in at least half-stop increments. Full-stop jumps just can't permit the fine-tuned control necessary for shooting color slide film.

Autoexposure modes include Shutter Priority (sometimes called Time Value), where you pick the shutter speed while the camera sets the *f*-stop; and Aperture Priority (or Aperture Value), where you choose the *f*-stop and the camera sets the shutter speed. The latter is more commonly used in landscape work because it generally involves concern about depth of field. Although I shoot mainly in the manual-exposure mode, I usually pick an *f*-stop for depth of field reasons before determining my shutter speed.

A third autoexposure mode is "Programmed Exposure," in which the camera selects both the *f*-stop and the shutter speed. If you're serious about landscape photography, you won't ever work in this mode. After all, the point is to be in control of the photographic process. How does the camera know what you want to do? I want to be in charge, taking full responsibility for both my photographic successes and failures.

A complete range of shutter speeds. Cameras are now being made with faster and faster shutter speeds. In terms of landscape photography, top-end shutter speeds of 1/2000, 1/4000, or 1/8000 sec. are meaningless. In fact, you'll find that you rarely use any speed much faster than 1/500 sec. if you're shooting a slow, fine-grained film at a stopped-down aperture. For example, consider that the sunny *f*/16 exposure (blazing full sunlight, remember?) for Fujichrome 50 is 1/60 sec. at *f*/16; an equivalent exposure is 1/2000 sec. at *f*/2.8, but I can't think of any time that I've ever shot a landscape at such a setting. Far more often, you'll be working at slow speeds, because some of the most beautiful light occurs early and late in the day. I would much rather have a camera that offers a range of slow shutter speeds than fast ones.

Quite a few camera bodies currently offer timed shutter speeds as long as 30 seconds, although sometimes these shutter speeds are available only in selected exposure modes. Beyond 30 seconds, you can always time exposures with the second hand on your watch, or do the old "one-thousand-and-one, one-thousand-and-two..." routine. For very long exposure times, accuracy really doesn't matter too much. After all, being off by 10 or 15 seconds on a four-minute exposure is meaningless. One stop less than four minutes is two minutes, and one stop more than four minutes is eight minutes. What is 15 seconds either way?

Depth-of-field preview. For landscape photography, I wouldn't buy any camera without a depth-of-field preview provision that permits you to stop the lens down to your shooting aperture. This lets you preview the depth of field that will appear in the final photograph. Normally, when you look through a lens, you are viewing with it wide open; you can see only the depth of field rendered by its widest *f*-stop, not the depth of field of the *f*-stop you plan to use for your exposure. Very little landscape work is done at wide-open apertures. As a professional, I want to see exactly what the film sees and not be forced to guess about the results. In fact, in my opinion, a depth-of-field preview is so vital for all photography that I wouldn't even consider buying a camera lacking this feature.

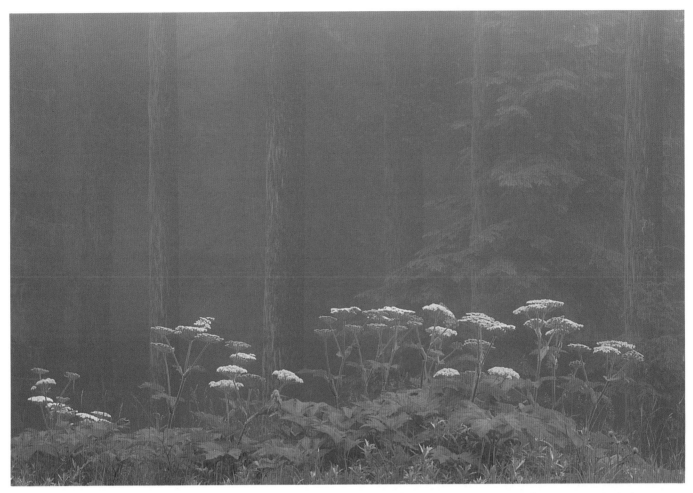

COWPARSNIP AND SPRUCE TREES IN FOG.
Nikon F4, Nikon 105mm lens, Fuji Velvia.

I carefully composed this picture to isolate the white cowparsnip flowers against the darker tree trunks. The type-E viewfinder screen in my Nikon, with its etched grid lines, helped me keep the trunks perfectly vertical, while using a short telephoto lens enabled me to stand back and look into the trees, rather than up at them.

A complete system of lenses. At the very least, lenses covering a range of focal lengths from 24mm to 300mm should be available. Better yet would be a range of 20mm to 600mm. You might not need all these focal lengths right now (although I've never met any photographer who didn't want at least one more lens), but it is better to have them available than not. For example, the three photographs in this section illustrate a broad range and use of a camera system's lenses. I took all three within a week's time in the same location, the Olympic National Park in Washington State. They were all made with the same camera body but with vastly different lenses.

For landscape and scenic work, the speed of a lens, which is equal to its widest aperture, is not very important. Fast lenses are just larger, heavier, and more expensive. If you're always going to be shooting at *f*/5.6 or smaller, why lug around a fast lens? Actually, as I'm discovering, there is one good reason: the world seems to get dimmer as we get older. Sometimes it is great to have a fast lens because it allows a lot more light for focusing.

This is particularly true of today's zoom lenses with wide-open apertures between *f*/4.5 and *f*/5.6. Add a polarizer, which cuts the light transmission by two stops, shoot in late afternoon light ...and suddenly I can hardly see through the lens.

Speaking of zoom lenses, I think that current zooms are great. Zooms from 12 or 15 years ago were so-so in quality, just not equal to fixed-focal-length lenses. Not any more. New zoom lenses, being state-of-the-art optics, are superb. However, I still wouldn't buy a zoom range that is too extreme. Manufacturers can't make one lens to do all jobs, just as car makers can't offer one vehicle that works simultaneously as a truck, a limousine, and a sports car. Plus the "one lens does it all" philosophy is an invitation to disaster in the field. What if you take that once-in-a-lifetime trip to a great scenic location only to have your one-and-only lens malfunction?

I would also love to have tripod collars on all my lenses, especially on my zooms. This would allow mounting the lens, rather than the camera body, on the tripod head; shooting a vertical

composition would then be accomplished by rotating the lens, not flopping the head. Very few zoom lenses offer this feature, but most of them need it.

Remote release. Surprisingly, a few cameras exist that don't work with any kind of remote release, either mechanical or electronic. I use a cable release to minimize vibrations whenever I'm shooting scenics with my camera on a tripod. Electronic releases tend to be rather delicate—the wires break if flexed very much—and they are fairly expensive.

That completes my list of essential camera features for landscape work. The following features, while not mandatory, are certainly useful if available:

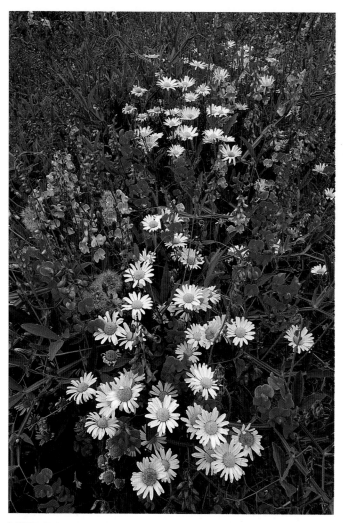

MIXED FLOWERS. Nikon F4, Nikon 24mm lens, Fuji Velvia.

Here I wanted the viewer to be part of the scene, to feel enveloped by this mixture of flowers. I photographed this intimate landscape scene with my 24mm lens, positioning it a scant 18 inches from the front flowers. Precise framing was mandatory, as I wanted to exclude some distracting elements surrounding my subject. The small f-stop necessary for enough depth of field dictated a slow shutter speed. I waited, cable release in hand, for a complete lull in the wind, then tripped the shutter.

Mirror Lock. Inside every 35mm SLR camera is a mirror that must swing up out of the way before light can reach the film. Although "swing up" implies a gentle movement, in reality what happens when you trip the shutter is that the mirror slaps up against the camera's pentaprism finder. This creates vibrations during the exposure, which in turn leads to unsharp pictures.

A mirror-lock provision is a means of raising the mirror out of the way after you've composed and set the exposure. This is important to do if you are shooting at the most vibration-prone speeds on any camera—between 1/8 and 1/15 sec.—when you're using lenses of 100mm or more. If your camera doesn't have a mirror lock and you want to do everything possible to gain sharpness, just avoid these speeds by shooting faster or slower. When exposures are long enough, vibration from mirror slap won't degrade the image. Assume, for example, that the vibration lasts 1/15 sec; then 1/15 of a 1-second exposure would record as unsharp, but 14/15 of the second would be sharp.

Not all cameras offer mirror locks. Those that do have this feature activate it in different ways. For example, with a Nikon F4 the mirror lock is a mechanical lever that you can use at any time and that keeps the mirror up until you trip the lever. This construction prevents you from using the lock if you're shooting on autoexposure because the camera can't see through the lens to set the exposure. An advantage is that the mirror stays up if you want to fire off several frames. Canon EOS cameras with mirror locks use a different mechanism: the lock is set after a 2-second delay in the self-timer. Consequently, you can shoot on autoexposure; the camera takes a meter reading, flips up the mirror, the self-timer runs, and then the shutter fires. But this sequence has to be repeated with every frame you shoot. Read your camera's instruction manual carefully to see how your mirror lock works. (Regardless of how it is set, a mirror lock should only be used with a tripod-mounted camera because you can't see through the lens when the mirror is locked up.)

If your camera doesn't have a mirror-lock feature, don't worry. I certainly wouldn't trade camera bodies just to have this one feature, although I would look for it if I were purchasing a new body. But if you already own a camera with a mirror lock, use it. Over the years, locking the mirror has become such a habit with me that I find myself flipping it up even when I'm shooting with a 20mm lens at 1/250 sec.

Interchangeable viewfinder screens. One advantage of the newer autofocus cameras is that they come with decent viewfinder screens, generally a clear, all-matte type. I hope that the days of the split-image rangefinder screen—where you had to bring together two half-moon images—are over.

Changing an unsatisfactory screen is worth considering if you're serious about shooting landscapes. I suggest using the viewfinder screens made for architectural work. These are normally clear matte screens with a grid overlay etched into them, sort of a tic-tac-toe arrangement. Nikon calls their grid screen the "E" screen; in the Canon system, it is a "D" screen; and Minolta calls it a "Type S". This grid is extremely helpful in making sure

that horizon lines remain square with the world or that vertical lines are indeed upright. In fact, I like using a grid screen so much that I have them in all my camera bodies, and I use them for all my photography, from wildlife to scenics to closeups.

Spotmetering provision. Many new cameras have built-in spot meters, or narrow-angle meters. Great! This feature lets you meter a small section of a scene rather than depend on an overall reading. Suppose you're photographing a waterfall with white water cascading over black rocks, and you're standing some distance from the falls. The worst thing you could do is to burn out the highlights by overexposing the white water. So how would you achieve correct exposure? An overall meter reading, even a center-weighted meter reading, would take in both light and dark tones. Only if their tonalities were equidistant from medium tone, and only if you metered exactly the same amount of the white and the black, would you arrive at a correct exposure.

With a spotmeter you could read the white water alone and then place it 1½ to 2 stops open from the meter reading to render it white, not middletone gray. By the way, if your camera lacks a built-in spotmeter, switching to a longer focal-length lens accomplishes the same thing as it narrows what the meter can see. Thus, you could meter using a 300mm or 400mm lens, then transfer that exposure value to whatever lens you want to use.

Autofocus. I think autofocus (AF) belongs in a category all by itself, perhaps called "optional-but-by-no-means-necessary." After all, a landscape isn't going anywhere, so you should have enough time to focus. One drawback with an AF system is that your choice for the point of sharpest focus rarely falls precisely at the AF indicator as you're composing the picture. That is, often you must aim at a spot that you want to be in focus, lock

in the focus so that it doesn't change, and then recompose. So one hand has to hold down the AF lock, one hand locks in the autoexposure compensation, and a magical third hand is needed to operate the tripod head. Sometimes a manual-focus, manual-exposure system is a lot easier.

Autofocus can be worthwhile in low-light situations or if your eyesight needs a little help. But regardless of current advertisements, good pictures can be made without AF.

Analog display in viewfinder. This feature is by no means a necessity, but I personally really love it. An analog display meter, which appears in the viewfinder, looks something like this:

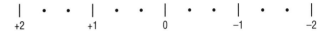

Ever see anything like this before? Basically, it reflects the exposure system I described on page 26! When I first looked through a camera with this display—in my case, a Nikon F4—I walked out of the store with that camera. All I could think about was that, finally, there was a camera that displayed exposure information exactly as I conceptualized it: in stop values on either side of medium tone. And I could even see this information while looking through the viewfinder!

How does having an analog display help? Suppose I want to make an area "light," or one stop open from medium. No longer do I have to take a meter reading, then open up one stop. All I have to do is get the meter indicator to read out at "+1". The diagram above, like the analog display in my Nikon, reads out in 1/3-stop increments; some other cameras read in 1/2 stops. Given any choice, I would want a display that shows at least plus or minus 2 stops from the meter reading.

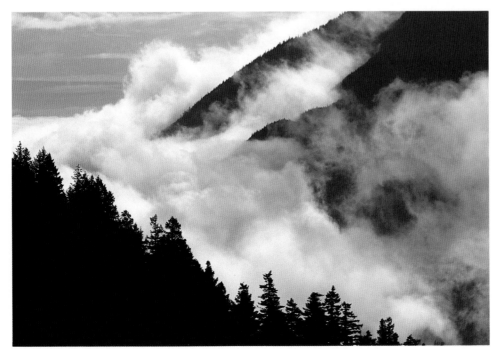

CLOUDS AND MOUNTAIN RIDGES, Olympic National Park, Washington. Nikon F4, Nikon 500mm lens, Fujichrome 100.

Only by using a very long lens—in this case, my 500mm—could I isolate this particular section of the scene. I spotmetered the clouds and opened up the exposure to make them a very light tone. With my lens mounted on a heavy tripod, I set the exposure, then locked the mirror up to prevent any vibrations from degrading the image. As the clouds moved around the ridges, I exposed several frames using a cable release, always waiting a few seconds between shots to allow any vibrations to dissipate.

Film

There is no single correct film for landscape photography. In fact, I'll go one step farther and say that the best film of all, for whatever photography you're doing, is simply the film that you like the best. But how do you find out what kind of film that is? First, you must answer some questions. Do you want slides or prints? Do you ever plan to submit your pictures for publication? Do you want to do darkroom work? Is getting any sort of picture at all a miracle to you, or are you a precise and careful worker?

I think that if you're reading this book, you're probably reasonably skilled in photography and want to improve your work, both technically and aesthetically. If so, I urge you to shoot slide, or transparency, film—it is sharper than print film, it is the type of film used for printed publication, and best of all, it gives you precise feedback on your work. When you look at a slide, you are looking at the original piece of film that you exposed. You can immediately see whether you made any mistakes in exposure, composition, or use of your equipment. This isn't so with print film. Is that print fuzzy because you handheld your camera, or because the automated printmaking machine had drifted slightly out of alignment? As for proper color rendition, learning anything from a color negative is beyond my ability, and I've been shooting film as a professional photographer for a long time now.

If you haven't already chosen a standard film, you should run a few tests to determine some film characteristics. Buy several rolls of different films (one roll of a given film isn't enough for a test). Shoot side by side comparisons in the same light, preferably with the same lens and the same composition, by loading one camera with one film and another body with another film. Be sure to use a tripod. Do this in different lighting conditions to see how the films handle high- and low-contrast situations: overcast, bright sun, late sidelight. Shoot some fast exposures and some very long ones. Try different-colored subjects, and especially try shooting black, neutral gray, and white.

If possible, have the same photography lab process all the film. Then lay it all out on a light table, use a good-quality 4X to 8X loupe, and pick the shots you like. Compare color rendition, how grainy the films appear, and how they handle contrast. Now you're ready to settle on one or two films that you particularly like. Learn their characteristics thoroughly so that you know how to handle them in the field.

Transparency films can basically be divided into the Kodachromes, which must be machine processed, and the E6 films (so called because of the chemicals used) such as Ektachrome, Fujichrome, and Agfachrome. Kodachrome must generally be mailed to a film processor because few locales have labs with machinery for developing Kodachrome. E6 films can be processed at hundreds of local labs or even at your kitchen sink if you can control time and temperature, although I would strongly advise you *not* to do your own processing this way. Time and temperature must be controlled precisely for good color balance. In fact, if you shoot E6 films and aren't getting clean renditions of white and black subjects, then question how it was processed before you blame the film. Try another lab.

Personally, I think that you'll get the best results by using the sharpest, most grain-free film possible. After all, you've paid a lot of money for the best optics available, so why not be able to see this quality on the film? As a general rule, film quality and film speed are inversely related; as film speed goes up, quality goes down. I'm not suggesting that you should shoot the slowest film

KODACHROME 25

FUJI VELVIA

Here is a pair of pictures from one of my film tests. I arranged various colors together and, in unchanging light, shot the identical framing with the same lens at the same f-stop. These films definitely have different color renditions. One isn't better than the other; they are just different. Which do you prefer?

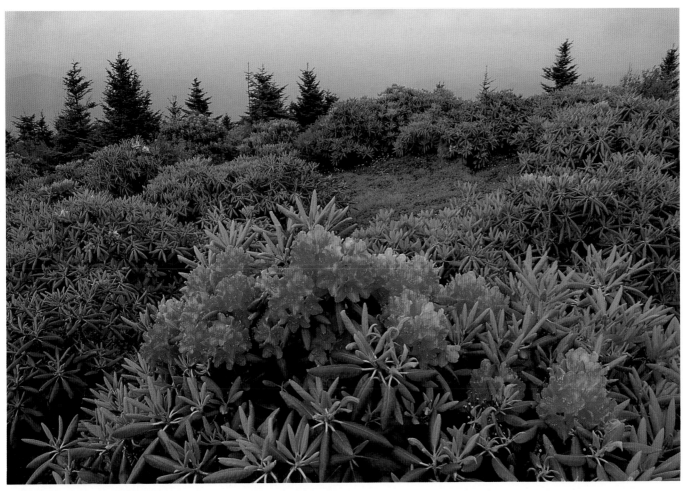

RHODODENDRON on Round Bald, Roan Mountain, North Carolina. Nikon F4, Nikon 24mm lens, Fuji Velvia.

Bright flowers on a dull day were a great subject for the slow, fine-grained Fuji Velvia film that I used. This color-saturated film recorded all the fine details within the composition.

all the time, or indeed that you shoot any one film all the time. Pick the film you like best given your working conditions.

If you think you'll ever publish your pictures, then you should shoot slow-speed, high-quality transparency film for one simple reason: your competition is doing so. Of course, if an image is rare enough, you could sell a picture of it shot on any film whatsoever; for example, the first verifiable shots of Bigfoot or of the Loch Ness Monster would be saleable regardless of the film. They could be color slides made from a left-over, out-of-date, discontinued color print film. But what about a sunset shot or one of autumn leaves? Everyone has worked these subjects—with the best films, the best optics, the best photographic technique. In order to compete, you have to be at least equal. I would love it if all other working professionals handheld their cameras, shot ISO 1000 film pushed a stop, and then made duplicates for submission. My work would look so much better!

Your film choices will probably change over time as newer films enter the market. Ten years ago, I used only two films, Kodachrome 25 and 64. Today almost all my landscape work is on Fuji Velvia, with Fujichrome 100 and some Kodachrome 200 rounding out my choices. Film changes truly amaze me. Not long ago I couldn't have imagined a publishable-quality ISO 100 or 200 film; why, I was a working professional when "High Speed Ektachrome" was a blazing ISO 160.

Also, consider your progress as a photographer. When I look at some of my early work, I'm truly amazed. Was I really that bad? If these were the shots I kept, what were the ones that I threw away like? I trust that I'll have this same attitude ten years from now when I cull my current photography. I sure hope I'll have improved, and not the opposite.

I'm often asked about the longevity of E6 films versus that of the Kodachromes. Kodachrome images show the least deterioration if—and this is a big "if"—you keep your slides stored under ideal conditions: in the dark at 40°F and at 40-percent relative humidity. But when photographs are exposed to light, such as when slides are projected or when they're on an editor's light table, then E6 films last longer than the Kodachromes. Another frequent question regards which film gives the most "realistic"

rendition. The implication is that somehow the most "realistic" film is the best. My answer is that no film even comes close to reality, which is fine with me. All films have a color bias, one way or another. If I truly wanted realism, I wouldn't bother photographing—I would just go outside and experience reality. Photography by its very nature is unrealistic. We are surrounded by chaos, a jumble of images and light, which we arbitrarily order through composition, choosing one perspective over another, a wide-angle lens over a telephoto, prints or slides. Pictures are what we take, realism is what we experience. If realistic color is a criteria for choosing film, where does that leave black and white?

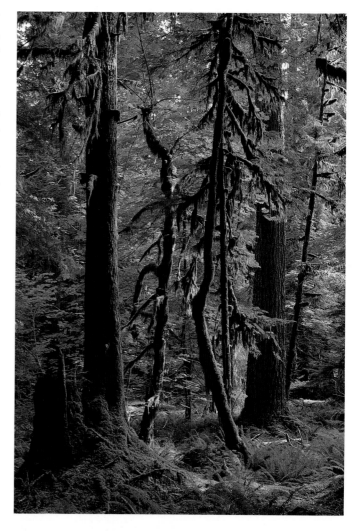

OLD GROWTH FOREST, Olympic National Park, Washington. Nikon F4, Nikon 50–135mm zoom lens, Fuji Velvia.

The ability to record contrast is a major test for all color-transparency films. This scene is about as contrasty as most slide films can possibly handle; you can see some detail in both the highlights and the shadows simultaneously, although the deepest shadows areas are starting to go black. No film, however, can record the contrast range that the human eye is able to detect.

WINTER SNOWSTORM. Nikon F4, Nikon 105mm macro lens, Kodachrome 200.

Kodachrome 200 is my favorite film for the winter conditions in which this picture was taken: a snowy scene in extremely flat, low-contrast light. The film is very sharp but also very grainy. In this flat light, the film grain puts texture back into the snow.

TRIPODS AND HEADS

Without a doubt, the most important photographic accessory on the market is a tripod. If you want to improve the technical quality of your photographs, buy a quality tripod and use it. Unfortunately, most tripods don't fall into the "quality" category. Perhaps tripods are really designed off-planet by short Martians—so many tripods are too short, pinch human fingers, are too flimsy to support much weight, and have controls seemingly fashioned for some other race's appendages. I firmly believe that most human photographers curse tripods, and consequently don't use them because they've never had the opportunity to use a good one.

I'm always amazed at how many people buy expensive lenses because of their optical reputations, then handhold their cameras while shooting at slow shutter speeds. I can just hear these photographers as they look at the resulting pictures: "Boy, that lens isn't sharp. I'd better get rid of it and buy another." No, buy a tripod, and use it. After all, you can always make an unsharp picture, but only a sturdy tripod offers the possibility of repeatedly getting razor-sharp images.

An old rule of thumb states that to obtain acceptable sharpness when handholding a camera, you need a shutter speed at least numerically equal to the focal length of the lens you're using. In other words, if you're shooting a 50mm lens, you need a shutter speed of at least 1/50 sec. A 105mm lens demands a 1/105 sec. minimum, a 200mm lens needs 1/200 sec., a 500mm lens requires a 1/500 sec. shutter speed, and so on.

Therefore, if you want consistent sharpness, handholding a camera restricts you to using bright light, fast apertures, short focal lengths, or fast film. But some of the best lighting for landscape work is early and late in the day or during stormy, overcast periods. Wide-open apertures offer little depth of field, while fast films sacrifice quality. And using only short focal lengths restricts your range of composition. Why not use a tripod?

There is no such thing as a lightweight, sturdy tripod for field use. Beginning 35mm photographers often believe that since their camera is fairly small, a small tripod will work just fine. They forget to consider that as they progress to longer focal-length lenses, they're magnifying all the problems they encounter as well as getting a tighter image. Compared to the normal 50mm lens, a 100mm lens is twice the power. Using that 100mm lens will increase by a factor of two all the effects of vibration, sloppy focusing, and poor technique. At its long end, an 80–200mm zoom lens magnifies problems by four. You must hold the lens four times as sturdily, and work four times as carefully, to achieve the same image quality as with your 50mm lens. Using a 300mm, 400mm, or 500mm lens increases the absolute necessity of employing a good, sturdy tripod.

The sturdiest tripods have the fewest leg sections. Every joint in a tripod is a potential weak link and a potential problem in the field. Plus the fewer the leg sections, the faster a tripod can be set up and taken down. To check for sturdiness, mount a camera and long lens on a tripod with all its legs extended to their full length, and lock all the controls. Focus on a nearby subject, then watch through the viewfinder as you lightly tap first the legs, then the front of the lens. If the image jumps wildly, find another tripod.

When its legs are fully extended, a good tripod is able to position the camera over your head when the tripod is set up on a flat floor. Why do you need this extra height? When you're working in the field, tripods seem to shrink. Stooping over your camera for any length of time will quickly dampen your enthusiasm, while raising a centerpost more than a few inches turns a tripod into a monopod with a three-legged base. Or imagine that you're standing on a steep hill, with your lens aimed at a right angle to the slope. One tripod leg must be positioned beneath your body if you're looking through the viewfinder. Your tall tripod just got shorter.

One recent spring, I was shooting in the Columbia Gorge Scenic Area, near Portland, Oregon. I found a great composition of a waterfall, but there was a major problem. The exact place I needed to position the camera was in the middle of a small stream, directly above a slick, mossy rock. If I balanced on the rock, there wasn't enough room left for the tripod legs, but if I stood in the water, I couldn't see through the camera. I needed a tripod tall enough to extend the legs into the stream while I teetered on the rock. Luckily I got the shot, although the experience turned out to be more an agility test than I would have liked.

If you must work with a short tripod, extending its centerpost is not a good way to add height, as this rapidly decreases the tripod's stability. You can certainly get away with extending the 'post a few inches if you're shooting short focal-length lenses, but longer lenses will magnify any movement. I would avoid extending the centerpost at all if I could. Tripods are at their sturdiest with no centerpost extension whatsoever.

Just as important as having a tall tripod is being able to operate it at low levels. Most photographs are taken from roughly five feet above the ground—human eye level. By simply changing your shooting position, you can make your photographs of anything stand out from all the rest. Unfortunately, very few tripods drop low to the ground. Inverting the centerpost, as advertised by tripod manufacturers, is an invitation to disaster. How can you possibly crawl in between the tripod legs and work all the camera and head controls upside-down, let alone try shooting with a long lens? Have you ever noticed that those advertisements never show a photographer actually working with an inverted centerpost?

Here are my recommended choices for well-made tripods that offer flexibility, sturdiness, and both low and high positioning:

Gitzo models 320, 341, and 410R. Gitzo tripods are French-made, relatively heavy tripods that are rock solid and dependable. In fact, the Gitzo catalog states that they carry a "full warranty for

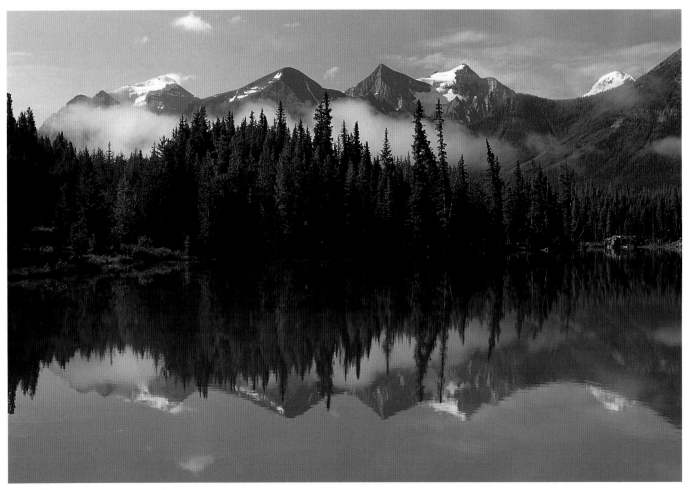

HERBERT LAKE AND THE BOW RANGE MOUNTAINS, Banff National Park, Canada. Nikon F4, Nikon 50–135mm zoom lens, Fuji Velvia, polarizer.

For this early morning shot I needed to work quickly, as the light was changing rapidly. Being familiar with how to set up my tripod equipment most effectively was crucial. Without a solid support, I could never have recorded the detail within this picture.

life—plus reincarnations." Their model 320 is my first choice for an all-around tripod. It comes with a long centerpost that totally defeats its low-level positioning ability; you can either buy an accessory five-inch-long post, or just shorten the long one with a hacksaw or tubing cutter.

The Gitzo 341, with the same legs as the 320, gives you the option of removing the centerpost assembly entirely and replacing it with a flat platform. Consequently, this tripod will go absolutely flat on the ground if you need that shooting position. The Gitzo 410R is a larger, heavier version of the 341, offering the same ground-level ability. For the difference in weight and price, I would probably buy the 410R over the 341 due to the former's extra 6 inches in total leg length. Even with the legs fully extended, the 410R is rock solid; I've shot focal lengths from 20mm to 1000mm using this tripod. With either the 341 or the 410R, I urge you to purchase the flat platform along with the tripod.

Gitzo tripods are anything but inexpensive; however, an investment in one will last and last. You'll undoubtedly buy new camera bodies and switch lenses while keeping the same Gitzo tripod. I'm still using the 320 I bought in 1977, and my 410R has just logged in six years of use. By the way, every picture in this book was taken with my camera firmly mounted on a Gitzo tripod.

Bogen 3021 (3221). These two models are the chrome and black-anodized versions of the same tripod. Bogen is the United States distributor for a large line of tripods actually made in Italy by Manfrotto (and known by that name everywhere else in the world).

For the money, the Bogen 3021/3221 twins are, in my estimation, the best tripod buys on the market today. Although not quite up to the standard set by the Gitzo tripods, dollar for dollar no other models can compete with them. Manfrotto continues to make improvements to this line, replacing weak

parts with stronger versions. If the 3021/3221 has a drawback, it is that the tripod is a little short; the leg length is about 6 inches less than the Gitzo 320. If you're 5'10" or taller, and work in uneven terrain, you'll notice this problem as you continually resort to extending the centerpost.

The equipment suggestions made above are for tripod legs alone, without heads. To top off any tripod you can add a three-way pan/tilt head, or a ball-and-socket head. Major differences in operation exist between these two types of heads, but there is no clear-cut winner. Choosing one or the other type is really a matter of personal preference. I suggest you take your camera equipment, including your shortest and longest lenses, to a well-stocked camera store and play with different heads to see which kind you like.

Pan/tilt heads offer precise operation. Movement in each axis of adjustment—swiveling, tilting forward or backward, and tipping left and right—is governed by a separate control handle. This allows you to make minute changes in composition in one direction without changing any other alignment. Having three different handles to loosen and retighten, however, slows you down. The price you pay for total control is loss of speed in operation.

Ball heads make up for this by having only one control handle. When it is loosened, all movements are free. For ease and speed of operation, ball heads cannot be beaten. The best ball heads are large and offer a tension or drag adjustment on the ball itself so that when the control handle is loosened, the ball doesn't just flop around. This is especially important as you use longer and heavier lenses.

Ball heads do have an advantage in that you can flop the camera for a vertical to either the left or the right. This means that, without moving the tripod itself, you can move the camera position about five inches, a neat trick when you're set up in a tightly confining area that restricts tripod-leg placement. Although you can do the same with a pan/tilt head, you'll end up with the head itself reversed—all the control handles will be facing opposite their normal direction.

Regardless of what type of head you like best, fitting a quick-release system to it is a good idea. This involves a plate that attaches to the tripod socket of your camera body or lens, and it in turn fits into a clamp mounted on the tripod head. Quick-releases speed up attaching cameras to heads and make the process much easier, especially when your hands are cold or you're wearing gloves. Plus you can remove a camera, then put it back onto the tripod, without changing your original composition.

Two quick-release systems have become de facto standards. The Arca type (used by several ball head manufacturers) uses a dovetail arrangement of plates sliding into a screw clamp. The Bogen system employs large, hexagonal plates and a lever action clamp. Both work well; the choice is again personal preference.

Here are my suggestions for heads:

Bogen 3047. This is the best pan/tilt head for the money. It incorporates a Bogen quick release.

Bogen 3038. A heavy ball head, it uses a locking lever rather than a knob control. It comes with a Bogen quick-release built in, although it can be easily custom converted to the Arca-type release.

Arca-Swiss B1. An expensive but precision-made ball head. I would buy only the version with the Arca quick-release clamp.

Studioball QR. A large, massive ball head with the Arca-type quick-release.

Two distributors offer Arca- and Bogen-style quick-release plates and adapters custom-made to fit specific lenses and cameras. I highly recommend both of these companies. Custom

This Nikon F4 camera is mounted on a Studioball head. Note how massive the head is and the large diameter of the ball. Generally speaking, the larger the ball, the sturdier the head.

plates are well worth the expense; they cost little more than the generic one-size-fits-all plates from Bogen and Arca, and they offer a far more secure mating of plate and equipment. For information, contact:

Kirk Enterprises
4370 East US Highway 20
Angola, IN 46703
(219) 665–3670

Really Right Stuff
P.O. Box 6531
Los Osos, CA 93412
(805) 528–6321

Finally, here are some ideas for using a tripod in the field. First, find your composition without using your tripod. Why? Because the moment you erect a tripod, you tend to trap yourself into shooting from that exact spot, simply to justify the trouble you went through extending the legs and mounting your camera. Lay your tripod down, and handhold the camera while you scout out the area. Move around searching for the right spot; try a low shooting position and a high one; test out a vertical and a horizontal framing. This is easy if you're handholding your camera. After you've decided on the right shooting location, go get your tripod and set up. Tripods may have legs, but so do you, and generally it is better to use your own.

Quality tripods and heads are some of the best compositional aids available. Because they force you to slow down, they let you carefully study the image seen through the viewfinder. For example, you can control where you place the edges of the frame, which is often a problem when shooting with a handheld camera, as the frame's edges are always moving slightly. Not so with a tripod-mounted camera—it gives you a solid picture frame. Take your time, frame carefully, and make all the minute adjustments necessary to achieve precisely the picture you want.

AUTUMN SUGAR-MAPLE LEAF AND DEWY GRASS. Nikon F4, Nikon 105mm macro lens, Fuji Velvia.

A real test for many tripods and heads is the ease with which they enable you to shoot vertical compositions. A good head should hold solidly in any position. Here I was shooting from quite low to the ground; only a flexible tripod allowed me this camera viewpoint.

POLARIZING FILTERS

For landscape photography, the filter I use most often is a polarizer. This is not to say that I use a polarizer all the time; far from it. I firmly believe that filters should be used only when you make a conscious decision to do so, when you can articulate a specific reason to use one. I'm not a great fan of filters at all, particularly the "special effect" filters with such names as *cross star, rainbow, enhancer,* or *sunset.* As far as I'm concerned, these are tinsel and hype.

Under many conditions, polarizers increase color saturation, yielding richer and more intense hues: greener foliage, redder roses, and bluer skies. Most subjects reflect a certain amount of natural glare from their surfaces; along with atmospheric haze, this glare tends to diffuse the way that we see the colors. Polarizers can eliminate some of these diffusing elements and produce richer colors on film. To use a polarizer, screw it onto the front of your lens, and then turn its rotating mount until you like what you see.

Polarizers are most commonly used to darken the blue sky. This is actually where I use polarizers the least; current films tend to be color saturated, and it is easy to overdo this dark-sky effect. But how much this filter will darken the sky depends on the type of sky and your shooting angle in relation to it. Seen through a polarizer, a clear blue sky will darken appreciably at right angles to the direction of the sun; yet a gray, overcast sky will show hardly any effect at all.

Here is a simple way to determine which areas of the sky will darken most: point your index finger at the sun, then extend your thumb at a 90° angle to your finger, like a child's imitation play pistol. If you keep your index finger pointed at the sun and rotate your wrist, your thumb will travel in a plane across the sky.

This plane, at 90° to the axis of the sun, is the area of maximum darkening for any given elevation of the sun, the plane that will show the maximum effect when a polarizer is used. At high noon, with the sun overhead, this area is near the horizon. But at sunset, the strongly polarized band passes overhead. This "thumb and index finger" trick always works, as long as you remember to twist your wrist.

Using a polarizer on a wide-angle lens often accentuates this plane of maximum polarization. We tend to think of the clear blue sky as being all one tonality, but it really is not. Look closely, and you'll discover that the sky naturally darkens in tone farther away from the sun. If you take a picture using a 24mm lens with no filter, the sky will be rendered as an uneven tonality, since the lens sees such a large angle of view (the picture angle is around 84°). When you shoot this through a polarizer, this effect is heightened even more. One side of the frame is near the axis of the sun and shows little polarization effect, the other side is off axis and shows great effect. If this graduated tone in the sky bothers you, there are several remedies. You could pick a longer focal-length lens, or you could frame your shot to encompass the least sky possible. You could also shoot a vertical composition to limit the angle of view across the top of the frame.

I use polarizers most frequently to remove the glare from vegetation. Often when I'm shooting on an overcast day, and especially in the rain, I reach for a polarizer to saturate the colors of all those shiny leaves. Be careful if you use a polarizer this way in low-light situations, as it cuts the amount of light reaching the film, necessitating a slower shutter speed if you want to keep using the same *f*-stop. Inevitably, just when you're forced into using slower shutter speeds, the wind seems to increase exponentially.

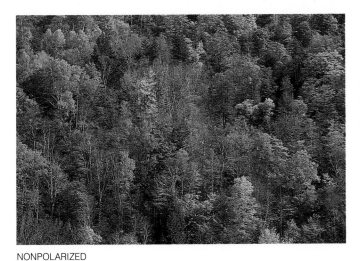

NONPOLARIZED

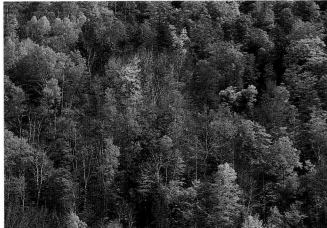

POLARIZED

AUTUMN WOODS, Vermont. Nikon F4, Nikon 50–135mm zoom lens, Fuji Velvia.
This pair of photographs illustrates the situation where I most often use a polarizing filter: to remove glare from vegetation. The light was from an overcast sky, yet the polarizer saturated the colors and added some snap to the picture on the right.

Polarizers change your base exposure between one and two stops. If you add one to a lens and see no change whatsoever as you rotate it, you have in effect added a one-stop, neutral-density filter. At maximum polarization, where you see a big difference as you rotate the filter, it is a two-stop difference in exposure. Between these two extremes, you can split the difference when compensating for exposure. Metering through the filter takes care of that, but be careful if you're using a hand meter or shooting with the sunny $f/16$ values. What is the proper exposure if you're shooting a midday landscape using a polarizer at maximum effect on a sunny day? The answer is to start at sunny $f/16$, then open one stop for sidelighting (at midday the sun is overhead while you're photographing toward the horizon) and two more stops for the polarizer; that is, the correct exposure is sunny $f/5.6$ or any equivalent.

Two kinds of polarizers are available: circular and linear. They look exactly the same; both are round filters you screw onto the end of a lens. Unless it is distinctly marked as a circular one, a given polarizer is probably the linear type. Most current cameras—the Nikon AF bodies, the Canon EOS series, the Minolta Maxxum line—need the circular variety to meter correctly and to autofocus precisely.

To determine whether your camera's TTL metering system works with a linear polarizer, mount one on a lens and take a meter reading off a dull, evenly lit area that is all one tonality. A flat, off-white wall in your house will work great. If the meter reading changes when you rotate the filter in its mount, then that particular camera requires a circular polarizer to meter TTL correctly. You can use a linear polarizer, as long as you meter without it and then work in filter factors; however, it makes

NONPOLARIZED

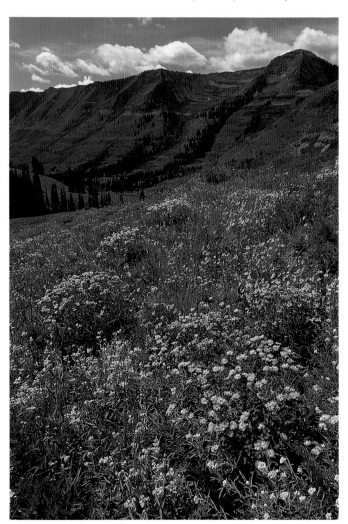

POLARIZED

ANTHRACITE MESA AND SUMMER FLOWERS, Colorado. Nikon F4, Nikon 24mm lens, Fuji Velvia.

Adding a polarizer did two things: it darkened the blue sky, making the clouds stand out; and it strengthened the colors of the flowers by removing glare from the leaves.

more sense just to buy a circular one that can be used on all cameras, including the models that accept linear polarizers.

I'm in the habit of deciding whether I want to use a polarizer by holding it up and rotating it as I look through it. It is an arbitrary decision—do I like the effect or not? Most of the time I don't bother mounting the filter on a lens when I do this. But I have to be careful with my circular polarizers because they are not really two-directional; there is a right direction and a wrong direction to look through them. One way—the way a lens would look through them—gives a pronounced polarization effect, while looking through them the other way does not. When I hold them up to look at a scene, I always make sure the screw threads are facing me; then I'm looking through it the right way.

Not sure if your polarizer is linear or circular? Hold your polarizer at arm's length in front of a mirror so that the filter and its reflection overlap. If this overlapping area is dark (and flip the filter over, since circular polarizers are directional), then you've got a circular one. If you see no difference when filter and reflection overlap, you have a linear version.

Watch out for vignetting when you use polarizers on lenses shorter than 50mm. These filters tend to be fairly thick; if you add a lens hood to the filter, or if you stack filters (which I wouldn't do, as this degrades optical quality), you can easily cut off the corners of the frame. This probably won't show up in the viewfinder if you're viewing through the lens wide open. Point your lens at the sky, and use your depth-of-field preview to see if you're getting a full-frame image. Nikon has solved this problem by making its polarizers just a little wider than the lens diameter. For example, a Nikon polarizer may have 52mm filter threads, but the glass itself is 60mm in diameter.

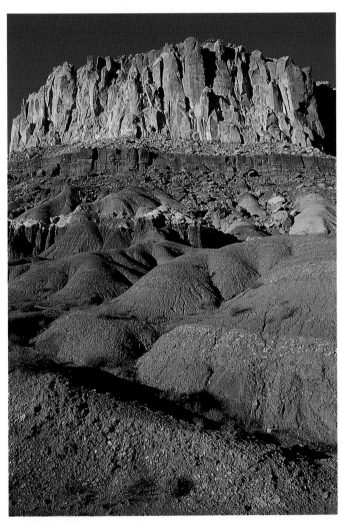

NONPOLARIZED

POLARIZED

ROCK FORMATION, Capitol Reef National Park, Utah. Nikon F4, Nikon 35mm lens, Fuji Velvia.

Compare the effects of using the polarizer in these two photographs taken late in the day, with straight sidelighting. In the foreground, there is little difference. At the top of the frame, however, there is a definite difference in color saturation in the rock formation. In the picture made with the polarizer the sky is almost midnight blue. Do you like this effect, or is the picture overpolarized?

GRADUATED NEUTRAL-DENSITY FILTERS

A major obstacle facing all landscape photographers is film's inability to record the contrast range seen by our eyes. People are able to accommodate visually a much broader spectrum between highlights and shadows than film can. When we glance at a scene, detail simultaneously appears in both the highlight areas and the deep shadow zones. Our eyes can accommodate a range of roughly 12 to 14 stops. As noted earlier in the "Film" section, color slide film can, at best, handle about a 5-stop span, from brightest highlight to darkest shadow. Recognizing this limitation and subsequently learning to "see" subjects in the same manner that film records contrast are important goals for any landscape photographer.

Fancy advanced-metering systems in cameras, and newer and better films, haven't changed this basic limitation. If the scene encompasses more than a 5-stop range, you've got a problem. Expose for the lightest area, and the darkest sections will block up, turning into a detailless blob. Expose for the darkest area, and the highlights burn out, leaving a washed-out expanse. Split the difference and neither section looks good.

You can easily tell if you're facing this situation before you press the shutter button. Just meter the brightest area and then the darkest area, placing them tonally where you want them to fall, and compare meter readings. Suppose you're shooting a scenic of a snow-capped, sunlit mountain. In the foreground of your composition lies a stream with moss-covered boulders, all in shadow. Can you expose to hold detail in both mountain and stream?

You meter the snow area on the mountain, and the meter says 1/250 sec. at f/16. Open up two stops to make the snow white. The resulting exposure: 1/60 sec. at f/16. Now meter the shadowed stream. Here the mossy rocks are medium-toned anyway, so you don't have to compensate. Your meter says 1/60 sec. at f/4. This means a four-stop difference between the two areas. If

you shoot to make the snow appear white, the shadowed mossy boulders will be four stops darker, or "extremely dark" in tone. Make the mossy rocks medium, and the snow will be four stops lighter—but the film cannot record this, so all that will appear on your slide will be a blank section of film base.

A partial solution to the problem of limited contrast range is to use a graduated neutral-density filter to effectively compress the tonal range of the scene. I say "partial" because using one of these filters doesn't guarantee that everything will record on your film; indeed, at times these filters create their own set of problems.

Neutral-density (ND) filters simply cut the amount of light transmitted to the film. A true ND filter adds no color of its own to a scene; it is neutral and does nothing at all besides reducing the light. ND filters are available in different degrees of density; that is, different filters can cut the light by one stop, two stops, three stops, and so on.

Graduated filters have more density in one area of the frame, a density that tapers to a clear filter at the other edge. Rather than reducing light evenly across the whole picture area, as with a standard ND filter, graduated filters reduce the light over only a predetermined area of your composition. This depends on where you position the dark area of the filter; you can add density anywhere you want, effectively compressing the contrast range of a scene. Just be aware that graduated filters shift from density to clear in a straight line across the filter, so it certainly helps if the contrast in your picture also changes in a straight line. Graduated filters are available in neutral-density and in colored versions. I would avoid the latter, as many of the colors available look unrealistic.

Graduated ND filters are available as standard, round, screw-in filters and in rectangular shapes for filter holders that, in turn, screw onto a lens. Most screw-in filters are made of glass and have one major drawback: the graduation line, where the filter changes from ND to clear, falls exactly through the center of the filter. Half the filter is dark ND and half is clear; consequently half your picture will be darkened, half will not. In terms of composition, this "center of the frame" placement rarely occurs where you want the division to fall.

Much more useful are the rectangular filters. Typically made from plastic or an acrylic-resin material, these allow you to position the fade-out line anywhere you want. Rectangular filters are produced for use with specific filter holders; the holder allows the filter to slide from side to side and to rotate. In the field I rarely use a holder because bringing it means one more thing to carry. Instead, I hold the filter in front of my lens, making sure I don't bump the lens during exposure. With a little practice this technique has worked fine, and I can see no difference between my pictures made with or without the holder.

The drawbacks with acrylic-resin filters are that they tend to hold static electricity and attract dust, they scratch easily, and some are not neutral at all but yield a distinct color cast. If your

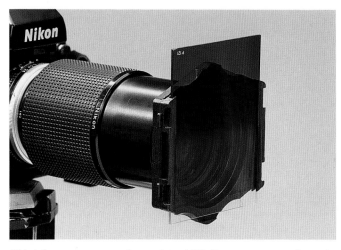

This is how most rectangular graduated ND filters are meant to be used, in a filter holder that screws onto the end of a lens. The holder can be rotated, and the filter can be slid into any position.

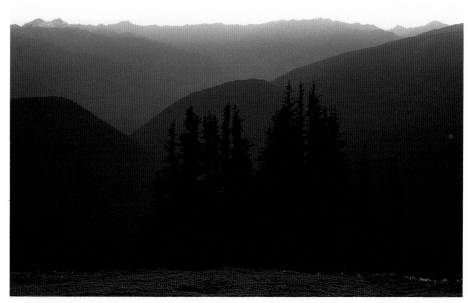

RIDGES AT SUNSET, Olympic National Park, Washington. Nikon F3, Nikon 105mm lens, Kodachrome 25.

To bring out the rich colors of sunset, I feathered the edge of a two-stop filter across the sky and into the edge of the mountain tops. The foreground exposure remained unchanged.

WITHOUT FILTER

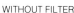

WITH GRADUATED ND FILTER

camera store carries them, try shooting a few test frames through various filters to find the most neutral ones.

The usefulness of graduated ND filters outweighs any problems they create by a long shot. In fact, I suggest you buy two of these filters: a one-stop and a two-stop version. You can always stack them together for a three-stop sandwich filter if you really need to do so, although optical quality will definitely suffer.

To understand how to use ND filters in the field, let's go back to my previous example of the snowy mountain and mossy stream, where there were four stops between the two areas we wanted properly exposed. If we could compress this into a two-

stop difference, the film would be able to record both the snow and the mossy rocks, the former as white and the latter as medium green. The solution is to put a two-stop graduated ND filter over the lens so that the dark half covers the snowy mountain. Meter the snow through the dark part of the filter and re-orient the snow as a white. You've cut the light on that section of the frame by two stops, so the stream will record properly on the film. Always re-orient the highlight tone when using graduated ND filters, especially if you're not sure exactly how many stops there are between highlight and shadow. The worst mistake you can make photographically is to burn out the highlights.

You need to position a graduated ND filter carefully. When you're looking through your camera, the graduation line is very difficult to see, especially when your lens is wide open. Use your depth-of-field preview to stop your lens down, and then slowly move the filter into location. Rotating the filter back and forth just a little will help make the graduation more visible. Be sure not to slide the filter too far so that you end up adding some density to the shadowed side of the frame. If you do, you'll create a dark band running across the area where highlights and shadows meet. On the other hand, if you don't slide it far enough into the picture area, you'll leave a bright highlight along this meeting area. By the way, if you shoot with your lens wide open, the ND filter will have little effect, as the filter lies considerably outside the depth of field of the wide-open aperture. ND filters work best when you're stopping down to small apertures, particularly when shooting wide-angle lenses.

Don't try to position a graduated filter by looking at where the graduation occurs in front of the lens, as doing so can give a false impression of the final result. The percentage of density covering the lens' front element doesn't necessarily equate with how much of the film is affected. To position the filter correctly, there is no substitute for looking through your lens, using

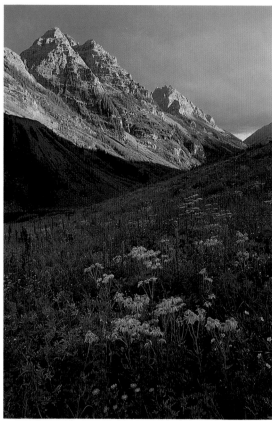

WITHOUT FILTER

PYRAMID PEAK, Colorado. Nikon F4, Nikon 24mm lens, Fuji Velvia.

Here I used a one-stop graduated filter to drop the tonality of the sky and sunlit mountain peak. Compare the near hilltop on the right side of the frame in each picture, and you can see where the graduation occurs.

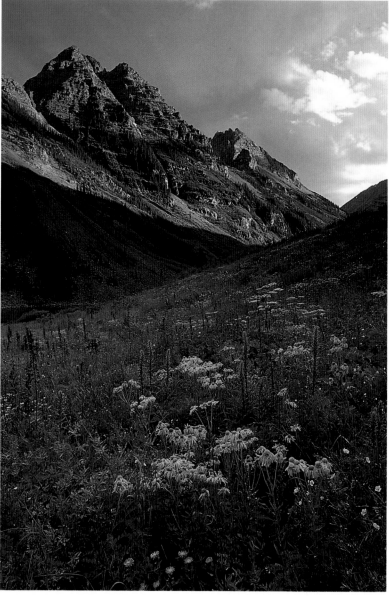

WITH GRADUATED ND FILTER

your shooting aperture. And one more thing—when you look at a graduated ND filter, the greatest change from density to clear appears to be in the lighter area. However, what shows up on film as far as where the change actually happens relates more to the dark side of the graduation.

True graduated ND rectangular filters in different strengths are available from a number of manufacturers including Tiffen, Singh-Ray, and B+W. All these brands are fairly expensive, running about a hundred dollars per filter. Cokin offers two "graduated gray" filters that aren't true ND filters but are the least costly way to play.

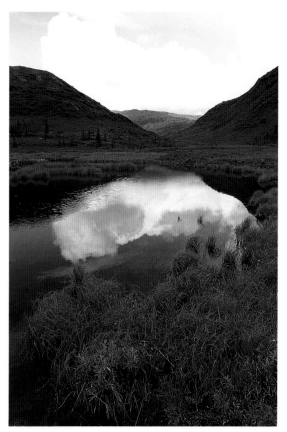

WITHOUT FILTER

POND AND HILLS, Alaska. Nikon F4, Nikon 24mm lens, Fuji Velvia.

One problem with using graduated ND filters appears in this pair of pictures. Whether you use a rectangular or a round screw-in filter, the graduation always occurs in a straight line. But here I needed to reduce the exposure of a V-shaped area of sky between the hills. When I used my graduated ND filter, the graduation fell across the hillsides, dropping their tonality as well as the sky's.

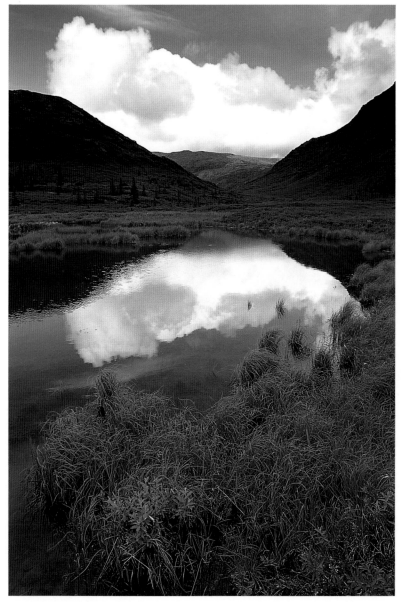

WITH GRADUATED ND FILTER

LENSES

SAGUARO CACTUS AT DAWN, Saguaro National Monument, Arizona.
Nikon F4, Nikon 300mm lens, Fuji Velvia, polarizer.

WHAT LENSES DO

Photography is a means of ordering the world around us. Taking a picture, we emphasize one aspect of our experience over another by choosing exactly what to photograph, isolating the subject, and deciding how much of it to include in the frame. We give importance to that subject—in effect declaring "Look at this!"—through the choices we make composing it, the point of view from which we photograph it, and the photographic tools we use. Primary among these tools are the lenses we own. Before I discuss how to use specific lenses in the field, here is an overview of lens terminology and how lens choice affects the viewer's perception.

The two most basic aspects of any lens are its focal length and its maximum aperture; the latter denotes the lens' speed. *Focal length* is defined as the distance between the optical center of a lens and the film when the lens is focused on infinity. This distance is almost always measured and expressed in millimeters, although occasionally people refer to a one-inch or a two-inch lens. In practical terms, focal length is a more useful definition in terms of how it relates to an image and how it changes the image as compared to some norm. In 35mm photography, that norm is the image produced by a 50mm lens.

50mm lenses are often called "normal" lenses, although this only means that lenses around this focal length normally come with cameras. There is nothing about this focal length that is "normal" as far as how we humans actually see, neither the angle of view created by a 50mm lens nor how its focal length relates to the focal length of our eyes. Perhaps calling a 50mm lens a "standard" lens would make more sense. Indeed, 50mm lenses became the standard lenses on 35mm cameras more through an historical accident than any rationale on the part of camera manufacturers. Any lens with a focal length numerically greater than the standard 50mm is generally called a "long" or "telephoto" lens, while any focal length numerically smaller than 50mm is a "short" or "wide angle" lens.

There is a direct relationship between the focal length of a lens and two byproducts: the lens' angle of view, and the image size it produces. *Angle of view* refers to how much a lens sees, how much of a scene it encompasses from any given shooting location, the angle of its vision. Angle of view decreases as focal

300MM LENS

24MM LENS

SPRING TREES. Nikon F4, Nikon lenses, Fuji Velvia.

These two views of the same springtime yellow-poplar forest were taken from very different vantage points. With my 24mm lens, I'm standing inside the forest, looking up and out, while the lens separates the trees and exaggerates their height, making them seem quite tall. In comparison, with my 300mm lens, I'm standing outside the forest and looking down into it. Here the focal length compresses distance, emphasizing the impression of the trees being tightly packed together. The emotional overtones carried by these two pictures, and consequently a viewer's perceptions, are extremely different.

length increases. From any one location, the longer the focal length, the less of a scene the lens sees. Telephoto lenses have very limited coverage, while wide-angle lenses, as their name implies, cover a broad field of view.

When the angle of view changes, so does the *image size*, or how large things look through the viewfinder. If you're shooting from a fixed position, there is a direct relationship between the focal length of a lens and the size of the image on the film. The shorter the focal length, the smaller the image of any object; the longer the focal length, the larger the object will appear on the film. The linear size of the image varies directly with the focal length used. If you double the focal length (from 50mm to 100mm, from 100mm to 200mm, from 200mm to 400mm), you double the size of the image recorded on film. For example, if you're photographing a tree with a 50mm lens and its image is 1/4-inch long on the film, switching to a 100mm lens from the same location would increase the size of the tree's image to 1/2-inch long on film; a 200mm lens would make it 1-inch long.

The *speed* of a lens reflects its maximum aperture, or its widest f-stop, and is relative to the focal length of the lens. Lenses with large maximum apertures are called "fast" lenses, since they let in more light than a "slow" lens with a smaller opening. A lens with $f/2$ as its wide-open aperture is "faster" than an $f/2.8$ lens; it in turn is faster than an $f/4$ lens. The f-stops on all lenses are determined the same way; they are numerically equal to the lens' focal length divided by the optical diameter of a given aperture, the hole through which light passes. Suppose that you have a 100mm lens and the optical diameter of the largest aperture is 50mm. The f-number of this aperture is $100 \div 50$ or $f/2$. Another 100mm lens which is $f/4$ means that its optical aperture is 25mm in diameter.

Obviously, fast lenses must be physically large lenses, and fast telephoto lenses must be extremely large. That 100mm $f/4$ lens may have a maximum aperture 25mm in diameter, but a 600mm $f/4$ lens has an opening 150mm in diameter. Big, fast lenses mean large elements, more weight and bulk, more difficult construction, and a lot more cost.

At the same time, a lens is "fast" only in relation to its focal length. The same maximum aperture could be considered fast or slow, depending on the lens. A 50mm $f/2$ lens is pretty standard in speed, not really fast but not really slow. A 100mm $f/2$ lens, however, is fast; a 200mm $f/2$ is extremely fast; and a 400mm $f/2$ would be considered supersonic if anyone made one. It would also be roughly the size of a Buick.

Regardless of the focal length, the same f-stop admits the same amount of light to the film. A 50mm lens set at $f/4$ and a 500mm at $f/4$ transmit exactly the same amount of light. This allows us to use hand-exposure meters and such rules of thumb as "sunny $f/16$".

Zoom lenses incorporate many focal lengths into one lens. There is no difference whatsoever between a photograph taken with a fixed 200mm lens and one taken with a zoom set at 200mm; the zoom simply lets you carry a lot of focal lengths together in one package. The tradeoff is that most zooms are bulky compared to a single focal-length lens and typically rather slow, although fast, expensive zooms are certainly available. Most zooms are not optically quite as good at every length compared to fixed lenses of the same focal length, but zooms offer so many more focal lengths that are not available as fixed focal-length lenses. After all, if you need a 127mm or a 93mm lens, then a zoom is the only answer.

AUTUMN RED MAPLES IN FIELD, Michigan. Nikon F4, Nikon lenses, Fuji Velvia.

This sequence illustrates what happens when you keep your camera position the same and change focal lengths. The perspective is the same in all four of these photographs, as I didn't move my tripod. Switching to a different lens simply changed the cropping of the picture, including more or less of the scene. Note that the 105mm version is essentially just the center section pulled out of the 24mm shot.

24MM LENS

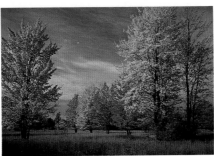

35MM LENS

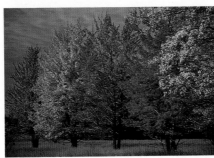

50MM LENS

105MM LENS

Don't get me wrong—zoom lenses are not bad. Far from it. I'm just saying that if you compare a 28–80mm zoom against a fixed 28mm lens, a 35mm lens, a 50mm lens, and an 80mm lens, then the zoom might not perform as well somewhere in this range. But to get all those focal lengths, you would have to carry all those lenses instead of just one, and you would still miss all the in-between focal lengths available within the zoom's range. New computer-designed zooms, especially those made by quality companies, can certainly hold their own against fixed-focal-length lenses. Let me repeat that good photographic technique can make up for any deficiencies in equipment. Mediocre equipment used with perfect technique can produce wonderful pictures; great equipment used sloppily produces trash. I use zooms, and I use fixed-focal-length lenses; and I shoot them all from a sturdy tripod.

Macro lenses focus into the closeup range all by themselves, without any additional extenders or accessories. I've heard people say that macros can't be used for landscape work. Not true. In fact, macro lenses tend to be some of the most highly corrected optics available. Most manufacturers offer macro lenses in roughly 50mm and 100mm focal lengths.

Perspective is how a scene appears from any given location. All lenses yield the same perspective if used from the same camera position. The objects in the scene—the nearby trees and the far-away hills, for example—will appear to be in the same relationship with each other in all photographs taken from the same spot. When you change lenses without moving your camera position, you're simply changing the framing of any picture. This means

changing where the edges of the picture are, how much or how little of those trees and hills are included in your viewfinder. Changing fixed-focal-length lenses or zooming a zoom lens are the same thing. A long lens lets you crop tightly into the scene, while a short lens expands the frame. But both lenses, indeed all lenses and focal lengths, show the same perspective from the same viewpoint.

Changing your physical location not only changes perspective, it also shifts the apparent relationship between elements in a scene. The distance between two objects appears to be much greater when you are close to them than when you are farther away. For example, look at a row of telephone poles. The closest ones will seem to be a good distance apart, but as they get farther away, the poles appear closer together. This is often called "telephoto compression," but it has nothing to do with telephoto lenses; it simply reflects the principle that things far away seem close together. Similarly, objects that are physically close to the camera appear proportionally much larger than those far away. The telephone poles nearby are tall, while those far away shrink in size.

You can use both perspective and lens choice to affect the viewer's perception of a scene. Choosing the vantage point from which to photograph sets the perspective. If you then use a long lens to pluck out a distant section of the landscape, you can stack the foreground and background tightly together, effectively condensing the scene. Or you could use a wider lens to do the opposite, to decompress the relationship between foreground and background while encompassing more within your view. There is no single correct lens for landscape photography. It is your choice.

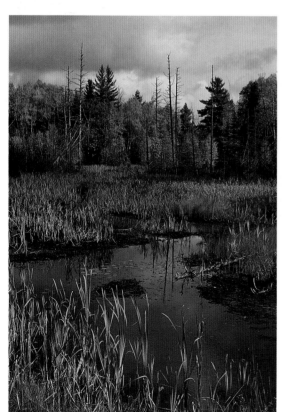

55MM LENS

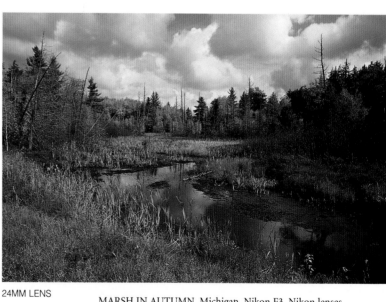

24MM LENS

MARSH IN AUTUMN, Michigan. Nikon F3, Nikon lenses, Kodachrome 25.

This pair of photographs reflects the photographic tools available to me that day. I changed lenses to change the viewer's perception of the scene; I slightly changed my shooting position; and I flopped the camera from a horizontal to a vertical. The result: two contrasting portraits of the marsh.

WIDE-ANGLE LENSES

Wide-angle lenses, as their name implies, take in a wide field of view and include all focal lengths 35mm and shorter. They decompress the landscape, making distant objects seem even farther away while accentuating nearby objects, effectively emphasizing the space between foreground and background. Wide angles are useful for taking in the entire scene, for encompassing the grand sweep. Yet it is this very characteristic of inclusiveness that makes these lenses the hardest focal lengths to control.

The temptation when using a wide angle is to include everything you see in front of you within its frame. Include that mountain, stick in those rocks over there, add that stream—get it all in one shot. The challenge, however, is how to order this mass of chaotic information. The more you pluck out a section of a scene by using a longer focal length, the easier composition becomes, as you are left with fewer and fewer lines, shapes, and colors to organize into a pleasing arrangement. Not so with wide angles. To use them effectively, you must be careful about selecting your camera position and very cautious about how much to include in the frame. All the elements in your composition should work together. Wide angles are not easy lenses to learn to use, but with practice, they offer amazing possibilities.

If I could only own one wide-angle lens, I would definitely choose a 24mm. This focal length is a great compromise between the need for wide coverage and the desire not to expand apparent distances. A good working pair of wide angles would be a 24mm and a 35mm lens, while a three-lens group might include a 20mm, a 28mm, and a 35mm lens. I've rarely wanted any lens wider than 20mm in the field, certainly not enough for me to justify buying an ultrawide lens, although I must admit I would like to borrow a 15mm for awhile to shoot the tight interiors of deep forests.

Instead of carrying all these different lenses, you could buy a zoom lens. Be aware that many zooms fudge a little as to focal length. One marked as a 28–80mm may be slightly longer at the short end and a little shorter at the long end, perhaps actually being a 30–75mm. I wouldn't worry about the long end, as there

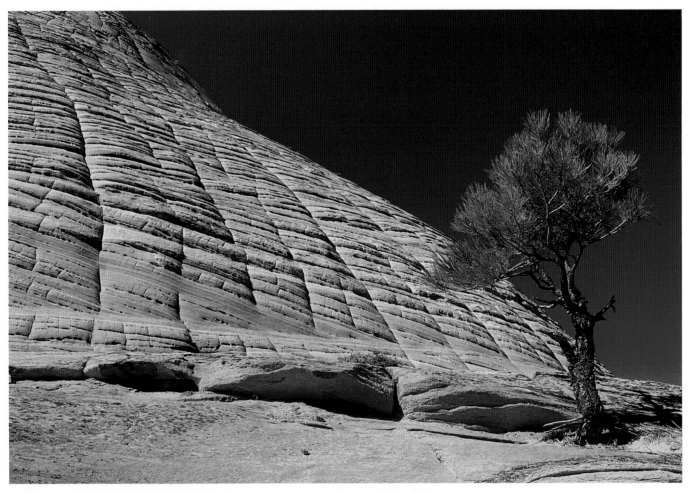

SANDSTONE STRIATIONS AND PONDEROSA PINE, Checkerboard Mesa, Zion National Park, Utah.
Nikon F3, Nikon 24mm lens, Fujichrome 50, polarizer.

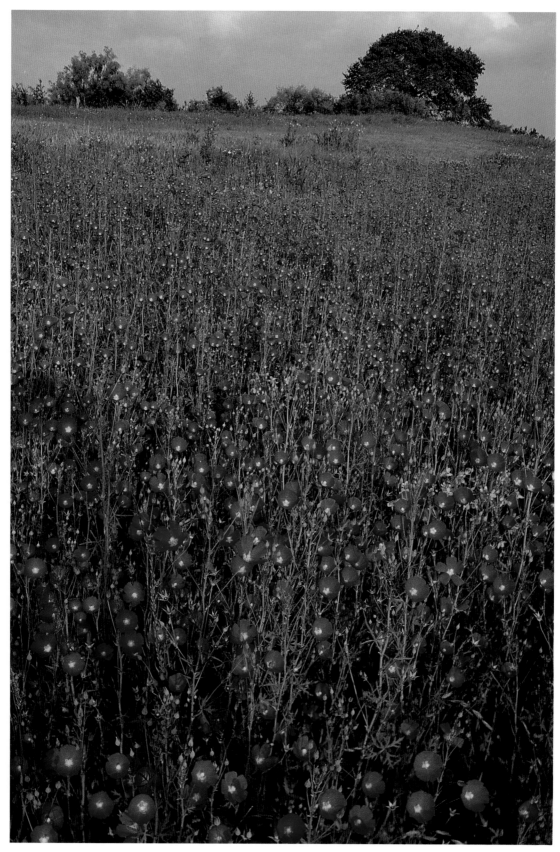

WINE CUP MALLOWS, Texas spring prairie. Nikon F4, Nikon 35mm lens, Fuji Velvia.

isn't much practical difference between a 75mm and an 80mm lens, but in wide angles every millimeter of focal length counts. While you're in the camera store, compare the coverage of a fixed-focal-length 28mm with that zoom set at 28mm to see if they yield the same image. Do this with them mounted on the same model camera body to disallow any differences in viewfinder coverage.

Another possible problem with all zoom lenses is their close focusing ability. Because wide angles exaggerate subject coverage, any difference in close focusing is critical. For example, several manufacturers are now offering 28–200mm lenses, but most of these only focus down to about 8 feet from the film plane. Assuming that these lenses really are 28mm in focal length, what would the horizontal coverage of a 28mm lens be at minimum focus? Roughly 11 feet across the frame! That would be the tightest shot you can get, and for this reason alone, avoid using an extreme-range zoom lens as a primary wide angle. You'd still have to carry a regular wide-angle for regular coverage.

Some wide-angle zooms with less extreme ranges do offer reasonably close focusing. Nikon's 24–50mm and Canon's 20–35mm both focus to 1.6 feet from the film. That is a lot better than 8 feet, but almost any fixed-focal-length wide angle will focus to about 9 inches from the film. On the other hand, the convenience of having either of these two zoom ranges, in my opinion, outweighs other factors. When you can't move your shooting location, zooms are so handy for precise cropping of the picture edges that I love them for location shooting. Just buy the best you can afford.

When you shoot up with any wide-angle lens, zoom or fixed, all vertical lines nearby appear to converge or tip. This is often referred to as "wide-angle distortion" and "keystoning," but it really just reflects the fact that these lenses exaggerate intervals in distance. The distance from the lens to the nearest point of the subject is much less than the distance from the lens to the farthest part. You can either use this effect compositionally, or keep the lens parallel with the ground to avoid it altogether.

A few words of caution about using any wide-angle lens: due to their extreme coverage, wide angles are prone to recording unwanted objects and *lens flare*. Large viewing angles often capture the sun's rays hitting the front of the lens, resulting in a line of hexagons (formed by aperture ghost images) spilling across the frame, which will spoil any shot. Because photographers tend to concentrate visually on the centermost section of a composition while looking through the viewfinder, they often ignore the perimeters of their compositions. Consequently, some strange-looking objects appear in pictures. I once saw a coffee-table landscape book in which the very opening picture, a grand sweep, included a Volkswagon parked in the extreme left-hand corner. Neither the photographer, nor apparently the picture editor, had noticed this intrusion before the book went to press. When shooting with a wide-angle lens, be extra careful both to check for lens flare and also to examine the edges of the frame for any unwanted intrusions.

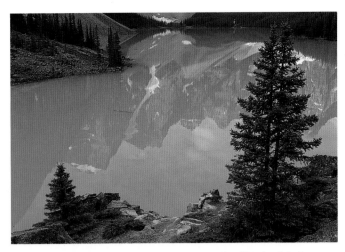

MORAINE LAKE AND WENKCHEMNA PEAKS, Banff National Park, Canada. Nikon F4, Nikon 35mm lens, Fuji Velvia.

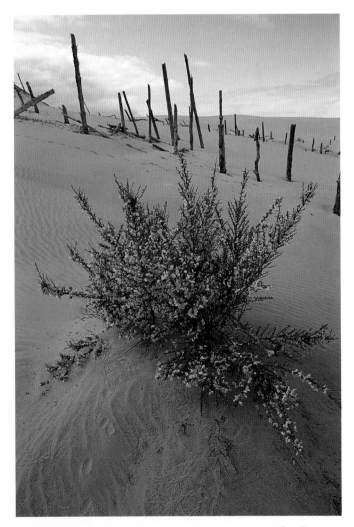

SCOTCH BROOM, Oregon Dunes National Recreation Area. Nikon F4, Nikon 24mm lens, Fuji Velvia.

NORMAL LENSES

I think that the 50mm lens is one of the most underrated of all focal lengths. I recently read an essay in a photography magazine that said point-blank that good pictures can't be shot with a 50mm lens because it is too limited in application. Hogwash! The only limitation to any lens is the person standing behind it. Cameras and lenses are simply tools that you use to record your visualizations. Whether or not you have a particular focal length in no way limits your imagination.

If you own a standard 50mm or 55mm lens, odds are that it is one of the sharpest, most highly corrected optics in your camera bag. This focal length has been around for years and is relatively easy to make. In terms of quality per dollar, 50mm lenses are a real bargain, especially since you can easily find unused ones that have been traded in for do-everything zooms. For just a few dollars you can pick up a compact, relatively fast, razor-sharp 50mm lens. I've watched a number of photographers who only own wide-range zooms with maximum apertures in the $f/4$-$f/5.6$ range be amazed at how easy it is to focus an $f/1.8$ normal lens, especially in dim light.

If you want a multipurpose lens in this focal length, consider buying a 50mm macro lens. Macro lenses can yield outstanding scenic results, and have extremely close-focusing ability. Remember that only a lens' focal length determines how a picture "looks." Pictures shot with a fixed 50mm, a 50mm macro, and a zoom lens set at 50mm will all look the same. Most 50mm macro lenses are about $f/2.8$ wide open, which is slightly slower than standard 50mm lenses but considerably faster than many zooms that cover the 50mm range. Almost all macros stop down to $f/32$, one stop more than standard lenses, if you need extra depth of field.

A 50mm macro lens conveniently does double duty. You can photograph subjects ranging from vast landscapes to tight close-ups simply by changing focus, while maintaining optical quality across this whole spectrum. Most current 50mm macro lenses focus down to 1:1 coverage; in other words, they can focus down to a subject as small as 1 x 1½ inches. Now, that is a closeup. Most normal 50mm lenses can't provide this kind of coverage, and zooms in the 50mm range are even worse. Having close focusing available is certainly a convenient option in any lens.

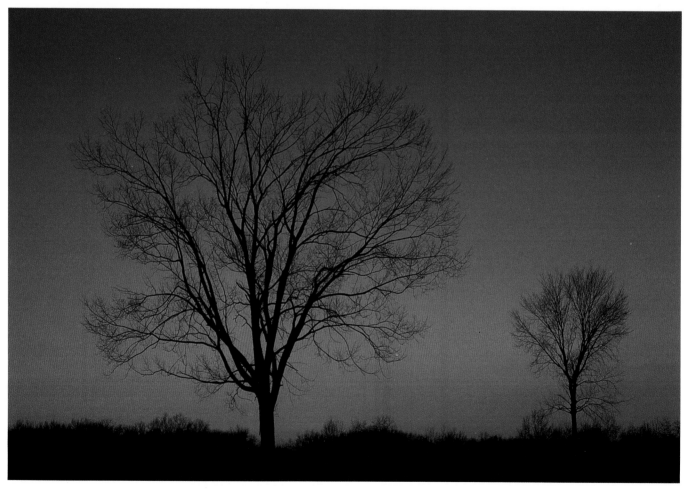

AMERICAN ELMS AND WINTER SKY, Michigan. Nikon F3, Nikon 55mm macro lens, Kodachrome 25.

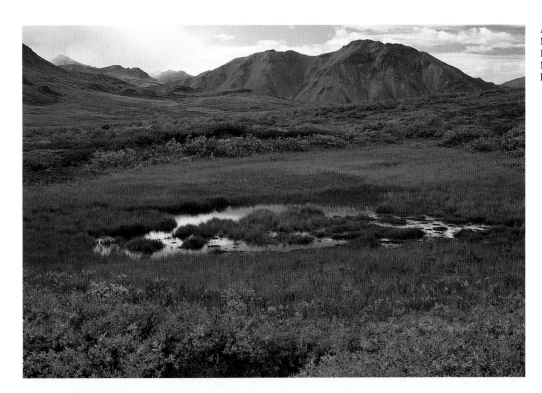

AUTUMN TUNDRA POOL
NEAR POLYCHROME PASS,
Denali National Park, Alaska.
Nikon F3, Nikon 55mm macro
lens, Fujichrome 50.

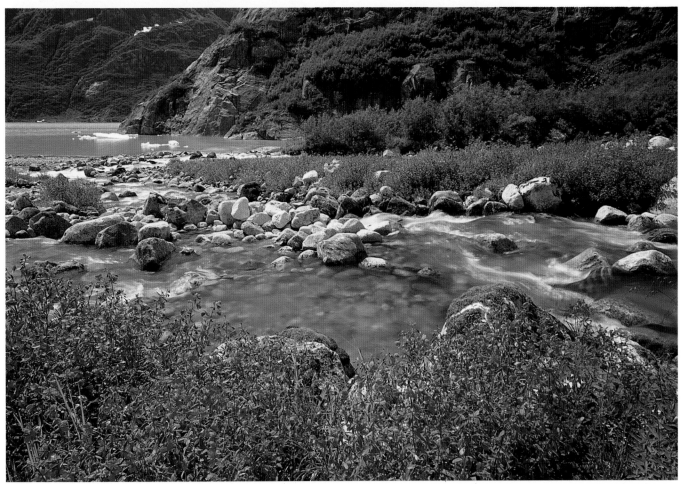

STREAM WITH FIREWEED, Tongass National Forest, Alaska. Nikon F4, Nikon 50mm lens, Fuji Velvia, polarizer.

SHORT TELEPHOTO LENSES

Not long ago, if you wanted to shoot with a telephoto lens, you had a choice of four focal lengths: 85mm, 105mm, 135mm, or 200mm. Although excellent lenses are still available in these fixed focal lengths, new possibilities abound. This lens range was one of the first to benefit from zoom technology; consequently there are all sorts of 70–210mm and 80–200mm lenses available. In general, zooms in the short telephoto lengths (with a zoom ratio of about 1:3) are some of the best zooms available, as they maintain optical quality throughout their entire focal-length range.

I've always liked short telephotos for field photography. Most are reasonably compact and thus easy to carry, plus they are affordable. As a rule, they are also relatively easy to handle outdoors, as you can basically treat them like overgrown 50mm lenses. The exceptions here are some of the fast zooms that desperately need tripod collars. In my opinion, any lens over 135mm with a maximum aperture of $f/2.8$, or any lens longer than 8 inches, could be improved by the addition of a tripod collar. Mounting an 8-inch long lens weighing $2\frac{1}{2}$ or 3 pounds directly onto a camera body and then screwing the camera onto a tripod so that the lens is cantilevered out into the air is definitely a liability in your fight for sharp images.

The short telephotos have two great advantages. First, they render excellent portraits of the landscape. I once read that the focal length of the human eye is roughly equivalent to that of a 105mm lens on the 35mm film format; thus, pictures taken with this focal length are pleasingly familiar because this is how we see the world. Portrait photographers often use short telephotos to create flattering shots of people. I often say that I consider myself a portrait photographer, but instead of people, I shoot portraits of the land.

Short telephotos are also good for capturing an extremely diverse realm of subjects. You can shoot large areas of a scene or closeup views with the same lens. In fact, short telephotos are my first choice for working on closeup details in a landscape. Most camera companies offer macro lenses in the 100mm range, and Nikon and Canon still make manual-focusing 200mm macros. Any short telephoto can be made to focus extremely close by adding an extension tube. With short-telephoto zoom lenses, by far the easiest way to work details is by adding a "+ diopter" or "closeup lens" to the front of the zoom. Regardless of your zoom's brand name, I would recommend using Nikon's two-element diopters, as they are high quality and readily obtainable. (Nikon's 3T and 4T diopters come in 52mm filter size, the 5T and 6T in 62mm diameter. For a detailed discussion of closeup photography, and of using diopters on zoom lenses, see my book, *John Shaw's Closeups in Nature*, also published by Amphoto.)

COCKLE SHELLS ON BEACH, Florida. Nikon F4, Nikon 105mm macro lens, Fuji Velvia.

AUTUMN MAPLE AND
SPRUCE TREES, Michigan.
Nikon F4, Nikon 50–135mm
zoom lens at 135mm, Fuji Velvia.

300–600MM LENSES

Very long focal-length lenses—300mm and longer—are simultaneously among the easiest and most difficult to use for landscape photography. They are the easiest in terms of composition, yet the most difficult to handle in actual field conditions.

Long focal lengths let you pare down your photographic coverage to the bare essentials of composition. Many people have difficulty using wide-angle lenses, as their broad coverage encompasses so much that the resulting photographs are cluttered with unnecessary information and objects. Not so when a long lens is used. A 300mm or 400mm lens lets you pluck out one section of a view or simplify a picture by concentrating on a detail rather than the totality.

For example, suppose you are standing at a national park overlook before a vast scenic landscape: mountains in the distance, a valley dropping away in the foreground. As you look at this scene, your mind's eye may pick out two or three significant points of interest, the most interesting highlights of the view. At the same time, you are bombarded with additional physical information: the feelings of vastness and grandeur, the openness and exposed height of the overlook, the chill of the mountain wind, and the sweep of nature before you. Recording all this on one piece of film would be extremely difficult. Instead of trying to include everything, use a long lens to extract only the dominant highlights and you'll produce a more successful photograph.

I've always called this way of using a long lens its "isolation effect," although I've heard other photographers call it "optical extraction" or "plucking a section." The idea is to construct a feeling of the whole scene not by showing it all, but by featuring the important elements. As useful as this technique is, however, photographing with long lenses involves overcoming some very genuine obstacles that demand your attention.

First of all, a tripod is an absolute necessity. As discussed earlier, increasing focal length means magnifying camera vibrations, so your equipment must be kept as steady as possible. If you're going to shoot a scenic with a 300mm or longer lens, use the sturdiest tripod and head you possibly can. All tripods are more securely solid if you don't extend the leg sections, so work this way if your tripod is a little shaky.

SNOW FORMS, Yellowstone National Park. Nikon F4, Nikon 400mm lens, Fuji Velvia.

Another liability of long lenses is that their size alone makes them act like sails, catching every little breeze. Keeping your tripod low helps here, too, as does hanging a camera case from the centerpost so that it just barely grazes the ground. Use a remote release, either a cable release or electronic cord, to trigger the shutter, and lock up the mirror in your camera if possible. Don't shoot continuous frames with your motor drive. Take one frame, wait a few seconds for the whole outfit to settle back down, then take another frame.

If you're shooting with extremely long lenses, 600mm or longer, you might have to use two tripods to get a critically sharp photograph: one tripod under the lens, one under the camera body. This is a terribly awkward way to work, but it does add sharpness. I've also used a monopod with an attached small ball head to push up on the camera body when shooting with my 500mm lens and teleconverters.

Most lenses are not at their sharpest at either end of their aperture scale. Generally speaking, the best f-stop for sharp focus on any lens is about two or three stops down from wide open. If you're using a 50mm lens, this is no big deal. Starting with a 50mm *f*/2 lens, three stops down from wide open puts you at *f*/5.6, which usually equates with a reasonable shutter speed. But starting with a 400mm *f*/5.6 lens, three stops down is *f*/16. The resulting exposure would definitely require a tripod for sharp pictures, as your shutter speed would be slow, probably falling into the vibration-prone range of 1/8–1/15 sec.

Filter problems are quickly apparent when you work with long lenses because cheap filters can actually prevent you from achieving sharp focus. Once in a workshop, a participant just couldn't focus on a distant mountain ridge with his 300mm lens, an expensive good-quality optic. No matter how he focused the lens, the image never looked sharply defined; it was always just a little bit fuzzy. As soon as we removed his generic skylight filter, the difficulty disappeared and the image popped distinctly into focus.

Even without a filter, sharply focusing a distant subject with a long lens is hard to do. It is much easier to focus a lens up close than far away, because any movement of the focusing collar means less shift of distance when you're composing nearby subjects. With my 300mm *f*/4 lens, I move the focusing collar as much to shift focus between 9 and 10 feet as I do between 40 feet

STORMY SUNRISE, Saguaro National Monument, Arizona. Nikon F4, Nikon 300mm lens, Fujichrome 50.

AUTUMN COLOR, Great Smoky Mountains National Park, Tennessee. Nikon F3, Nikon 300mm lens, Fujichrome 50.

and infinity. Suppose I'm trying to focus precisely on a subject 200 feet from my camera. A minute twitch of the focusing collar could cause me to miss focusing by a gross amount.

Don't make the mistake of thinking you can crank a long lens over to the infinity mark on the focusing scale—the ∞ mark—to guarantee that distant objects will be sharp. Most long focal lengths are constructed so that their focusing barrels turn beyond infinity (an interesting concept!) to allow for expansion and contraction of these lenses as temperature changes.

Atmospheric conditions are a major issue when you're shooting with long lenses. The pictures they produce often look muted, soft, or dull because the compression effects of long focal lengths emphasize haze and dust in the air, and magnify heat-wave distortion. The best approach is to use them in clear air and not during midday heat. Polarizing filters can help somewhat to remove atmospheric glare and saturate colors, but have you ever tried to buy a polarizer for a fast long lens? My 300mm $f/4$ lens requires an 82mm-diameter front filter, and my Nikon F4 camera needs a circular polarizer. Discount camera-store prices for this filter alone are at least two hundred dollars.

Some manufacturers of long lenses have addressed this problem, for example, by putting a drawer for screw-in filters in a slot near the back of the lens. A few camera companies offer polarizers made for long lenses, and Tiffen offers a special "thin" polarizer that works with some lenses. When I wanted to use a polarizer with my longest lens, the Nikkor 500mm $f/4$, I couldn't because the lens has no front filter threads at all.

However, all Nikon long lenses have a filter drawer arrangement that takes screw-in 39mm filters. Tiffen made me a special-order circular polarizer in this size. Since the filter drawer slot is too narrow for a standard rotating filter, I had them mount only the glass without the rotating ring. To rotate the filter to the desired position, I have to look through it as I screw it in, then insert the drawer back into the lens. While this is a primitive arrangement and frustratingly slow to use, it cost me only seventy-five dollars and works on both my 300mm and 500mm lenses.

Mike Kirk manufactures a special polarizer for owners of Nikon long lenses. This apparatus allows you to rotate the filter inside the filter drawer via a small external thumb wheel. This beautifully made accessory is far easier to use than my "screw-in-or-out" version. While costly, it is well worth the expense if you find yourself often needing to polarize your long lenses. Telephone Kirk Enterprises at (219) 665–3670.

If you don't own a long lens, I suggest you start out with a 300mm lens. A medium-speed one, about $f/4$ wide open, is fairly compact and easy to carry, and almost always has a good rotating tripod collar. A lens speed of $f/4$ is a decent compromise between size, weight, speed, and affordability. You'll find yourself taking this lens on field trips, whereas you'll think twice about carrying a heavy 300mm $f/2.8$ lens on a day-long hike. The faster lens is great for working wildlife in dim light, but how often will you be shooting a scenic with it wide open? There is no reason to carry fast lenses unless you need those maximum apertures.

THE RAMPARTS WALL, MT. WILSON, Banff National Park, Canada.
Nikon F4, Nikon 300mm lens, Fuji Velvia.

Canon's 300mm *f*/4 EF weighs 2.6 pounds, and its one-stop faster 300mm *f*/2.8 EF lens is 6.3 pounds. The cost of these two lenses shows the same differential, the 300mm *f*/2.8 being roughly three times as much as the *f*/4 version. For a lot less money, and in a much smaller package, you might want to consider a zoom that goes to 300mm. Canon offers two 100–300mm lenses. Each is roughly half the weight of the 300mm *f*/4 lens, and both are less than half the cost. Their drawback is lens speed: both are *f*/5.6 wide open. When you add polarizers, their viewfinder images become quite dark.

Longer than 300mm, you're in another world of lenses. There basically is no such thing as an inexpensive, compact, optically high-quality 400mm, 500mm, or 600mm lens. Super-long focal lengths are harder to manufacture, and fewer of these lenses are made, so their production costs are high and their price tags tend to be as big as they are. Consider Canon's 600mm *f*/4L autofocus lens. It is about 18 inches long (the lens itself without a lens hood or camera body) and weighs 13.2 pounds. Try to carry that on a casual hike! Add a camera body with motor drive, a heavy-duty tripod, and a head strong enough to hold a 13-pound lens…well, you're looking at an outfit weighing over 20 pounds, yet you have only one lens. For the cost of a Nikon, Canon, or Minolta 600mm *f*/4 lens, you could buy a used car and drive up closer to your subject. On the other hand, when you get such a lens into position, you can take unique pictures.

No discussion of long lenses would be complete without mention of one particular long-lens design, the mirror or catadioptric lens. In it, the light path is folded between two parabolic mirrors, producing a lens that is quite small and lightweight for the focal length. Most mirror lenses are rated as 500mm *f*/8, but almost all are a little slower in terms of actual light transmission, being around *f*/9 or *f*/10. I don't recommend these lenses for landscape work, unless their size and low price are overriding concerns.

Mirror lenses have several problems. Trying to focus a lens that is slower than *f*/8 is difficult under the best of conditions and impossible in low-light situations. Add a polarizer to a mirror lens, and you may end up trying to focus at *f*/16 or even *f*/22. Try that at twilight. Mirror lenses also lack aperture selection; they have one fixed aperture, take it or leave it; thus, you can't change depth of field by stopping down or opening up. Working with a fixed aperture also means you must control exposure totally by shutter speed, not the easiest way to work if you need adjustments in less than one-stop increments.

My biggest concern with mirror lenses is the fact that because light enters the lens in a doughnut-shaped hole around the front mirror, all highlights in the scene take on this doughnut shape in the picture. Every specular highlight turns into a little circle. You either like this effect, or you don't like it. I've never seen circular highlights in real life, so I don't care for them at all. My advice: use a mirror lens only as a last choice.

TILTING LENSES

Ever wonder how photographers who shoot those big calendar shots get so much depth of field in their pictures? Everything from the immediate foreground to the farthest point in the background looks sharp. Many of those photographers use 4 × 5 view cameras, so you might wonder whether this depth of field is just an attribute of the larger image sizes inherent with large-format cameras. If you want to create the most depth of field and the sharpest photographs, should you sell your 35mm camera and buy a view camera? The answer requires an understanding of some photographic principles that aren't discussed much any more, because many beginning photographers (and advanced ones, for that matter) have never used any cameras other than 35mm.

Large-format cameras are distinguished by one thing: a larger piece of film. This means that for any picture size, a view-camera image needs to be enlarged less than for a smaller format. For example, a 4 × 5 image needs to be magnified twice (in linear measurement) to make an 8 × 10 print. A 35mm image (roughly 1 × 1½ inches on film) needs to be enlarged about 6⅔ times to get to roughly the same print size. Immediately, you can see what this means: with less enlargement (less magnification, that is) the larger format will appear sharper. This is always true. The less you magnify any problem, the less apparent it will be. With less enlargement, the final print from a larger negative will always be sharper than a print from a smaller negative.

But does image size alone mean that 4 × 5 images are better? No, it just means that they are bigger. So what else could be responsible for that depth—that foreground to background sharpness—we see in large-format shots?

It could be the fact that large-format lenses have extremely small f-stops. Most Schneider and Nikkor large format lenses go to f/64, an f-stop considerably smaller than the f/22 or f/32 usually found on 35mm lenses. Does stopping a lens down to these minute apertures account for that "large format" look? The answer is no. In fact, although using the smallest f-stop on any lens yields a little more depth of field, it also usually starts to degrade the image slightly due to *diffraction*, a softening of the image caused by the way light passes through tiny holes. You gain depth of field by stopping down a lens, but since the aperture hole gets smaller and smaller, you lose sharpness. This is true with all formats, whether 35mm or 4 × 5. Small f-stops are not enough to create enormous depth of field.

Something many photographers overlook is that focal length is focal length, regardless of the film format used. All lenses of the same focal length give the same depth of field. That is, a 90mm lens used on a 35mm camera, on a medium-format camera such as a Hasselblad, or on a 4 × 5 view camera, yield *the same depth of field* when used at the same f-stop. Imagine a focused lens with an image cone projected behind it. Now imagine taking different-sized pieces of film and holding them in this focused cone, one after another, in the same spot. They all are in focus, all have the same depth of field, but (assuming the lens has enough coverage) they encompass different amounts of the focused image. The 35mm film needs just a little bit from the center of the cone, while the 4 × 5 film holds a lot more of the image.

And that is the heart of the depth-of-field issue. A 90mm lens on a 35mm camera is a short telephoto lens; it pulls out just a section of that projected image. A 90mm lens on a medium-format camera is roughly a normal lens, and a 90mm lens on a 4 × 5 is a wide angle. But all formats have the same depth of field at the same f-stop.

Would you use a 4 × 5 camera if its 90mm wide-angle lens had the same depth of field as your 90mm telephoto lens on your Nikon or Canon? Well, I've just said they *do* have the same

SENECIO FLOWERS AND THE GRENADIER RANGE, from Molas Divide, Colorado. Canon EOS-1, Canon 24mm TS-E lens, Fuji Velvia.

The front element of the lens is approximately 8 inches from these small flowers, while the distant mountains are miles away. I shot at roughly f/11 because I needed some depth of field—after all, the scene is not a flat plane—while at the same time I wanted to use the fastest shutter speed possible to fight the persistent wind from an approaching storm.

Viewed from above, the tilting feature of this Canon 90mm TS-E lens, mounted on a Canon EOS-1 camera, is clearly visible. This is one of the three tilting lenses Canon offers in their EOS system.

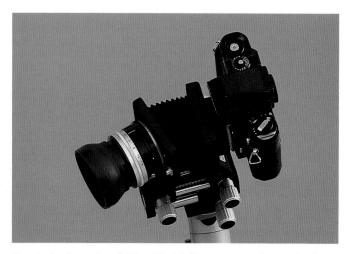

Here is the discontinued Nikon PB-4 bellows—mounted on a tripod, with a Nikon 105mm short-mount lens—showing the tilt feature.

depth of field. Consider this: a normal lens for a 4 × 5 camera is roughly 150–180mm. What kind of depth of field do you have with a 180mm lens on your 35mm camera? Not a lot, but it is the same depth of field the 4 × 5 photographer has with a 180mm lens, except for 35mm it means working with a telephoto focal length and for 4 × 5 it means a normal lens. Your depth of field at *f*/16 with a 180mm lens is the same depth of field a 4 × 5 photographer has at *f*/16 with a 180mm lens. If you use a lens that is normal for your film format, a 50mm on a Nikon or Canon, you'll actually have more depth of field in the resulting photograph than the 4 × 5 photographer has with a normal lens.

Why, then—if with any equivalent focal length, there is less depth of field as you go to a bigger film size—would anyone in their right mind ever shoot larger formats? How do they get that all-over image sharpness? The answer lies in the relation of the subject plane to the film plane. When you focus a lens, you're

actually bringing one plane of the subject into sharp focus. You stop a lens down to bring objects on either side of that plane into sharper focus. This is true regardless of the format you're using. With most cameras, the plane you're focusing on is always parallel to the film. But what if that is not the plane that you want to photograph?

Think about shooting a field of wildflowers. The camera is at eye level, and the flat field stretches away from you to the horizon. You aim the camera slightly down in order to see the flowers. But when you focus the lens, you bring into sharp rendition only one plane of the scene, a plane parallel to the film. This focused plane extends up in the air above the flowers, and down into the ground. What if you could change the location of the plane of the sharply focused image without changing the camera position or the point of view? Since you're shooting a field of wildflowers, the plane you're really interested in—the one you want to focus on and to photograph—is the plane of the field stretching away from you.

The major reason photographers use large-format cameras for scenic work is that they feature special lens movements for repositioning the plane of focus. Specifically, view cameras offer a *tilt* feature that, in my estimation, is the most valuable of all lens movements for the outdoor photographer. Tilt is the ability to rotate the lens, specifically to lean the lens forward or backward. Visualize a lens connected to the end of an accordion-like bellows, which is exactly what a 4 × 5 camera really is. The lens isn't rigidly connected to the camera but has the ability to gimbal around. Rotating the lens in the horizontal plane is called *swing* while rotating in the vertical plane is tilt.

When the image cone projected behind the lens is completely in focus, you can slice through this cone anywhere and effectively change where the plane of focus falls. And this ability to change the plane of focus, to move it where the subject dictates instead of always having it parallel to the film plane, is the great advantage of working with a view camera.

Tilting a lens makes use of what is called the *Scheimpflug Principle*, named after the man who first described it. Basically, it states that if you can get imaginary planes that extend from the film plane, the subject plane, and the lensboard plane to intersect, then you will have changed the plane of focus to coincide with the subject plane. Of course, you still must stop the lens down to provide enough depth of field to pull into acceptable focus anything lying on either side of the focused plane.

Imagine actually shooting that field of flowers. With a 35mm camera you first select your point of view and position the camera. Then, figuring out the closest and farthest distances in your composition by focusing on each, you use the hyperfocal scale on your lens and determine what *f*-stop yields enough depth to cover both distances. Now you set your lens to this *f*-stop, set the hyperfocal distance, pick the appropriate shutter speed, and shoot. The difficulty is that for broad foreground-to-background coverage, you'll probably end up working at the smallest *f*-stop on the lens, and this of course

means using a very slow shutter speed. After all, even in blazing sunlight Fuji Velvia needs an exposure of 1/30 sec. if you're using *f*/22. Since bright sun is not the best light anyway for those wildflowers, try shooting them in high overcast. Now the exposure is about 1/8 sec. at *f*/22. If the wind is blowing at all, you'll end up with blurred flowers.

Tilts are the answer. If you could tilt the lens so that the entire field of flowers was in focus with the lens wide open, you would only have to stop down a couple of stops to include slightly shorter or taller flowers, that is, the ones on either side of the plane of focus. Suppose you only need to shoot at *f*/8; in the same overcast light as before, your shutter speed will now be 1/60 sec., three whole shutter speeds faster that 1/8 sec., and the wind won't interfere with your composition.

While tilts are a major help in landscape photography, using a view camera does have some drawbacks. They're slow to set up, awkward to handle, the image on the groundglass appears upside down and backward, and 4 x 5 film is not the cheapest to shoot. One solution is to carry a view camera for scenic work and a 35mm for everything else. But what I really want more than anything else is a 35mm view camera. All I want for Christmas is an SLR viewcamera. Perhaps Christmas has arrived early this year! A few lenses offering tilts are now available for 35mm cameras. Granted, they are special-purpose lenses and by no means inexpensive, but you can shoot pictures with them that would be otherwise impossible in the 35mm format.

Canon is the leader in manufacturing tilting lenses for the 35mm format. For many years Canon has included the 35mm *f*/2.8 TS lens in its manual-focusing FD lens line. The TS stands for Tilting and Shifting lens (shifts are when the lens moves sideways but remains parallel to the film). This is Canon's perspective-control (PC) lens (also known as an architectural lens), and for years it was the only standard PC lens that incorporated the ability to tilt; all other brands of PC lenses offered shift movements only. When the Canon TS lens is mounted on a Canon camera, you can rotate the entire lens component so that you tilt the lens plane regardless of whether you're shooting vertical or horizontal compositions. This TS lens has a manual diaphragm and can be modified to fit other lens mounts by a competent repairman, although at a stiff price.

ALPINE WILDFLOWERS, Shrine Pass, Colorado. Nikon F3, Nikon PB-4 bellows with Nikon 105mm short-mount lens, Fuji Velvia.

Although the lens was tilted via bellows to the plane of the flowers, I still had to stop down for the depth-of-field coverage needed from the low grasses to the tops of the flower spikes.

These four pictures were made using Nikon PB-4 bellows and a 105mm short-mount lens. Here the lens was wide open at f/4 and focused on the middle box. No tilts were used. The front and rear boxes are definitely out of focus.

This setup was identical, but I stopped the lens down to f/16. Neither the front or rear box is sharply focused.

Now the lens was tilted to the plane of the box tops. The lens was wide open at f/4, and only the tops of the boxes are in focus. Notice that the print at the bottom of the boxes is not sharp.

Here the lens was not only tilted to the plane of the box tops, but I also stopped down to f/16 to provide enough depth of field. The entire boxes are in focus, top to bottom, front to back.

There are some other ways of getting tilts in 35mm formats. Manufacture of the Nikon PB–4 camera bellows is long discontinued, but it can still be found through used-camera dealers. In its normal orientation on a tripod, the bellows' front standard offers swings (and shifts too, for that matter). But with the bellows mounted on a tripod, if you flop the tripod head 90° to the side, the swing movement changes into a tilt movement. This arrangement is awkward and vibration prone, as the whole contraption is cantilevered off to the side of the tripod head, but it works. You can also rotate the camera on the back of the bellows for verticals/horizontals.

Because this is only a bellows with a tilting feature, you must put a lens on it. Adding a regular lens means you can't focus to infinity due to the extension of the bellows. You need to use either a short-mount lens made for a bellows (this is just a lens head, the glass and diaphragm with no focusing mount) or a high-quality enlarging lens. Nikon used to make a 105mm *f*/4 short-mount lens, and I've seen great results shot by a friend using a 135mm *f*/5.6 Schneider enlarging lens.

By far the best tilt-and-swing system for the 35mm photographer available now is the Canon EOS system, which includes three focal lengths incorporating tilts and shifts: a 24mm *f*/3.5 TS-E lens, a 45mm *f*/2.8 TS-E lens, and a 90mm *f*/2.8 TS-E lens. These are manual-focus auto-diaphragm lenses; since the EOS system sets all *f*-stops electronically via the camera body, the lenses cannot be adapted to any other mounts. If you want to use one of these lenses, you must have an EOS camera body.

You can effectively create more tilting focal lengths by adding a 1.4x teleconverter to these TS lenses. Suppose you have all three of the Canon lenses. Adding the converter to the 24mm *f*/3.5 TS-E makes it roughly a 35mm *f*/4.5; the 45mm *f*/2.8 becomes about a 63mm *f*/4; and the 90mm *f*/2.8 changes into a 126mm *f*/4. You could even try using a 2x teleconverter instead of the 1.4x, but make sure you have full-frame coverage. You should also realize that you're degrading the image quality somewhat with any added converter.

Here is how you actually use these tilting lenses in the field. With the lens wide open, focus on your foreground, then *slowly* tilt the lens forward until you see the background come into focus. Stop when it appears to be the sharpest. Now you'll probably have to trim the focus again slightly to hit the best point. That is all there is to it!

The first time you try this, you will probably make the tilting correction too fast. Try again. Tilt the lens slowly and deliberately while you watch through the viewfinder. With the shorter focal lengths you'll discover that just a few degrees of tilt makes a great difference. You'll also want to run some metering tests to check whether the particular camera body you're using gives a correct meter reading with the lens tilted. It is often easiest to meter before tilting the lens, then set the exposure as metered, and finally tilt and shoot.

You certainly don't need a tilting lens for every landscape photograph. Indeed, I use my TS lenses very rarely. But when you must be able to change the plane of focus, or when you need a faster shutter speed while at the same time maintaining foreground-to-background sharpness, there is no other way. Working with tilting lenses is as close to working with a 35mm view camera as you can come.

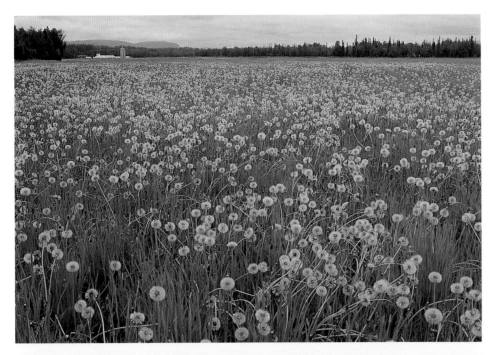

DANDELION FIELD, Alaska.
Nikon F3, modified Canon
35mm TS lens, Fuji Velvia.

*I shot this scene with the front
of the lens about 18 inches
from the nearest dandelion
seedheads, while tilting the
lens to the plane of the field.*

*I needed a long focal length in order to
reach out into this leaf-covered pond
without wading into it (below). Adding
a 2X teleconverter gave me, in effect, a
210mm lens with tilts. I stopped down
just one or two stops from wide open
because the leaves were all in one plane.
This allowed me a relatively fast shutter
speed to stop any drifting motion of the
leaves. If I had to reshoot this today, I
would add a 2X converter to my Canon
90mm TS-E lens.*

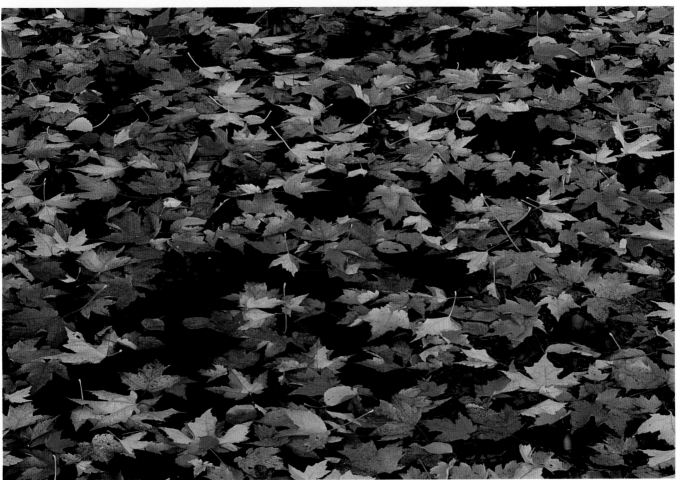

AUTUMN LEAVES, Michigan. Nikon F3, Nikon PB-4 bellows with
Nikon 105mm short-mount lens, Fujichrome 50, Nikon 2X teleconverter.

LIGHT
UPON THE
LANDSCAPE

TURRET ARCH, Arches National Park, Utah. Nikon F4, Nikon 20mm lens, Fuji Velvia.

SEEING THE LIGHT

Light is what makes the photographic miracle possible. Light transforms the ordinary and influences our perceptions of everything because it is the primary element of creation. Before you can take any photograph, before you can even think of recording anything on film, you must first literally *see the light*. Being aware of the light and how its quality affects perception of any subject is one of the things that sets the professional photographer apart from the amateur.

The way light falls on a subject is usually described in terms of how the subject is illuminated relative to the camera position. Basically, light has three directions: frontlighting, sidelighting, and backlighting. The angle of illumination affects how you expose a scene and influences a photograph's visual impact and its emotional overtones.

Frontlighting is, unfortunately, what many people consider "normal" photographic light: the sun straight behind the photographer, shining directly onto a scene. This type of lighting inspired the old adage "keep the light over your shoulder," advice given many years ago when films were slow and box cameras were always handheld. Direct frontlighting totally eliminates shadows; consequently, it is not very good for portraying depth or three-dimensional shape. But it is an easy lighting situation in terms of exposure, as all parts of the scene receive the same amount of illumination.

Backlighting is the direct opposite of frontlighting, as it places the sun behind your subject. The mood of a backlit scene varies according to the exposure, from dark silhouettes to airy, ethereal shapes. A good point to remember here is that film can't accommodate the latitude in contrast from dark to light that our eyes can. Human eyes distinguish a contrast range twice as great as any slide film can, so we rarely experience a backlit scene as a photograph portrays it.

Sidelighting is halfway in between frontlighting and backlighting; it is light coming from a right angle to the direction you are photographing. Sidelighting emphasizes shadows, and it is shadows which define form and texture. More than any other lighting condition, sidelighting gives a three-dimensional feeling to a two-dimensional photograph. Sunrise and sunset typically create sidelit subjects.

Besides having direction, light also has character that depends directly on the light source. For example, when the sun hangs in a clear sky, it is, effectively, a point source. Its undiffused light is harsh, creating inky black, hard-edged shadows. Under these conditions, a vast difference in exposure exists between a subject's highlight areas and its deep, dim shadows. All films exaggerate this disparity.

But light can also be soft, producing low contrast, as on an overcast day when the entire sky is one giant, evenly lit, omnidirectional light source. Now shadows are diffused or non-existent. Depth perception is diminished, but subtle pastel colors may be differentiated. Low-contrast light also occurs just before sunrise and just after sunset. The most extreme example of low-contrast light is the flatness of a dense fog.

And light has color. Early and late in the day, the light can be quite warm, tinted with yellows, reds, and oranges. In the middle of the day, light is far more blue, far cooler in color temperature.

BECKWITH MOUNTAIN AND ARNICA FLOWERS, West Elk Wilderness, Colorado. Nikon F4, Nikon 55mm lens, Fuji Velvia.

This photograph was taken with direct frontlight falling on the scene. Notice that there are basically no shadows; thus, the picture appears extremely flat and one-dimensional. Beckwith Mountain doesn't look grand and massive but rather seems like a cardboard cutout of a mountain made for a stage set. This isn't a pleasing light for photographing scenics—it is too dull, too flat, too unemotional.

AUTUMN COLOR, Green Mountains National Forest, Vermont. Nikon F4, Nikon 50–135mm zoom lens, Fuji Velvia.

The subject above was perfect for soft light, as this picture wasn't really of autumn trees but of color itself. A little moisture in the air added to the color's saturated feeling of depth. Subtle variations in tint and hue are visible. The overlapping of contrasting colors produced, to a lesser degree, the same feeling of three-dimensionality that shadows produce in a strongly lit scene.

THE FIERY FURNACE FORMATION AT SUNSET, Arches National Park, Utah. Nikon F4, Nikon 24mm lens, Fuji Velvia.

Notice how sidelighting delineates every form, separating each individual item within the picture frame. Every blade of grass stands uniquely by itself. The light itself conveys depth within the picture, and the colors it creates in the subject contrast nicely with the slate-gray, stormy sky.

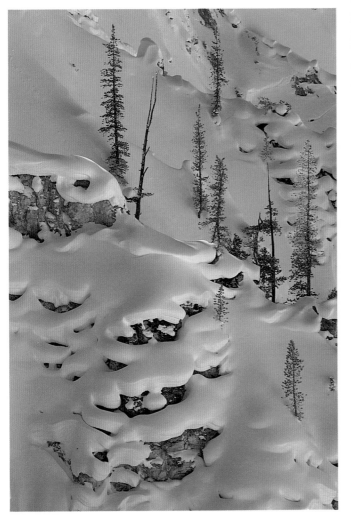

ROCK WALL DETAIL at Artist Point, Grand Canyon of the Yellowstone, Yellowstone National Park. Nikon F4, Nikon 300mm lens, Fuji Velvia.

Notice that while this is soft light, it is still directional. The bright, overcast day had a high veil of clouds covering the sky. I was photographing into the shadowed side of the canyon. But the light falling on this wall was actually bouncing off the opposite side of the canyon, making it, in effect, a giant white reflector.

THE CHANGING LIGHT

Although the direction of light and the kinds of contrast it produces have been discussed, it is important to remember that these are not constants. The light illuminating a subject changes over time, and with this change comes a shift in the viewer's entire emotional response to a photograph. Photographers have a tendency to take a picture and then say, "Here is how this subject appears," but that statement is not exactly true. More accurate would be "Here is how this subject appears in this light at this particular moment."

As the light changes from moment to moment, from day to day, and from season to season, it alters the appearance of the landscape. As a photographer, you should become visually sensitive to this process and be aware of how the landscape is shaped by light. Learn to see what is happening around you, and you'll be able to respond quickly to the changing nuances of light. If you are technically prepared, you can record a range of emotions evoked by the interplay of light upon the landscape. But first you must see the changing light.

SAGUARO CACTUS, Saguaro National Monument, Arizona. Nikon F4, Nikon 55mm macro lens, Fujichrome 50.

These two photographs were taken less than a minute apart. At first, gray storm clouds totally covered the sky, imparting a somber mood to the scene. Then a shaft of sunlight pierced through, illuminating the foreground saguaro and heightening the contrast. The entire mood of the composition changed with this one shift in the light.

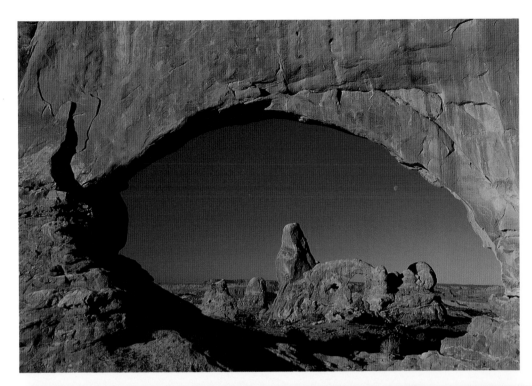

TURRET ARCH SEEN THROUGH
NORTH WINDOW ARCH, Arches
National Park, Utah. Nikon F3,
Nikon 24mm lens, Fujichrome 50.
Photographed just after sunrise.

*Emotionally, these two
photographs are miles apart, yet
they are the same subject, the
same lens, and almost the same
shooting position. All that has
changed is the light, and our
emotional response to the pictures
has totally changed with it. I'm
not suggesting that either
photograph is in any way better
than the other; that judgment
might depend upon why the
photographs were taken. But the
two versions are certainly distinct.*

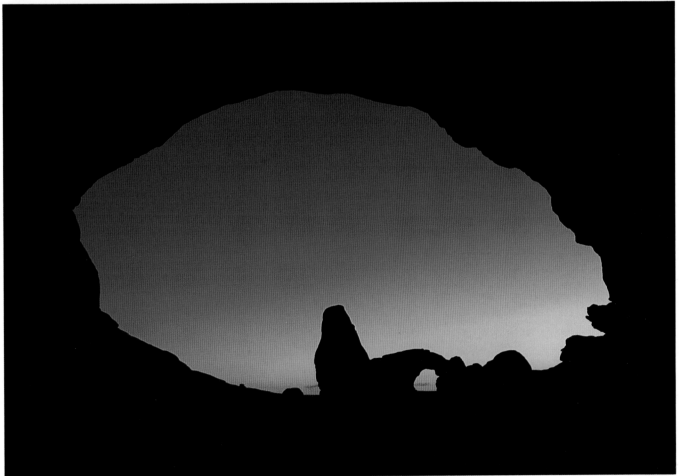

TURRET ARCH SEEN THROUGH NORTH WINDOW ARCH, Arches National Park, Utah. Nikon F4, Nikon 24mm lens, Fuji Velvia. Photographed at twilight.

BALANCED ROCK, Arches National Park, Utah. Nikon F4, Nikon 50–135mm zoom lens, Fuji Velvia.

Balanced Rock is an oft-photographed formation in Arches National Park. I was there late one stormy afternoon in May and took a fairly straightforward picture of it with grayish clouds obscuring the distant LaSal Mountains. I decided to wait to see if the light would change. The wind picked up quickly, while dust storms started swirling across the desert. When I was just about ready to give up, the rocks suddenly flamed, bathed in dust-diffused red sunset light. The total time elapsed between these two photographs: perhaps an hour.

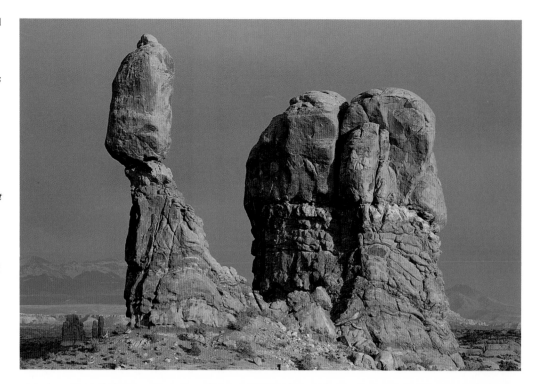

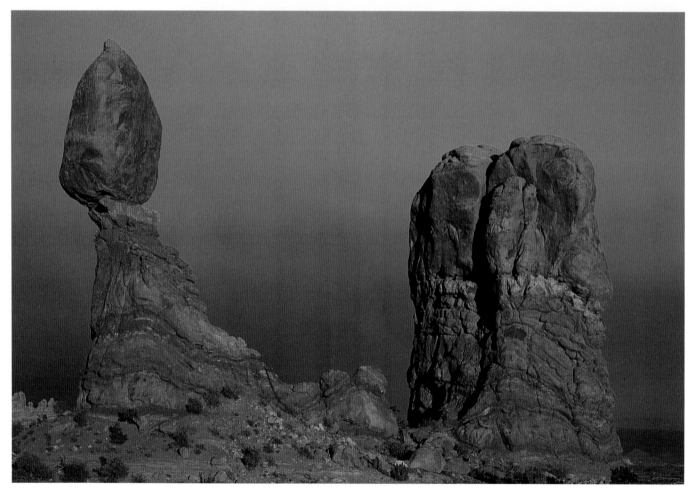

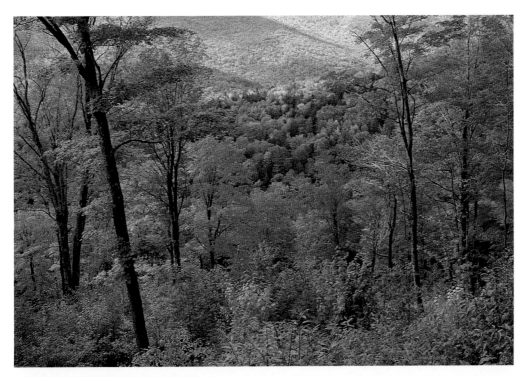

AUTUMN TREES, Vermont. Nikon F4, Nikon 105mm macro lens, Fuji Velvia.

The change in light between these two photographs was simply due to the shifting position of one large cloud shadow. It is amazing how quickly the light can change. These are actually two consecutive frames on a roll of film, taken just moments apart. With the different light comes a change in the feeling evoked by the pictures. A little stronger backlight on the leaves in the bottom photograph makes a slightly stronger statement about autumn in Vermont.

THE EDGE OF LIGHT

I believe that some of the most beautiful conditions exist when you are right at the edge between darkness and daylight, when it is neither night nor morning, afternoon nor evening, but instead is the fleeting moment in between these times. This edge of light is a subtle time, quick to change, and demands much of any photographer.

Working at these moments, the two major concerns you face are composition and exposure. You must be prepared beforehand for the conditions you encounter. Trying to find a good shooting location while the light is rapidly changing is a quick lesson in total frustration. Scout areas in advance so that you know where to be, then get there early to position your tripod exactly. Anticipation is the name of this game. Trusting to luck to be in the right spot, at the right time, with the right equipment rarely leads to good photographs. Make sure that your camera bag is packed with all the lenses you might need, that your cameras are loaded, and that you always have extra film with you. It is no fun to show up at a pre-dawn location only to realize that you left all your film in a motel miles away.

If you want to capture the edge of light, always be on the prowl for potential picture areas. Clean, simple compositions work best, because parts of your scene will undoubtedly be silhouetted against the source of light. Try to find unobstructed views with no power lines, no distant microwave towers, no manmade objects to intrude into the frame. Remember that you can hide roads and buildings in the dark areas of your picture by exposing for the sky, but any interior or exterior lights, or headlights, will record. I've checked areas in the middle of the day that seemed great, only to return at twilight to discover an outdoor security light glowing right in the middle of my planned shot.

At this time of day, metering for exposure is handled exactly the same as you would for any scenic at any other time of day. Meter the area you think is most important, and then assign it a

MT. McKINLEY AND ALPENGLOW, Denali National Park, Alaska. Nikon F4, Nikon 50–135mm zoom lens, Fuji Velvia.

This photograph was taken at about 4:00 AM on the summer solstice. To determine my exposure, I spotmetered the mountain itself, then assigned it tonality as a light magenta.

DAWN SKY AND BLACK WILLOW TREES, Michigan. Nikon F4, Nikon 105mm macro lens, Fuji Velvia.

I photographed this scene about half an hour before sunrise. A meter reading of the sky right above the horizon was the starting point for my exposure. This was actually not a very long exposure. Only by scouting the area the previous day did I know exactly where I needed to set up my equipment so early on this morning.

distinct tonal value by working in stops. Usually this means metering either the sky or another bright area of your scene and opening up. Most recently produced cameras have no difficulty metering in low-light situations. Current Nikon and Canon cameras can easily meter an exposure of 30 seconds at *f*/22 with ISO 50 film, but with older cameras you occasionally will experience some problems if you try to meter in dim light at a very small shooting aperture. For example, suppose you're working on a twilight scene in which you need to shoot at *f*/22 to ensure enough depth of field; however, when you try to take a meter reading your camera won't respond. What do you do?

Try metering at a more open aperture. The majority of TTL camera meters are not at their most accurate in extremely dim light. Instead of metering with the lens set at *f*/22, try a reading at *f*/2.8 or so. After all, if you can get a meter reading with the lens wide open, it is relatively easy to count stops over to your planned shooting aperture. Just remember that each smaller

f-stop on the lens requires a doubling of time for correct exposure. Assume you got a meter reading of 1 second at *f*/2.8. What should the shutter speed be at *f*/22? Count the stops: 1 second at *f*/2.8 is 2 seconds at *f*/4, 4 seconds at *f*/5.6, 8 seconds at *f*/8, 16 seconds at *f*/11, 32 seconds at *f*/16, and 64 seconds at *f*/22 (1 minute for practical purposes, since a few seconds either way is meaningless here).

If you shoot at this exposure value—regardless of how you determined it—you'll end up with underexposed slides due to *reciprocity failure*. Reciprocity is the doubles and halves relationship between *f*-stops and shutter speeds, the concept that increasing one and decreasing the other yields equivalent results. However, this doesn't hold true at low-light levels and subsequent long exposures. Regardless of what works under normal conditions, 1 second at *f*/2.8 does *not* equal 1 minute at *f*/22 in terms of what the film records. You have to add some light to compensate for longer exposures.

How much additional light is necessary depends on the film you're using. Each film has distinct characteristics in low-light situations. Some need a little more light, some a lot more; some shift color, some do not. I would advise you to standardize on one film for ultra-long exposures as much as you possibly can. Both Kodak and Fuji provide information about long exposure corrections (see the charts on the opposite page), but I still urge you to run some tests. After all, these are your photographs, and your idea of correct exposure and the manufacturers' ideas of correct exposure may not be the same.

Look at the results of my film tests (bottom chart). What they suggest to me is that at long exposures you should choose your film not only for color balance but also for exposure times. Say you need to shoot a calculated 8-second exposure, and you could use either Velvia (ISO 50) or Kodachrome 64 (ISO 64). These two films are roughly the same ISO index in normal lighting conditions, being only one-third stop apart. If you shot Velvia, your actual shutter speed would be 8 seconds plus one-half stop more, or 12 seconds altogether. Using Kodachrome 64, on the other hand, would necessitate the same 8 seconds, plus two stops more light, for a total of 32 seconds. Now imagine doing an even longer exposure. At a calculated 1-minute shutter speed, Velvia will be properly exposed after roughly 1½ minutes, while K64 needs 15 minutes.

One obvious question here is why not make the correction by opening up the aperture rather than always increasing time? Well, you can easily do so when you're working in one-third and one-half stops corrections. But—and this is of prime importance when you're shooting scenics—you're always decreasing depth of field when you go to a wider aperture. Generally speaking, landscape work is an aperture-priority type of photography; first you pick whatever f-stop you need for a scene, and this in turn dictates the shutter speed. If the reciprocity-failure correction runs into full stop values and you compensate by opening the aperture, your depth of field could change a lot.

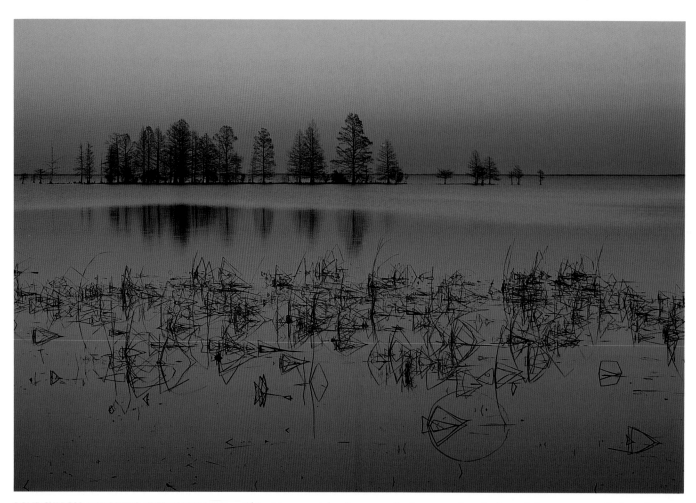

PONDCYPRESS AND REEDS AT TWILIGHT, Lake Mattamuskeet National Wildlife Refuge, North Carolina. Nikon F4, Nikon 50–135mm zoom lens, Fujichrome 50.

This picture was taken long enough after sunset that the sky and the water were all about the same tonality. I made the entire picture not quite one stop lighter than medium.

For example, think about what happens to Kodachrome 25 at a calculated exposure of 16 seconds at *f*/11. A correction of two stops open using the aperture is 16 seconds at *f*/5.6, while two stops open using shutter speed would be 64 seconds but still leave you at *f*/11. Will *f*/5.6 yield enough depth of field? On the other hand, is a 64-second exposure feasible? Or perhaps you should split the two, compensating with both shutter speed and aperture by shooting at 32 seconds at *f*/8? All three of these would yield correct exposure, but which works best? It depends on the circumstances you're facing. Ah . . . choices, choices.

KODAK'S RECOMMENDED ADDITIONS FOR LONG EXPOSURES

FILM	1 SEC.	10 SEC.	100 SEC.
Kodachrome 25	+½	NR	NR
Kodachrome 64	+1	NR	NR
Ektachrome 100X	+½	NR	NR
Kodachrome 200	NR	NR	NR

FUJI'S RECOMMENDED ADDITIONS FOR LONG EXPOSURES

FILM	1 SEC.	4 SEC.	8 SEC.	16 SEC.	1 MIN.
Velvia	-0-	+⅓	+½	+⅔	NR
Fujichrome 50	-0-	+⅓	+½	+⅔	NR
Fujichrome 100	-0-	+⅓	+½	+⅔	NR

Here are Kodak's and Fuji's recommendations for long exposures, given in additional stops of light needed. Note that the two manufacturers give different time increments (NR means these exposure times are not recommended). Both Kodak and Fuji also recommend using color-correction filters at exposure times longer than 1 second. I've ignored these filters here but suggest that you check the published information and run some tests of your own.

JOHN SHAW'S RECOMMENDED ADDITIONS FOR LONG EXPOSURES

FILM	1 SEC.	4 SEC.	8 SEC.	16 SEC.	1 MIN.
Kodachrome 25	+½	+1	+1½	+2	+3½
Kodachrome 64	+1	+1½	+2	+2½	+3⅔
Fuji Velvia	-0-	-0-	+½	+⅔	+1⅓
Fujichrome 100	-0-	-0-	+⅓	+⅔	+2⅔

Compare the results of some of my own tests for correcting long exposures, also given in additional stops of light needed, with Kodak's and Fuji's recommendations. I conducted my tests by bracketing exposures of a uniformly toned subject in unchanging light. I certainly have not tried all films at long exposures, and these results may not match your preferences. Treat these numbers only as a starting point for your work. Currently, I'm using Fuji Velvia for most of my long exposures and don't use any CC filters.

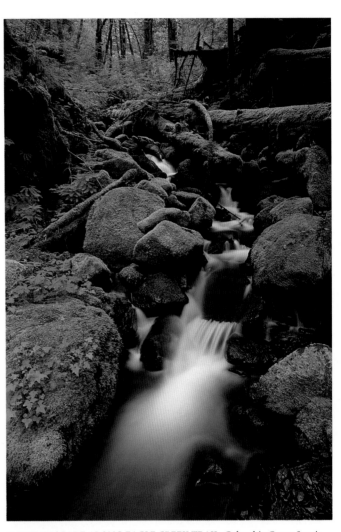

SMALL CASCADE ALONG EAGLE CREEK TRAIL, Columbia Gorge Scenic Area, Oregon. Nikon F4, Nikon 24mm lens, Fuji Velvia, polarizer.

Positioning my tripod was definitely the hardest part of taking this photo. I had one tripod leg straddling the small stream, yet I needed the highest vantage point possible in order to maintain my point of view. Shooting from a lower position would have meant looking up at the stream; my wide-angle lens would then have included a section of blank, white sky. The low light level from being in the deep woods on an overcast day, a small f-stop, slow film, and my polarizer all contributed to a long exposure with a final shutter speed of about 30 seconds.

BAD WEATHER IS GOOD WEATHER

You may have heard the old quip about how to make great photographs: "It's *f/8*, and be there." In reference to good landscape photographs, the statement should be a little broader: "It's *f/8*, and be there in good light." But good light means different things to different people. For non-photographers, good light usually is associated with good weather: clear, blue-sky days with no storm clouds in sight. How many people have you heard describe their vacation in this manner, talking about the perfect weather of bright sunshine, day after day after day? Or how many times have you heard complaints about the bad weather that ruined a trip? Here bad usually means any sort of precipitation, rain or snow or even fog.

To a landscape photographer, however, these conditions are reversed. Good weather is often some of the worst weather possible. Cloudless, blue-sky days are, photographically, the most boring and dull days imaginable. Stormy weather, on the other hand, is often exactly what you want, as it has mood, character, and emotion, all the factors that can transform a mediocre photograph from just being okay to being WOW!

One photographic problem with clear, cloudless skies is precisely that the sky is all one color—it will record on film as a featureless, textureless expanse. If you are shooting on a clear day, I strongly suggest that you include in your frame as little sky as possible. Crop tightly, or frame so that foreground objects push upward into the sky area of the picture. Half a frame of solid, unrelieved blue doesn't contribute to an emotionally moving photograph.

Granted, working in bad weather can be difficult. Photographing in the cold involves two basic problems: keeping your equipment functioning, and keeping yourself functioning. It doesn't matter how well your camera works in the cold if you can't stand being outdoors. Any active-wear outdoor clothing catalog—such as those from R.E.I., L.L. Bean, or Patagonia—will offer the latest in practical winter fashions.

But there is no such catalog solution for keeping your cameras operating in extreme cold. The lubricants in modern cameras work fine, even down to extreme temperatures, which has eliminated any need to winterize cameras unless you're planning on spending a great deal of time in polar conditions. The main source of cold-weather camera problems is the batteries. Modern cameras tend to be totally battery dependent, and as the temperature drops, so does the efficiency of any battery, until the modern electronic camera just stops working.

The solution is as obvious as it is easy: keep the batteries warm. Carry at least one extra set of batteries inside your coat, and exchange these with the ones in your camera as soon as you begin to experience sluggish operation. This is particularly true of the 6-volt lithium batteries many popular cameras now take. For extended cold-weather work, I personally prefer working with a camera that uses AA batteries rather than lithiums.

By the way, I always use a motor drive, even in cold weather. Although I'm aware of advice against using motor drives in cold, dry environments, as static can build up and leave small lightning marks on the film, I've never seen this on any of my film. Besides, given today's cameras, you would be hard pressed to find one without a built-in motor or winder.

The other cold-weather camera problem is moisture, primarily condensation that can play havoc with a camera's electronics. Bring a cold camera into a warm, moist, indoor environment, and you'll have instant condensation on both the outside and the inside of your equipment. Big, fast lenses have enough air inside them to leave condensation between the element groups. If you know you'll be going back outside shortly, try to leave your equipment out in the cold. If you have to bring your gear

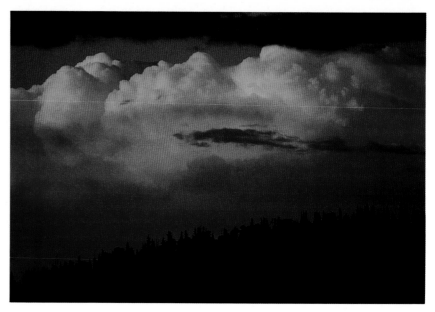

CLOUDS AT SUNSET, Colorado. Nikon F4, Nikon 200mm macro lens, Fuji Velvia.

Giant storm clouds were piling up just at sunset. I metered the clouds, placed them about one-half stop lighter than medium, and took the picture.

inside, keep it in a sealed case so that it warms up slowly. Better yet, while you're still outside, wrap your equipment in a large plastic garbage bag, and squeeze out as much air as possible. When you bring it indoors, the condensation will form on the outside of the bag.

Much of the same advice applies to working in wet weather. Keep yourself and your equipment dry. Several accessory companies offer rain covers made for specific lenses. Or you can do as I did, and make your own. I went to my local fabric store and bought some waterproof nylon, then measured my most-used lenses so that I could sew some lens covers. They aren't very pretty, but they work. I particularly wanted to protect my expensive, long-focal-length lenses.

In the field I always carry a couple of plastic bags tucked away in my pack, just to cover everything in case I'm caught in a downpour. I also carry a waterproof nylon stuff bag—available through any backpacking supplier—with a drawstring closure. I can tuck a camera with long lens into this, pull the drawstring tight, and protect my equipment. For short lenses I carry something that may sound a little funny when I mention it, but it works great in the field: a shower cap. It has an elastic band that keeps the cap in place when I place it over my tripod-mounted camera and short lens. I don't shoot through the shower cap, I just use it as a camera raincoat. I can leave the camera on my tripod as I search out a precise location, then quickly remove the shower cap to shoot.

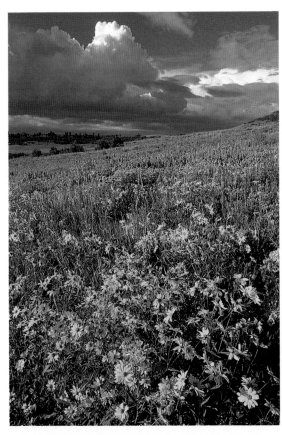

SUNFLOWERS AND FLEABANE, Colorado. Nikon F4, Nikon 24mm lens, Fuji Velvia.

Here is a situation where an approaching afternoon storm was welcome; a blank, blue sky wouldn't have helped the photograph.

Huge snowflakes were coming down when I took this picture (right). To stop the movement of snowflakes so that they hang in the air, you need a fairly fast shutter speed. Shoot at too slow a speed, and the flakes won't record on the film at all.

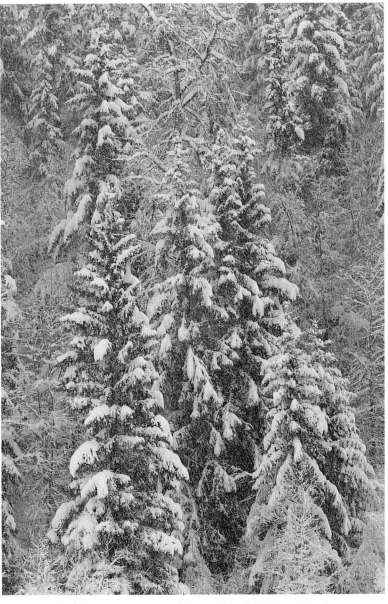

TREES IN WINTER SNOWSTORM, near Dalton Cache, Alaska. Nikon F4, Nikon 80–200mm zoom lens, Kodachrome 200.

THE LANDSCAPE AS DESIGN

SUNSET, Saguaro National Monument, Arizona.
Nikon F4, Nikon 300mm lens, Fuji Velvia.

DESIGNING A PHOTOGRAPH

A good landscape photograph is a synthesis of many decisions, all of which work together in unison. First, you must find a visually interesting subject. Your goal is to present this subject to your audience in a pleasing composition, one appropriate to the personal statement that you intend to make. Your composition must support how you have defined your subject, so that there is no confusion as to what is the visual center of interest. And finally, the entire photograph must be produced in a technically competent manner. Omit any of these ingredients, and your photograph fails.

The last item on that list—technical control—is not the least important. You must be proficient enough to control the medium, and total control of the photographic process is what you should strive to achieve. You must become a precise technician, controlling shutter speeds and *f*-stops, choosing the right lenses for the job, and working carefully but surely. You need to develop a rational, strictly scientific approach to the procedures. Photographic control should be very logical, in that step one is followed by step two, followed by step three, and so on. This way you'll become comfortable with using your equipment correctly to record the best images possible.

The problem for most people is that they just don't use their cameras very often. So every time they pick up their equipment, they must start over at the very beginning of the learning process. At the same time they are bombarded by manufacturers' claims that the camera not only can do everything photographic by itself, but also can do these things well: automatic exposure, automatic focus, and, recently, automatic composition, too. Well, I'm here to say that regardless of these claims, if you want to be a good photographer you *must* learn good technique.

Letting a camera make all the decisions is not the answer; remember that it is only a machine with no concept of how you want a photograph to appear.

But good technique alone is not enough. A picture can be razor sharp and perfectly exposed, and still not be visually exciting. You must be an artist as well as a technician; the two must be combined in a unified approach for truly successful photography. Great photographers are craftspeople who with their

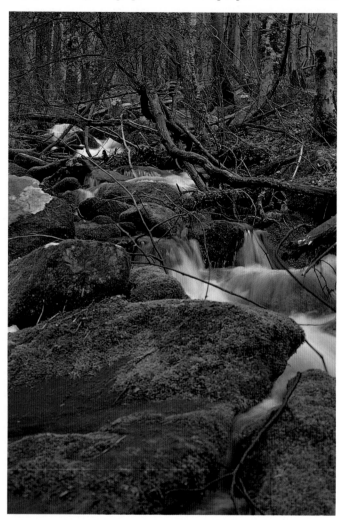

STREAM AND MOSSY ROCKS, Tennessee. Nikon F2, 55mm lens, Kodachrome 25.

This photograph has major problems, in terms of both technique and composition. What exactly is the subject here? Is it the stream or the mossy boulders? Why have all the branches, the limbs, and the general clutter been included? What's that bright white spot on the left edge of the frame about one-third the way up from the bottom? There is a snarl of vegetation across the top of the picture—what's the point of all this? Why is the foreground, the closest area to the camera, out of focus, while some of the mossy rocks farther away are sharply in focus? This is not a good photograph.

ROCKS AND REFLECTIONS IN FOREST LAKE, Banff National Park, Canada. Nikon F4, Nikon 200mm macro lens, Fuji Velvia.

No doubt is left in a viewer's mind as to what I was photographing, because there is nothing extraneous in the frame. By eliminating everything else, I focused the viewer's attention onto the scene I had chosen.

tools take pictures composed by the artists in them from their inner visions and emotions.

Composition is the art of imposing order and structure on the random natural world. Pleasing composition doesn't happen automatically or by chance. Regardless of how intriguing a subject may be, simply pointing a camera at it doesn't guarantee you'll make a photograph that engages the viewer's mind and emotions. Composing a picture—deciding where to put the edges of the photographic frame and how to arrange the elements within it—must be a conscious act on your part.

The starting point is to choose a subject, and only one subject. If I could summarize the major compositional problem most beginning photographers exhibit, it would be not simplifying a picture. More potentially good photographs are lost to visual clutter than to any other flaw. Answer these two key questions before you press the shutter: "Why am I taking this photograph?"

and "What do I want to show the viewer?" If there are four or five things you're trying to achieve in one picture, or four or five elements you want to highlight, you need to simplify.

I think you should be able to define precisely what the subject is of any photograph you take. Vague feelings are not enough. Try verbalizing out loud exactly what you're interested in photographing, then include within the viewfinder only what fits your definition. If you look through your camera and see something besides your definition, then you know it is time to recompose, tighten up the framing, and simplify.

A friend of mine illustrates this concept of choosing one dominant photographic subject by comparing the outcome to a written description. It takes several paragraphs to describe everything included within a bad photograph. A few sentences will do for a mediocre picture. A good picture requires but one sentence. A great photograph—well, a great one needs only a phrase.

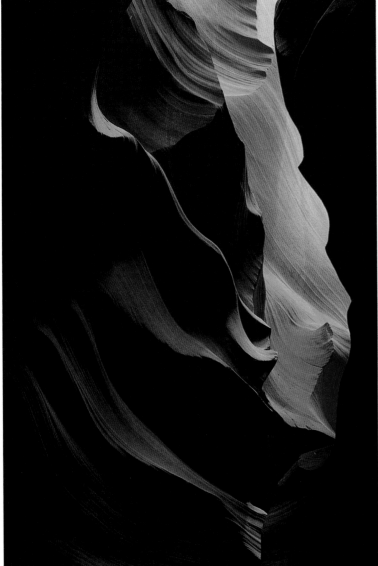

SANDSTONE SLOT CANYON, Arizona. Nikon F3, Nikon 50–135mm zoom lens, Fujichrome 50.

Here the light modeled sweeping forms of eroded sandstone. Simplicity doesn't mean there must be only one element within the frame. Rather, simplicity denotes a unity of purpose; the design encompassed may be complex, as in this case, but it works as a unified whole.

PHOTO-GRAPHICS

One of the strongest compositional techniques is to work in the most graphic way possible. I think we would take better pictures if we didn't do "photography" but instead concentrated on working with "photo-graphics." This means being absolutely concerned with the primary elements of graphic design: color, line, pattern, texture, and form. It means simplifying an image down to the bare bones. It means using the photographic tools—lenses, films, light, and exposure—to seek out and to record design elements, rather than just taking a snapshot.

Most day-to-day photography is really photojournalism. Our pictures record events, places, and people, photographs in which the content—the subject matter itself—is emphasized far more than any design element. I'm not suggesting that recording these things isn't valid; far from it. Photographs of graduation, of vacations, or of your new puppy dog are important in that they tell stories about our lives. But this photojournalistic approach tends to carry over into landscape photography as well. You might take a picture that only says "Here are some autumn trees," when you could be making a masterpiece, a photo-graphic that declares "Here are red leaves tracing an S-curve of color against contrasting green foliage." There is a major difference between these two approaches.

An easy way to discover whether you're doing "photo-graphics" is to think about how you describe one of your landscape pictures. If the only thing you have to say is about its content, it is a journalistic record. On the other hand, if the photograph demands that you use design vocabulary such as line, shape, color, pattern, or texture, then you know you've succeeded.

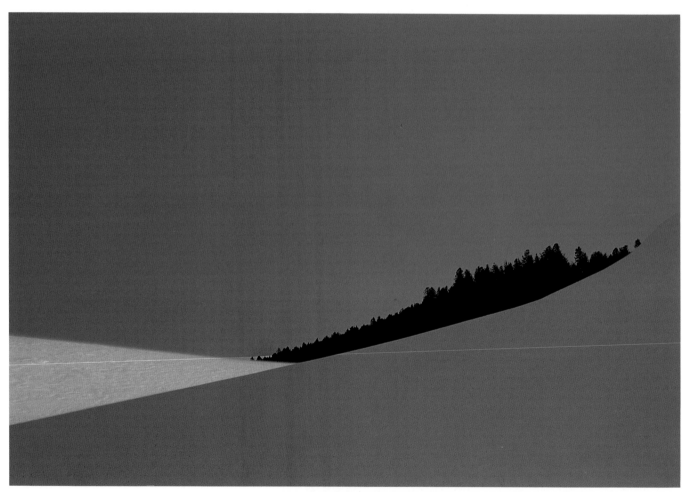

SNOW-COVERED HILLS AND AFTERNOON SHADOW, Yellowstone National Park. Nikon F4, Nikon 80–200mm zoom lens, Fuji Velvia.

Here is a truly basic graphic design of blue, gray, and white, anchored together by the black slash of treetops; yet there are additional visual factors at play. The blocks of color grow in size at a proportional rate; the gray shadowed area is proportionally larger than the white, just as the blue is proportionally larger than the gray. Strong lines cross at angles; no line is square with the borders of the frame.

PATTERN IN IRIS FIELD, Oregon. Nikon F4, Nikon 300mm lens, Fuji Velvia.

Repeating bands of color and texture march across the frame in geometric precision. One diagonal line, despite being the narrowest line in the picture, stands out against this regular pattern. An elevated vantage point helped me compress the field with my stopped-down telephoto lens while I avoided including the sky or other superfluous elements.

OLD PINYON PINE BRANCH IN DRIED SANDSTONE MUD, Capitol Reef National Park, Utah.
Nikon F4, Nikon 35mm lens, Fuji Velvia.

You can almost feel the rough texture in this photograph, the alligatored wood lying on the coarse, crumbling earth. The cracks in the pinyon pine branch echo on a small scale the identical pattern in the dried mud. Even the overall branching shape of the pine is repeated in the design of some of the largest dark cracks of mud. I picked my viewpoint very carefully to avoid having the tips of the pinyon appear to fall directly onto a crack.

PINYON PINE GROWING FROM SANDSTONE, Escalante Canyons Wilderness Area, Utah. Nikon F4, Nikon 50–135mm zoom lens, Fuji Velvia, polarizer.

This is a study in contrasts in line, texture, and form, between the sandstone, the tree, and the cloud. All three have uniquely different textures, from the exfoliated stone, to the prickle of the tree, to the wisp of a cloud. Parallel lines in the sandstone contrast with the curve of the pinyon. The free-form clouds hang softly in the sky.

TREE AT TWILIGHT, Michigan. Nikon F3, Nikon 300mm lens, Kodachrome 25.

Line and color—that is all there is to this photograph. The horizon line is intersected by the line of the tree trunk at a strong point in the frame. From this same spot, the salmon color radiates outward into the violet of a twilight sky. Simple graphic elements make a strong, dramatic statement.

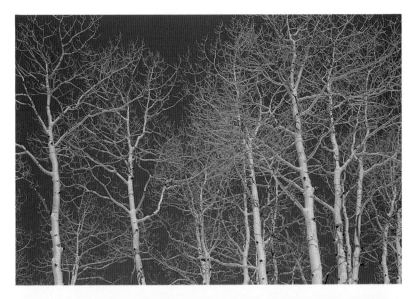

QUAKING ASPENS AND MIDWINTER SKY, Utah. Nikon F4, Nikon 105mm macro lens, Fuji Velvia, polarizer.

White aspen trunks jump out against the deep-blue mountain sky. The complex spiderwebbing of tree limbs made this a difficult photograph to compose. I had to position my camera carefully for the least overlapping of tree trunks.

SHADOWS AND LANDFORMS, Blue Hills Wilderness Area, Utah. Nikon F4, Nikon 300mm lens, Fuji Velvia.

This photograph is about repetition: repeating textures separated by repeating lines. The lack of visual clues as to scale and origin—just exactly what is this?—forces the viewer to concentrate on the graphic design itself.

VERTICAL OR HORIZONTAL?

A basic compositional decision is how and where to place the rectangular photographic frame around your subject. Your primary concern here is choosing a vertical or a horizontal orientation for the frame. People take many more horizontal than vertical pictures, perhaps because 35mm cameras are easier and more comfortable to handle when held horizontally. Information displayed in the viewfinder is certainly harder to read when the camera is tipped over on its side. Or perhaps this preference reflects the natural orientation of our vision, which takes in more material horizontally than vertically. Whatever the reason, the number of horizontal pictures taken far exceeds the vertical ones.

The next time you get several rolls of film back from your processor—six or eight rolls at once—lay out all the film simultaneously on a light box. The reason for not doing this exercise on a slide projector is because when you project slides, you concentrate on only one picture at a time and tend to forget what you've seen previously. But with 150 to 200 slides spread out on a light box, it is relatively easy to spot your photographic tendencies. A lot of horizontals? Are the exposures consistently good or bad? Do you favor one focal length over any other? Are your horizon lines straight, or all tilting in the same direction? Having an overview of a lot of film that you haven't previously edited is the best way to evaluate your own work.

Some theories suggest that a horizontal framing is emotionally quieter, more tranquil, and more calming, while a vertical frame conveys feelings of strength, power, and authority. Well, I'm not sure I agree with this. While I definitely think that changing an image's orientation changes its emotional impact, I don't believe that the orientation alone elicits emotion. Take a sheet of paper and cut it into the 1 x 1½ proportions of the 35mm image. Hold it horizontally, then hold it vertically. Does the direction itself convey a different mood? Or do you automatically visualize a subject within this frame? If so, does the subject matter combined with its presentation evoke the emotion you want? I think you'll agree that it is hard to separate what is included within a picture from how the picture itself is framed.

For example, imagine a tight head shot of a snarling grizzly bear with its mouth open and teeth bared. Would a horizontal version of this subject be quiet and calming? Would a vertical framing make the image strong and authoritative? Now change the subject from the bear to a single, dewy, violet blossom, and imagine vertical and horizontal versions of it. What are the differences here? How do you react? Finally, envision a photograph of a broad sweep of rolling wheat fields with puffy clouds in an endless blue sky. What would a horizontal frame say to you, and what impact would a vertical have? While you will certainly have

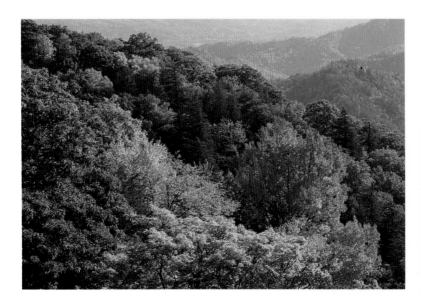

AUTUMN COLOR, Great Smoky Mountains National Park. Nikon F3, Nikon 105mm lens, Fujichrome 50.

In this pair of pictures I think one version is far more successful than the other. The red tree is basically in the exact same position, the lower right third of the frame, in both shots. But the vertical composition fades off into nothingness across the top half of the frame; all the interesting color, texture, and form is across the bottom half of the picture. In the horizontal image the entire frame works as a unit; the red tree belongs with the rest of the trees.

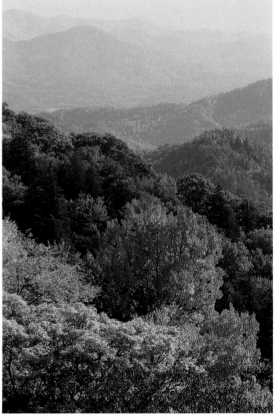

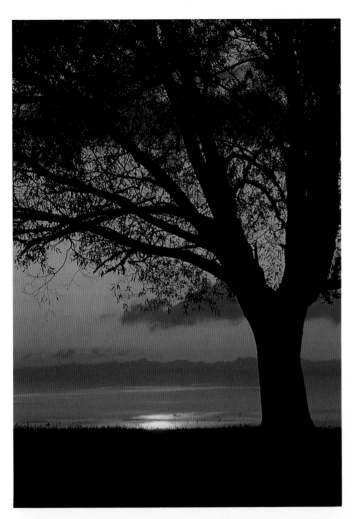

different emotional responses to all these examples, I believe you respond to the subject matter at the same instant you react to how it is framed.

Structure and content go hand in hand, supporting and reinforcing each other to make the strongest emotional impact possible. In a successful photograph, you can control this response by choosing the appropriate vertical or horizontal format for the emotion evoked by and projected onto your subject. Framing a picture horizontally or vertically shouldn't be dictated casually a rule of thumb or by which way it is easiest to hold the camera. How you orient the frame should be a conscious decision reinforcing, and reinforced by, your subject matter.

BLACK WILLOW AT SUNRISE, Nikon F3, Nikon 200mm lens, Fujichrome 50.

Although these photographs are very different emotionally, both versions are successful. I find the horizontal picture a little quieter than the vertical one. The horizontal shot is tranquil, beckoning me to stroll up to the tree and watch the sunrise. In contrast, the vertical photo is a little stronger. Looking at this framing of the scene, I have a feeling of slightly threatening weather to come. This response is partially caused by the much larger expanse of black at the bottom of the frame and the dark tones at the top—less of the bright sky appears.

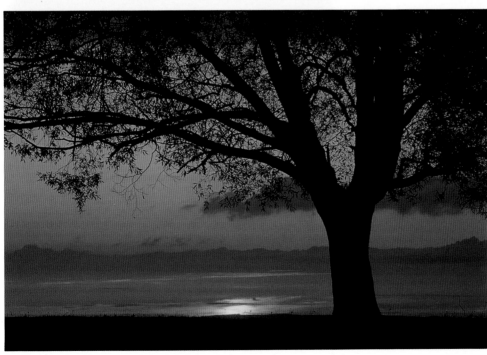

FOREGROUND DRAMA ADDS DEPTH

One way to increase the three-dimensional feeling of a photograph, or the apparent depth of a scene, is to work with a wide-angle lens very close to a foreground subject. A wide-angle lens exaggerates distance as it decompresses a scene. Things close to the lens appear large, forcing the viewer to participate intimately in the picture, while anything farther away from the lens recedes toward a distant horizon. Composing this way, you dramatically present a foreground subject in the context of its environment.

Be sure that your foreground is in absolutely sharp focus. It is very disconcerting to see a picture taken with a wide-angle lens where the horizon is more in focus than the foreground. After all, in everyday experience objects farther from us appear less sharply focused. Don't just point your lens at a nearby object and focus on it. Instead, use your depth-of-field preview and the hyperfocal distance of your shooting aperture to maximize how you utilize the depth of field available. If you simply can't use an aperture small enough to cover the entire scene—for example, suppose you need *f*/16 for total foreground-to-background depth, but the wind permits shooting at only *f*/8—then let the far background go soft before you lose foreground sharpness.

The closer you are to the foreground subject, the more critical your tripod and camera positioning becomes. Camera location affects not only how the foreground subject appears but also how the foreground relates to the background. If you are 20 feet from

SANDSTONE STRIATIONS, Zion National Park, Utah. Nikon F3, Nikon 24mm lens, Fujichrome 50.

Here I worked from a low tripod position, with my lens only a foot from the sandstone. Any lower, however, and the dominating sandstone foreground would have blended into the sky rather than the distant hills and trees showing on the horizon. I metered the sandstone, then slowed my shutter speed one stop to make the subject a "light" tone.

RHODODENDRON AT ROUND BALD, Roan Mountain, Tennessee. Canon EOS-1, Canon 24mm TS-E lens, Fuji Velvia.

I got lucky with this picture. The weather couldn't have been more perfect: periods of dead calm (unusual for a mountaintop) and high overcast lighting. In fact, the hardest part was positioning my tripod. I had to thread two legs into the rhododendron in order to get my camera in the right place.

the nearest part of the picture, a 6-inch change in camera location is basically meaningless. But if you're working with the lens only 2 feet from a subject, the same 6 inches in any direction becomes a gross movement.

In terms of the foreground/background relationship, try this little exercise and you'll understand what is happening. Hold a roll of film at arm's length, shut one eye, and look past the film at a book about 6 feet away. Move your head from side to side, and the film will appear to shift across the background but not by any great amount. Now hold the film a lot closer to your face, only a foot away. Move your head as before and notice this time that the roll of film is greatly displaced in relation to the background.

The closer the foreground is to the camera, and the farther away the background is, the more critical the location of the camera becomes. A subtle movement, the slightest shift of camera location, and the entire foreground/background relationship changes. Take extra time to position your equipment precisely, and you'll enjoy the punch that focusing on the foreground can bring to your landscape pictures.

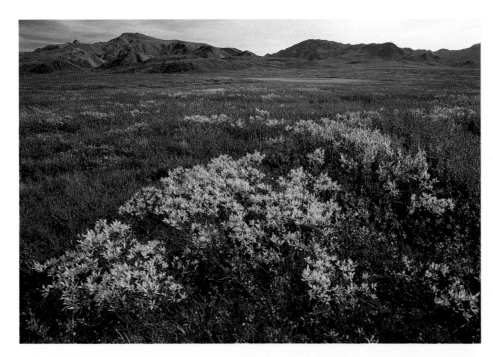

DWARF BIRCH AND WILLOW, Denali National Park, Alaska. Nikon F3, Nikon 24mm lens, Fujichrome 50, polarizer.

Autumn in Denali runs from the end of August through the beginning of September, and this was a good year for color on the tundra. I framed the curve of these dwarf willows as tightly as I could, while including the minimum of the sky with its thinly veiling clouds.

COYOTE TRACKS ACROSS BRUNEAU SAND DUNES, Idaho. Nikon F4, Nikon 24mm lens, Fuji Velvia.

I photographed this scene early one March morning as a low sun sidelit ripples in the sand and a coyote's tracks where it had loped across the dunes. I used my 24mm lens, positioned about three feet from the nearest tracks. Notice that I put the right side of the frame just to the right of a complete set of four tracks. I also cropped very tightly at the top of the picture so that the early sky would record as an extremely pale color. For my exposure, I assigned the sand a "light" tone, one stop above my meter reading.

AERIAL PERSPECTIVE

As discussed in the section on lenses, the longer focal lengths are often used to pull out one section of a landscape, to isolate one particular part of a scene. If you're photographing around hills or mountains, you can combine this feature with the *aerial perspective* phenomenon to produce strong, graphic photographs.

Aerial perspective, sometimes called atmospheric perspective, is an artist's term for creating apparent depth in a picture by changing the tone and color of objects receding in the picture plane. In reality, faraway sections of a scene appear lighter in tone and more muted in color. You can emphasize this aerial perspective by photographing with a long lens to compress the scene, and by working early or late in the day to take advantage of colors on the horizon. A long lens can stack a distant series of ridges together into repeating forms, separated by the lighter-toned valleys. This aspect of distance becomes especially apparent if any fog, haze, or dust in the air accentuates tonalities.

If you're shooting at sunrise or sunset with fog rising from valleys, remember that you're not trying to render everything in crisp, sharp detail. Instead, you're trying to magnify the softening effects of distance. You're not taking a picture of mountain details; you're taking a picture of line and shape and form. Don't curse the atmospherics for subduing elements of your scene; exploit these conditions to make a graphic statement.

Sunrise and sunset are times to be extremely careful with exposure. The worst possible thing you can do is to burn out the sky, already the lightest tone in your picture. It doesn't matter at all if the immediate foreground is rendered as a black silhouette against a lighter background. In fact, this is probably the best effect you can achieve. Our normal real life experience is to see detail in a highlight area and simultaneously behold a dark, black, blocked-up shadow section in which we don't discriminate anything. Doing the reverse in a picture—holding detail in the shadows while burning out the highlights—will make everyone looking at your picture uncomfortable.

So don't worry about the foreground exposure. Let it go black if need be. Meter the lightest area of your picture and assign it whatever tone you want it to be. Remember that you don't have to make a photograph literally depict what you see. The question to ask yourself is not "What tone is the sky right now?" but rather "What tone do I want to make the sky in my picture?" Meter that particular area, and only that area, by using the spotmeter built into your camera. If you don't have a spotmeter, mount an even longer lens on your camera to narrow the angle encompassed by the meter, and take a meter reading. Use this exposure information when you take the picture with your other lens.

MOUNTAIN RIDGES BEFORE SUNRISE, from Newfound Gap, Great Smoky Mountains National Park. Nikon F4, Nikon 200mm macro lens, Fuji Velvia.

Here the dawn sky was a light orange, so I made it only one-stop open from medium tone.

THE WHITE MOUNTAINS WITH
MORNING FOG, New Hampshire.
Nikon F4, Nikon 300mm lens with
Nikon 1.4x teleconverter, Fuji Velvia.

*I metered the lightest part of the sky,
then placed it tonally about 1½ stops
lighter than medium. Did it look like
this in reality? I don't know...but this
is how I wanted it to appear in my
photograph.*

*For the photograph below, I based
my exposure on the tonality I assigned
to the sky, knowing that the trees in
the lower right would appear as a
silhouette. I compared a meter reading
of the ridge behind the trees to my sky
exposure values. The three-stop
difference meant that the ridge
would appear as a dark tone and
the foreground would be black.*

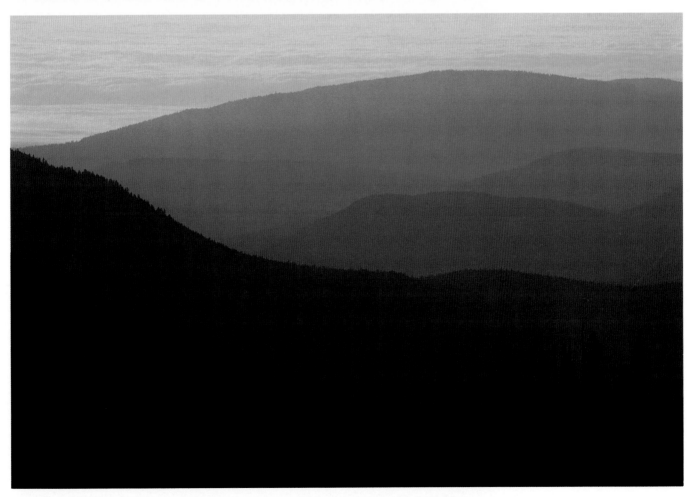

MOUNTAIN RIDGES AND TREES AT TWILIGHT, from Hurricane Ridge, Olympic National Park, Washington.
Nikon F3, Nikon 105mm macro lens, Fujichrome 50.

View Camera Techniques for 35mm Composition

Using a motor-driven 35mm camera to machine-gun images is no way to produce memorable pictures; instead you'll wind up with lots of slides destined for the trash basket. A far better way to work is to take the time to study every picture opportunity you face. Approach your 35mm camera with the same respect you would give to a large-format camera.

View cameras have several distinct advantages. First, they are glacially slow to operate, even under the best of conditions, when compared to a modern 35mm camera. You have to work from a tripod because the sheer size and bulk of a 4 × 5 camera precludes handholding it. It has no built-in exposure meter and consequently no autoexposure or programmed exposure modes. You must start with an external meter reading and correct for non-medium-toned subjects. And you get only one shot—that is all—before reloading the film, recocking the shutter, and going through the entire exposure process again.

Why would I ever suggest that this abysmally slow and tedious way of working could possibly be an advantage? Simple—it forces you to become a meticulous worker. Too many 35mm photographers want to blast away under the assumption that if they shoot enough film and use all their lenses, then something will surely turn out.

When you're shooting in the field, pretend your Nikon or Canon is a view camera. Work from a tripod, and carefully study the image in the viewfinder. Compose precisely. Before you shoot, look around the edges of the frame for any intrusions into the picture space. Are there any glaring hot spots of light that need to be controlled? Is the exposure set exactly as you want it to be? Is the horizon perfectly level? Is this the absolutely best camera location? Are you in charge of the photographic process? Pretend that instead of 36 frames on a roll of film you have only one frame that you can use; now make that one frame really count. If you know that you can't shoot dozens of variations of a picture, you'll be a more discerning, selective, and deliberate photographer.

View cameras also change the way you compose a picture. The image on a view camera's groundglass is upside down and backward. How can this help with composition? It forces you to respond to the subject matter not as an entity in and of itself, but in graphic terms. Photographers usually identify their subjects and respond to them in terms of this identification. For example, suppose there is a winter oak tree standing bare against the twilight sky. You would probably see this through your 35mm viewfinder, identify it as "tree," and work with it as "tree." This is not quite the case with a view camera.

When the image is upside down and backward, your perception is disoriented. Look at a view camera's groundglass and you don't see an image labeled "tree" anymore. Instead, you see line and shape and form and color. You won't relate to these things the same way you related to "tree." Your composition will change and, I'm firmly convinced, for the better.

I'm not urging you to get rid of your 35mm camera for a 4 × 5, but to make use of some of these compositional techniques. Try defining your photographic subject in graphic terms. Don't say "I want to take a picture of that mountain with the trees in the foreground," but rather imagine that "I want to photograph that repeating series of angles, juxtaposed with the straight fore-

OAK TREE AND WINTER TWILIGHT SKY. Nikon F3, Nikon 24mm lens, Kodachrome 25.

Notice that if you invert this picture, if you view it upside down, you tend to react to it graphically rather than first labeling it a picture of a tree. Strive to work with subjects as design elements rather that as labeled objects.

ground lines." Instead of looking at a flower in a meadow, try to see the scene as contrasts in color and texture.

When you receive your film from the processor, add another dimension to your critique by removing the easy identifications. After you've viewed your pictures normally, intentionally invert them. Put your slides upside down in a slide tray, or lay your film out on a light box upside down. Photographers are so familiar with their work that merely glancing at it brings back floods of memories about the conditions under which they took their photographs. By changing how you view your pictures, you can remove these emotional overtones and attachments and free yourself to concentrate on compositional evaluations. By the way, you can play this game with prints, too; just stand in front of a mirror to look at them.

BLUEBONNETS AND PAINTBRUSH ON TEXAS SPRING PRAIRIE. Nikon F4, Nikon 105mm lens, Fuji Velvia.

More than just being a picture of prairie flowers, this is a shot of an expanding, sweeping curve of blue and red.

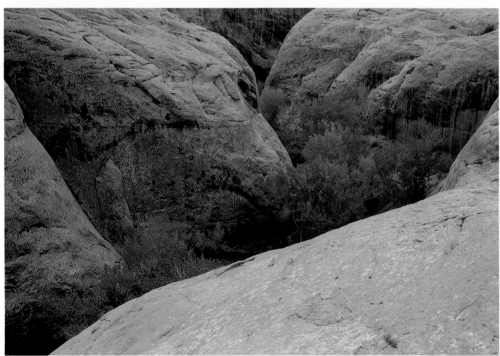

SPRING COTTONWOOD TREES ALONG A CANYON STREAM, Arches National Park, Utah. Nikon F4, Nikon 50–135mm zoom lens, Fuji Velvia.

Here I was standing on top of slickrock, looking down into a canyon defined by budding cottonwoods following a watercourse. In photographic terms, however, I was seeing the contrasting textures, colors, and lines formed by the sandstone and the spring leaves.

THE SEASONS

We tend to have fixed ideas of places, based on the way they appeared when we first saw them. After traveling to a new location, you will refer to your memory of it then, now indelibly etched into your mind as you experienced it on that trip. Never been to Vermont in autumn? Your first trip will yield distinct impressions and strong emotional responses, as well as quiet nuances of feeling. More important, your visual definition of it will be fixed according to the season. If your trip took place during the first week of October and there was gorgeous autumn color, you'll tend to believe that this is how Vermont always looks during the first week of October. If Groton State Forest was spectacular, then your impression will be that it is always spectacular. Have you been to the Oregon coast only once, when it was raining? From now on, you'll probably always think of Oregon beaches as rainy places.

Your understanding of a place, your concept of what it really is like, depends totally on your personal experience of visiting that locale. Photographers fall into this trap as easily as anyone else. It is easy to think you've really worked a location, when in reality you've photographed it only once. A travel phrase currently in vogue is "been there, done that." Photographers should amend this to "been there, done that—at one particular moment in time."

It is easy to forget how much things change, but it becomes more evident if you practice watching one subject go through the turn of the seasons. A good exercise is to photograph one particular area with the same lens yielding the same composition, throughout all four seasons of the year. Pick a locale near your home, or at least one you can visit during all seasons. Try to envision what one particular subject might look like at different times of the year. Choosing a scene to photograph through-

JANUARY MARCH MAY

STREAM THROUGHOUT THE YEAR, Michigan. Nikon F3, Nikon 105mm lens, Kodachrome 25.

On the first day of every other month, I shot this sequence of six photographs over a year's time.

out the year is far more difficult than you might expect. Is the location always accessible, or must you be prepared for bad road conditions? From what direction does the light come at different seasons? Can you be there in good light? If the scene you've chosen is open in winter, will it be overgrown in summer?

I've shot seasonal progressions of the same subject a couple of ways. I once mounted an aluminum strap on a wooden fence post so that I could simply screw my camera onto it and achieve exactly the same framing. Although the theory here sounds good, executing this plan was far too difficult. Trying to find a fence post in the right spot or planting one there is not practical.

A far simpler plan would be somehow to mark a location for your tripod and then return to that spot with the same tripod extended to the same height. I once flagged a stake with surveyor's fluorescent ribbon to mark my location, then shot with a fixed-focal-length lens positioned over the stake (using a zoom would have meant remembering the focal length at which it was set). This worked great until the day I arrived, to discover that someone had removed my marker. As a result, I suggest that you always shoot one extra frame the first time you're at a site, so you can carry it with you for a direct comparison when you return the next season.

Shooting seasonal progressions of one subject has unlimited applications, as simple as keeping a record of your house or garden thoughout a year, or as complicated as you want. Consider this photographic record, which I'm still kicking myself for not doing: There was an extensive fire in Yellowstone National Park during the summer of 1988. Immediately after the fire, I should have picked three or four prime locations and started a photographic journal of those sites through the seasons. Over enough time, say the following ten years or so, this could have become a fantastic photographic sequence showing the succession of plants and the rebirth of the forest. Hopefully, you'll learn to recognize and take advantage of such photographic opportunities as they occur in your area.

JULY

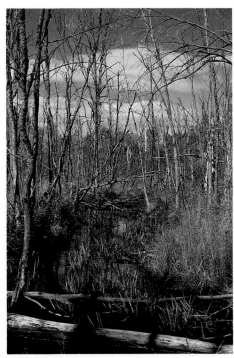

SEPTEMBER

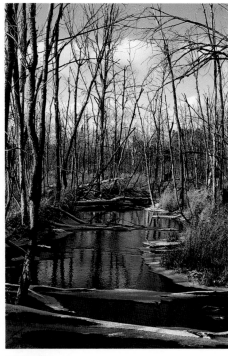

NOVEMBER

BEECH/MAPLE FOREST IN
FOUR SEASONS, Michigan.
Nikon F3, Nikon 105mm lens,
Kodachrome 25.

*I photographed this scene in a
remote corner of a local nature
preserve. Although I marked
the spot where I wanted to
shoot, the way I framed my
shots turned out to be slightly
different. If I had carried a
reference slide with me, made
to identify the exact position
whenever I photographed the
location, I could have
prevented this problem.*

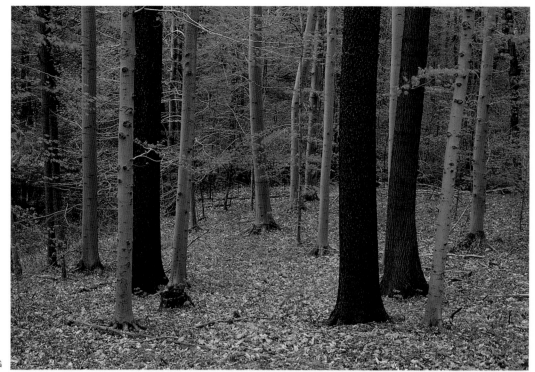

SPRING

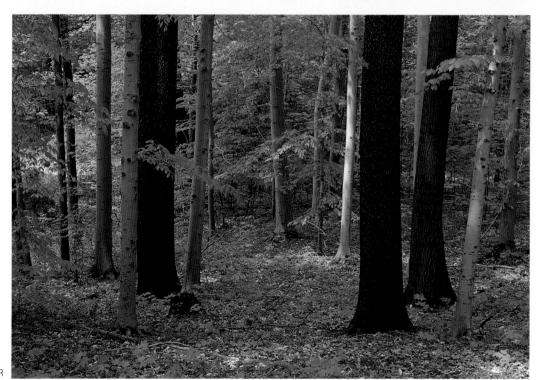

SUMMER

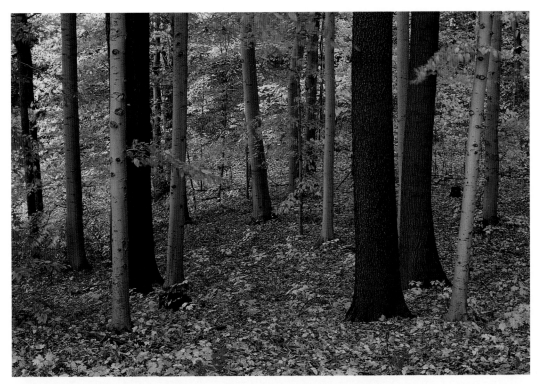

AUTUMN

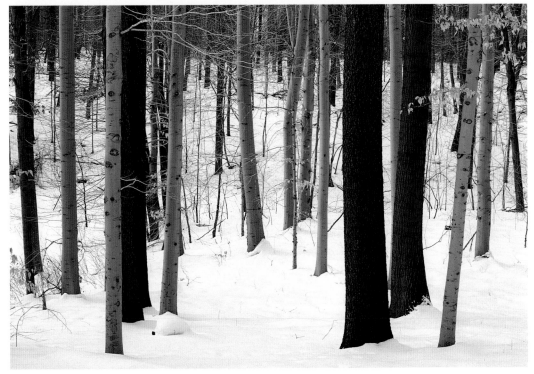

WINTER

PROBLEMS AND SOLUTIONS

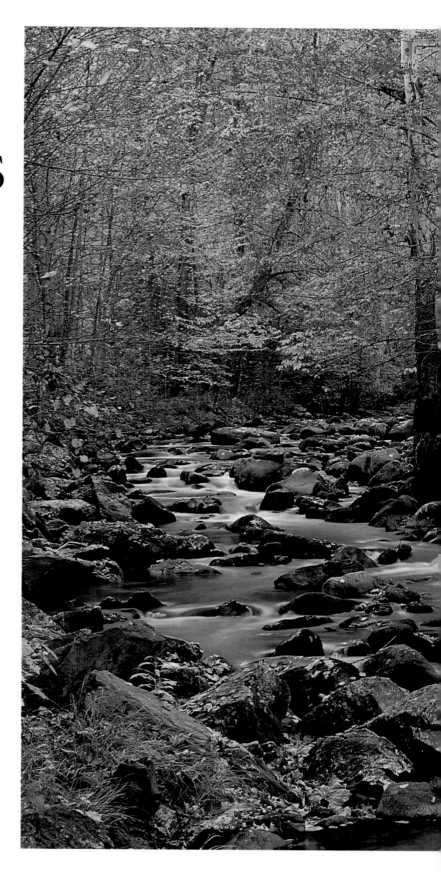

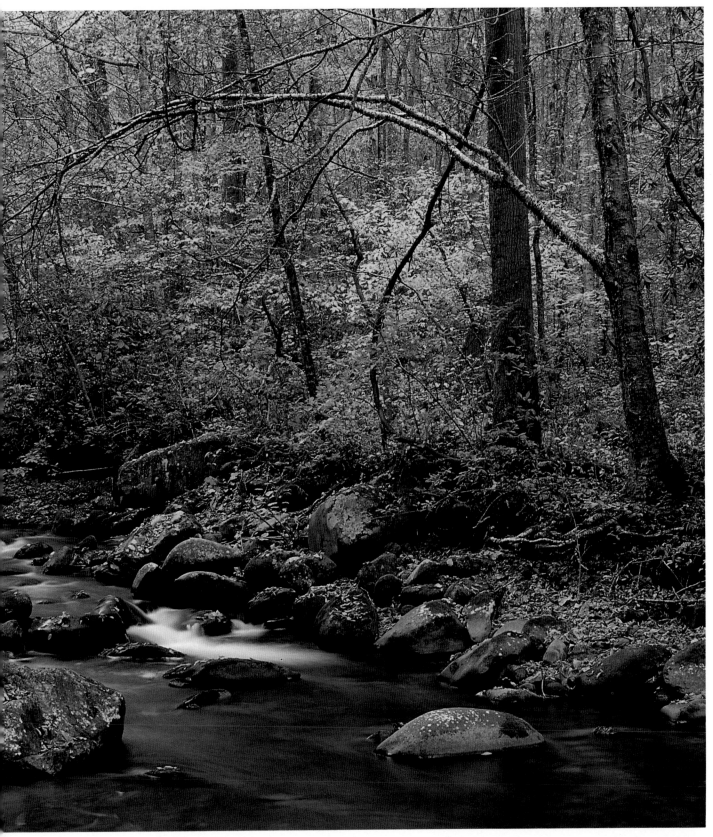

STREAM IN AUTUMN, Great Smoky Mountains National Park.
Nikon F4, Nikon 35mm Lens, Fuji Velvia.

Sunrises and Sunsets

Do you encounter problems when shooting sunrises or sunsets? Many photographers seem to experience special difficulty at these times—at least, I'm often asked how to make such exposures. It is really not so difficult to do if you stop to analyze the situation.

Your objective at this time of day is usually to silhouette objects in the foreground against a lighter-toned sky. One of two predicaments arises when you meter for this type of exposure. If the ball of the sun is in the picture, especially toward the center of the frame, its extreme brightness greatly influences the meter. Because it always tries to make what it is pointed at look medium-toned, in this case the meter tells you to stop down to make the sun medium; consequently, your picture turns out underexposed. If the sun is below the horizon, the meter reads the dark foreground and tells you to open up to render this foreground as medium; then your picture is overexposed. So what is the answer?

You'll be relieved to know that it is easy—and, as usual, it involves working in stop increments. Remember that you can make any section of your picture appear as any tone you want it to be. It doesn't have to be this tone in reality, the question is how you want it to look in the final shot.

Don't try to take a meter reading using your final composition. Instead, swing your lens to one side, and meter only the sky *without* the ball of the sun appearing in the frame. If you shoot at what the meter indicates as proper exposure, that particular section of the sky will become medium toned in your picture. Do you want it that way? Or lighter or darker?

As a rule of thumb, I suggest making the sky about one-stop lighter than medium—that is one stop open from the meter reading—especially if you're shooting silhouettes. For example, suppose I'm shooting trees silhouetted against the twilight sky. A meter reading taken from the sky alone says 1/4 sec. at *f*/8. Once I've recomposed exactly as I want to frame the shot, I let one stop more light hit the film by setting my camera to 1/2 sec. at *f*/8. Opening up one stop ensures that the silhouette will not blend in with the sky if it's dark. This can happen if you're using a wide-angle lens, because the edges of the scene, being far away from the axis of the existing light, appear darker anyway.

Working in stop values helps you predict whether or not a foreground shape will actually be silhouetted. Meter the sky and assign it whatever tonal value you want it to appear. Now meter the

OCOTILLO SHRUB AND SAGUARO CACTI AT TWILIGHT, Saguaro National Monument, Arizona. Nikon F4, Nikon 24mm lens, Fujichrome 50.

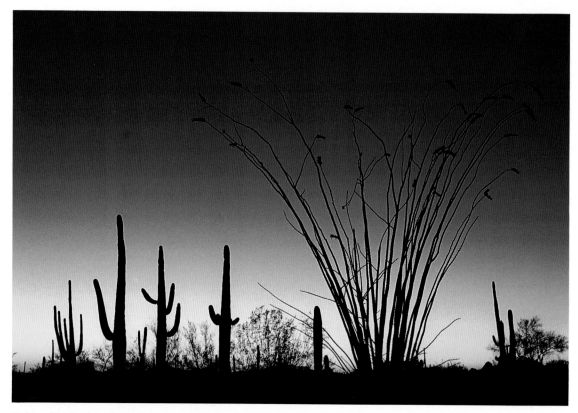

Taking this photograph posed two very difficult problems. The first was finding a vantage point that provided no overlapping silhouettes of cacti. This may sound as if it would have been easy, but believe me, it wasn't; I probably spent 45 minutes searching for just one location. Notice that my camera position is very low to the ground, so that I'm looking up through the ocotillo into the twilight sky. Exposure was easy: I metered the sky just above the ocotillo and arbitrarily decided to render that portion of the sky as a medium blue. In so doing, I let all the other tones fall wherever they might. The other major problem? Finding my car after I had finished photographing.

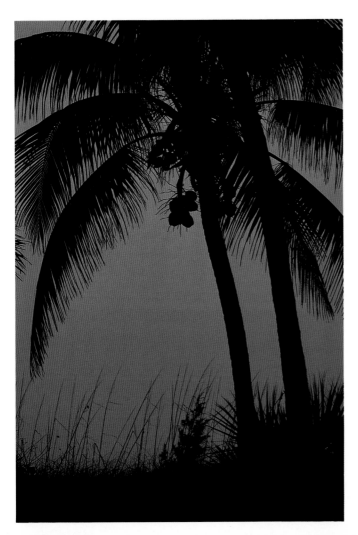

foreground to find out how many stops difference exist between it and the sky. Calculating your exposure in stop values is always helpful whenever you're shooting a contrasty situation. Even before you trip the shutter, you are able to imagine exactly how the results will appear, simply by comparing two meter readings.

For example, assume that the sky meters as 1/60 sec. at *f*/8. In order to make it a light tone, I decide to open up one stop to 1/30 sec. at *f*/8. A meter reading from the foreground indicates 1 second at *f*/8. What tone will it be in my slide? Well, there are five stops between these two meter readings, so a 1/30-sec. exposure will make the foreground appear five stops darker. By counting down stops on my metering chart (see page 26) you can see what will happen. Start at "light"—the tonal value I want the sky to appear—and subtract stops. Five stops down drops the subject totally off the bottom of the scale; thus, the foreground will definitely appear as a detailless black on the film.

COCONUT PALMS AT SUNSET, Florida. Nikon F3, Nikon 50–135mm zoom lens at about 135mm, Kodachrome 25.

This photograph was extremely easy to take. The coconut palms were growing along a public beach in the middle of Naples, Florida. I metered the sky (I had to walk up close to the palms in order to point my camera past the fronds and palmetto), opened up one stop from the meter reading, walked back to my tripod position, and took the picture. The best part of the story was the ice-cream shop directly across the street from this park; my tripod was no more than 30 yards from the store's front door. Ah, yes… camera in one hand, a rum-raisin ice-cream cone in the other.

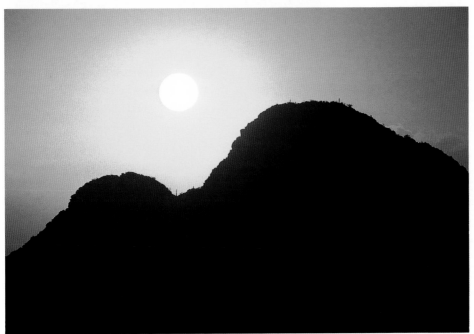

SUNRISE OVER SONORAN DESERT MOUNTAINS, Saguaro National Monument, Arizona. Nikon F3, Nikon 200mm lens, Kodachrome 25.

By shifting my camera position—by walking, that is—I aligned the rising sun with the notch in the mountains. I knew that if I exposed for the sky, the ridge would record as a solid black form. I metered the sky, without the sun in the frame, then opened up one stop.

MERGES, CONVERGES, AND APPARITIONS

An annoying problem, often unnoticed by photographers during the process of composition, is the merger of tones and shapes. Looking at the world with binocular vision gives humans depth perception; thus we know when one object is really in front of another, despite their both being the same tonality or color. One is closer, one is farther away, so we distinguish between them.

Not so with the one-eyed camera and its two-dimensional film. All objects on the film plane become a joined unit if they touch. On film they merge unless there are some additional clues that the two are not really part of one greater whole. This is particularly true when the objects are the same color, or when there are no indicators of relative distance from the camera.

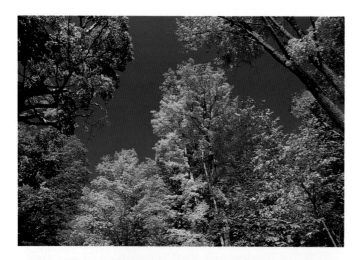

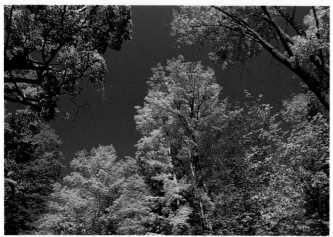

AUTUMN COLOR, Vermont. Nikon F4, Nikon 35mm lens, Fuji Velvia.

When I first set up this composition, I didn't notice the merge in the top picture. Only after taking a few frames did I realize that the central orange tree appears to be touching the orange tree extending above it from the right side of the frame. Because these trees are essentially the same color, it was hard to tell where one ended and the other began. By moving my tripod no more than 12 inches, I was able to eliminate this merge, allowing the blue of the sky to separate the trees.

For example, imagine a snapshot of Aunt Harriet, shown with a telephone pole growing directly out of the top of her head. We know that she doesn't really have such an affliction, but the photograph definitely suggests it. If we could see more of the pole—not just a section of it emerging from Harriet's head—we would know that she was standing in front of it. Such visual aids as depth of field (Harriet in focus, the pole not in focus) would also let us know the two are not connected.

Merging tonalities are the downfall of many otherwise successful photographs. You can prevent this problem by not overlapping two areas that are exactly the same in tonality if they are in reality separate objects. Imagine that you're shooting a picture of dark tree trunks against white snow. Standing there looking at the scene, you know that each and every tree is separate and individual. But if you overlap some of the trunks in your photo they will appear to merge. Where does one tree end and the next begin? Is one tree behind another, or are those two trunks growing out of only one stump?

To avoid creating merges, choose your camera's location carefully so that the viewer doesn't have to guess about parts of the picture. After you've set up a shot, spend a few extra moments meticulously examining the image through the viewfinder, checking for merges. Moving your shooting location just a tiny bit one way or another makes a great difference. I normally start determining my tripod position by handholding my camera. This gives me great flexibility; I can try out vertical and horizontal compositions, and frame my picture from both high and low positions. Once I roughly situate my tripod, I can make minute adjustments to precisely find the exact spot and avoid any merging tones.

Another potential problem in composition is an object that converges with the edge of the frame. Things that just barely touch the edge leave the viewer wondering about your intentions. Is there more to be seen, or is that all? Did you mean to position that object right at the edge, or is its location happenstance? To alleviate doubt, leave space around anything that could lead the viewer's eye out of the frame. Imagine a sharp leaf coming to a point right at the edge of your picture. To the viewer, the converging lines of the leaf point the way right out of the photograph. Leave some space for the viewer's eye to travel around that sharp pointy end and linger inside your image.

On the same note, don't include little things that seem to appear from nowhere in your picture. These apparitions are disconcerting and confusing. Where did they come from? For example, imagine a scenic photograph of a mountain and blue sky. Up in one corner the tip of a branch sticks into the picture frame. What is it doing there? Is it attached to anything? Include enough of the branch so that the viewer has no doubt that you wanted it included. Don't confuse your audience. Make sure when you incorporate only part of an object that your viewers know that you deliberately and intentionally chose that composition.

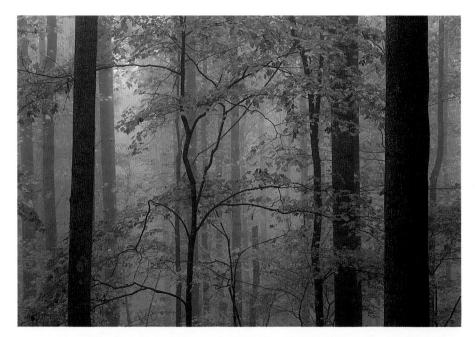

FOG IN DECIDUOUS WOODS, Great Smoky Mountains National Park. Nikon F4, Nikon 50–135mm zoom lens, Fujichrome 50.

Shooting into a mass of tree trunks is very difficult. How do you order all these lines? If you look closely at this picture, you'll notice that I intentionally made use of merging tones in order to simplify the composition. I chose a shooting location that made some of the trees appear to overlap and merge into one tone. For example, notice that the second dominant trunk from the right edge of the frame is really two *trees, not one.*

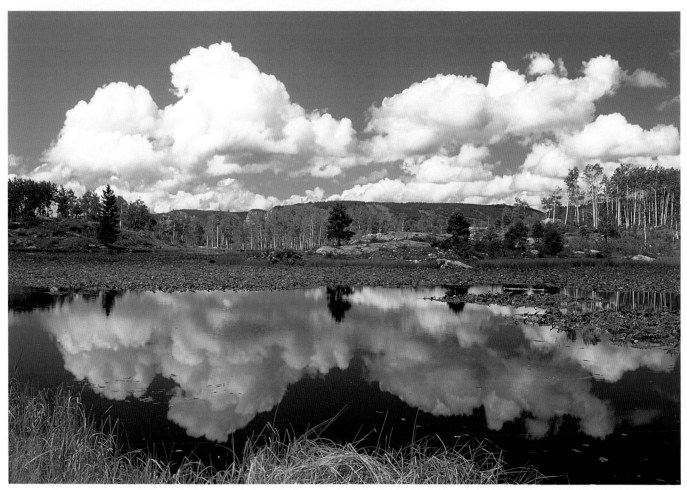

BEAVER POND AND CLOUD REFLECTION, Colorado. Nikon F4, Nikon 35mm lens, Fuji Velvia, polarizer.

Here I picked a shooting location that made the curve of the cloud reflection follow the curve of the foreground sedges. The white, blue, and green areas remain distinct and separate.

WHITE SKIES

Although overcast skies produce a soft, beautiful, low-contrast light, the sky itself doesn't photograph well under these conditions. Once again, photographers face a contrast problem. If you expose for the foreground landscape, the much brighter sky falls far outside the film's capacity to record an image. The results: a blank, white, washed-out sky.

Some films have a better capacity than others to hold a wide contrast range, and also to discriminate the subtle colors and delicate tonal gradations in an overcast sky. At present, I think Fuji Velvia is the best choice for these conditions. But even so, a great expanse of blank, white sky quickly kills a picture as it visually overwhelms everything else in the frame. Its brightness is too powerful

One solution is to use a graduated neutral-density (ND) filter to compress the tonal range. This is sometimes successful, but if the sky is really blank, you're just darkening it to a gray tone. Is this what you want? And graduated ND filters don't work well if you have something rising above the horizon line into the sky area. If you tone down the sky, you'll also darken that object. Imagine a scene including a tree with its lower half against the foreground and its top half against the sky. Using a graduated ND filter to tone down the sky a stop or two will also reduce the exposure on the top half of the tree. You'll end up with a half-dark, half-light tree. Not good.

A better solution is to crop the sky as tightly as possible in your viewfinder. Including just a sliver of sky works, especially if there is at least a slight hint of color in the sky. Be extremely careful as you compose. Working from a tripod, with a precision tripod head, is the only way to go.

Another possibility, and probably the most useful solution, is to just crop out the sky altogether. Here your lens choice is critical, as a short focal length will force you to include the sky no matter how you compose unless you're shooting down at the ground. The wider the angle of view of the lens, the worse the problem of unwanted sky. So reach for a long telephoto, a 200mm or longer, to isolate one section of the landscape. You'll be shooting into a scene, rather than up at it.

AUTUMN MAPLE IN FIELD. Nikon F4, Nikon 105mm macro lens, Fuji Velvia.

These two photographs were taken about two days apart, as a long period of overcast finally started to clear. Look what happened when a large expanse of blank, white sky was included within the picture (top). It overpowered the rest of the frame, producing a dull, uninteresting photograph. Just a few touches of blue broke up this bright expanse and totally transformed the image (left).

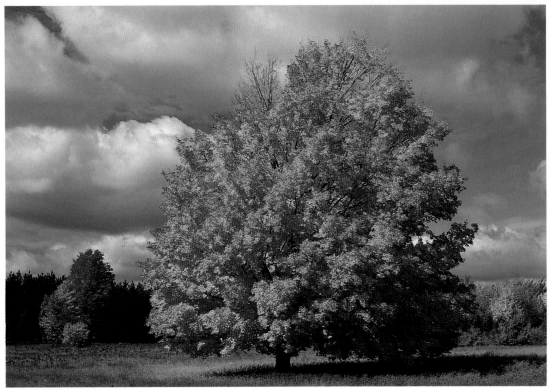

Contrails

Contrails are the trails of condensation that jets leave across the sky at high altitude, and they never look like clouds. A straight white line across the sky, especially through a clear blue sky, is an absolute giveaway that you're not looking at a cloud. Contrails are too perfect, too orderly, to be natural.

Contrails don't belong in photographs of nature, especially in shots of pristine wilderness, unless you're making a statement juxtaposing man and nature. One irony of working in the western United States is that some of the most spectacularly scenic national parks are situated under major flight paths. On cold, clear, low-humidity days—perfect days to photograph these wilderness parks—the sky is laced with contrails. One morning in late February, I stood in Arches National Park, in southern Utah, and counted 11 contrail lines across the sky. Developing a concept of wildness or portraying the eons of time that have shaped our world is impossible with the tracks of technology sprawled across the sky. I'm a real airplane nut who wants to get his pilot's licence, but I really don't like getting contrails in my pictures.

There is no way to remove a contrail short of not including the sky in your photograph. All you can do is wait for the vapor trails to dissipate; meanwhile, you stand around, check your composition for the umpteenth time, look at your feet, and watch the white-throated swifts flash past. Contrails...I hate 'em.

CONTRAIL OVER AUTUMN ASPENS, Turkey Creek Mesa, Colorado. Nikon F4, Nikon 50–135mm zoom lens, Fuji Velvia, polarizer.

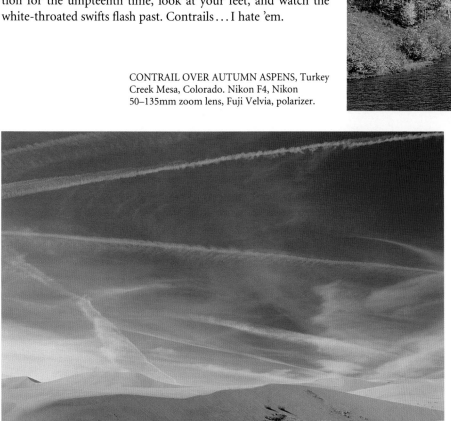

CONTRAILS OVER GREAT SAND DUNES NATIONAL MONUMENT, Colorado. Canon EOS-1, Canon 45mm TS-E lens, Fuji Velvia, polarizer.

Any contrail at all, no matter how small, definitely shows up against the deep-blue Colorado sky (top). A few seconds later, the airplane was out of my picture frame.

Another day in Colorado (left) atmospheric conditions didn't allow the contrails to dissipate. Consequently, I couldn't include the sky in any landscape photographs for the entire day.

TILTING HORIZONS

COCONUT PALM AT SUNSET. Nikon F4, Nikon 300mm lens, Fujichrome 100.

There was only one place from which to shoot; I couldn't move closer or farther from these palms. I needed a long zoom lens to change the framing of my shot, but I had to use the fixed-focal-length 300mm lens I had with me. Consequently, I concentrated on fitting the palms tightly within the picture frame and didn't notice the crooked horizon until too late.

One of my pet peeves is seeing a photograph with an obviously tilted horizon line. Are these shots taken during earthquakes when the entire landscape is tipping over? Well, that is how they look to me. Photographs of leaning lakes especially annoy me—I think I'm anticipating that the water will start pouring out one side of the picture.

One reason that everyone occasionally takes such pictures is that our tripods are often too short. When you're shooting from a slightly bent-over position, you lean your head one way or another in order to see through the viewfinder. If you focus with your right eye, you'll tip your head slightly to the left. Use your left eye, and your head will tip to the right. Whichever way your head goes, so goes the horizon in the picture.

To prove this point, try this exercise. Set up a tripod-mounted camera so that the eyepiece is about one foot below your eye level. Compose a shot that includes an obvious horizon line, viewing with whichever eye you normally use to focus. Make sure the horizon appears level. Now look through the camera with the other eye and check out that horizon. Sure enough, it will appear tilted. Straighten it out, and then switch eyes again. Wow! Now the horizon is tilted back in the other direction! By the way, if your pictures often "tip," on critical review you'll notice that they usually lean in the same direction because you focus with the same eye most of the time.

One solution is to make sure your camera is really at eye level when you're shooting from that vantage point. Not having to stoop to see through a viewfinder solves many horizon problems. Be sure that you buy a tripod that is tall enough for field work.

Of course, you don't want to take all your pictures from eye level. In fact, a quick way to make your photographs stand out from the norm is to work from another viewpoint, to shoot from considerably lower or higher. When doing so, you should be extra careful about leveling the horizon if you have a "tilting tendency." Spend some additional time before you shoot making sure the world remains square and true.

Most camera stores sell small bubble levels that slide into a camera's hot shoe and work in both horizontal and vertical orientations. These levels can definitely help you keep lines in plumb; so will using a grid-focusing screen, as these have etched lines that you can use as references. If your camera offers interchangeable viewfinder screens, I would definitely switch to a grid.

Here is a helpful hint. After you've set up your shot, take a giant step backward, away from your tripod. Now look at your camera back. It is usually quite easy to see if it is square with the world. If it is level, so is your photograph.

Environmental Problems

When you're shooting in the field, problems arise that are totally unforeseen. These gremlins craftily enter unannounced—but they definitely make their presence known as uninvited guests.

Insects are a prime example. They are involved in a whole list of unanticipated activities. Opening and closing a camera while you're surrounded by swarms of mosquitos and blackflies can be a challenging procedure. I've loaded mosquitos as well as my film and trapped blackflies in my camera while changing lenses. I once squashed a blackfly when I tripped the shutter and the mirror swatted it against the bottom of the viewfinder screen. I don't know which was more difficult, cleaning the remains off the screen and the mirror, or reassembling the parts without catching a few more inside. Now when I work under insect-plagued conditions, I madly wave my hands around to chase off any little critters before changing lenses or film, and before shooting.

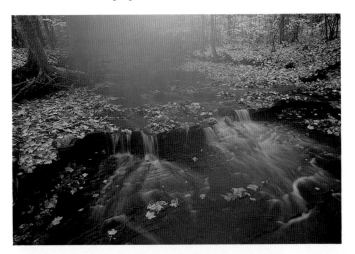

Slathering yourself with insect repellent is not necessarily the answer. Some of the strongest repellents are 100 percent DEET, a chemical that actually softens plastics if the two come into contact. Possible victims include eyeglass frames, plastic lenses, and some camera parts. I once had a Nikon F3 with my fingerprints forever etched into the film-advance lever, courtesy of DEET.

Similar to insects are raindrop and snowflake gremlins. Rainy and snowy conditions are great to shoot, but keeping equipment dry is tough. It is hard enough changing film in the rain, but more frustrating is shooting through a raindrop on the lens. Wide-angle lenses in particular, when stopped down to $f/16$ or $f/22$ and focused on a close subject, will almost bring that raindrop into focus, which means that, at the least, a section of your picture will be blurred. Check the front element often to make sure no drops are on it. Don't tip the lens straight up to look down at it, or you'll see even more raindrops appearing. Using a lens hood helps keep the droplets off the glass.

Hair in the film gate is another gremlin, but it doesn't show up until you're viewing your processed film. Hairs, lint from sweaters or gloves, indeed any small thread trapped at the film curtain where it is in focus—all cast perfect shadow images onto film. Develop a habit of periodically checking the film gate of your empty camera to make sure nothing is intruding into the frame. With no lens attached and the camera on "bulb," trip the shutter and, with your finger still holding down the release, open the camera back. Check the film opening and carefully clean the area. Once all is clear, allow the shutter to close, then clean out the rest of the camera's film compartment. Don't touch the shutter curtains, and definitely don't blow compressed air directly on them, as this could severely damage the shutter.

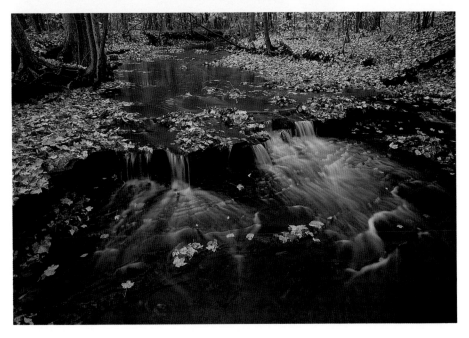

STREAM IN AUTUMN, Ohio. Nikon F4, Nikon 20mm lens, Fuji Velvia.

I actually shot several frames before I realized that a large raindrop was on my lens. I was shooting with my 24mm lens stopped down, which emphasized the blurred area caused by the drop. Luckily, I kept checking the lens and discovered the problem while I was on site and could reshoot.

PREVENTING FLARE

No matter how good your equipment, at times you will be plagued by flare problems. Whenever sunlight directly strikes the glass in a lens, some light bounces between the elements rather than passing through to the film. No lens transmits 100 percent of the light, but modern lens coatings have increased the transmission rate tremendously. Flare still shows up, however, either as a softening of the entire picture or as ghost images of the diaphragm blades. Zoom lenses tend to be more flare prone than single-focal-length lenses, as zooms have many more glass elements.

Adding a filter to the front of a lens greatly increases the probability of catching flare, as a filter is just a flat surface hanging out there in the sunlight. I strongly suggest not using filters at all, unless you have a specific reason for doing so. If you can articulate out loud why you're using a filter—if you can succinctly state a reason—definitely go ahead and use one. Otherwise, think twice. A lot of photographers place an ultraviolet (UV) filter on their lens and leave it there permanently to protect the lens' front element. Well, I'll leave that choice to you, although I've always wondered about the wisdom of adding a ten-dollar filter to an expensive lens. After all, if the lens designer had wanted another piece of glass in the light path, it would have been included in the original design. Remember that *anything* placed in the light path degrades your final image; you must decide if the effect to be gained by using a filter outweighs other considerations.

I'm in no way suggesting that you not use filters, although you should buy the best possible. When using a bad filter you have, in effect, added a lens element, and not a very good one, sometimes distorting the image. By the way, cheap filters can prevent autofocus (AF) lenses from working correctly. If you're having focusing problems with an AF lens, take any filters off and try again.

Stacking filters is not a good idea unless you simply cannot avoid it. Every air-to-glass surface will greatly increase your chances of adding flare; yet I constantly see photographers add filters, especially polarizers, to lenses already equipped with UV filters. One at a time, please. I once met a man using an 80–200mm zoom lens on which he had mounted simultaneously a UV filter, a skylight filter, and a polarizer. He wanted to know why he was having trouble focusing—"I just can't get a sharp image," he lamented—and why the corners of his pictures were dark.

The best solution to flare problems is to use the proper lens hood at all times; just remember that if you stack filters on the lens, the hood could end up being moved forward far enough to vignette the picture. Whenever possible, keep direct sunlight from striking the front glass element of your lens. Often when I'm shooting strongly sidelit scenes, I'll shade the end of my lens with my hand or my hat, even though I always use lens hoods. Of course, if the sun is actually in your picture there isn't much you can do, although removing any filters does help.

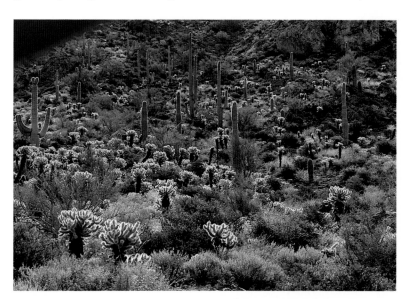

CHOLLA AND SAGUARO CACTI, Arizona. Canon EOS-1, Canon 90mm TS-E lens, Fuji Velvia.

Look at that ghostly flare on the extreme right edge of the frame of the photograph at right. I just didn't notice it while I was shooting. On the other hand, while shooting the photograph above I could easily see the flare in my lens, so I used my hat to shade my lens; you can see how I neatly included the hat in upper lefthand corner of the picture. Sometimes you can't win.

FLARE AND CLOUDS, Saguaro National Monument, Arizona. Canon EOS-1, Canon 20–35mm zoom lens, polarizer.

VIEWFINDER COVERAGE

Ever see the acronym WYSIWYG? It became popular with the explosion of desktop publishing software a few years ago and stands for "**W**hat **Y**ou **S**ee **I**s **W**hat **Y**ou **G**et," referring to the layout of text and graphics on a computer screen. Many photographers believe in WYSIWYG as they are looking through their viewfinders, so they are often rudely surprised when processed film comes back. With many 35mm cameras, what you see is *not* what you get.

The problem is viewfinder coverage. Check the back of your camera's instruction manual, in the technical specifications section, and you'll discover that the manufacturer tells you how much of the image on film can actually be seen in the viewfinder. Most cameras yield about 93 to 94 percent of the image. But some show a lot less, while a few models give 100 percent viewing. To complicate this whole matter, almost all slide mounts cover some of the image, and if you're shooting print film, no print size fully correlates to the negative dimensions.

Nikon F4 and Canon EOS-1 owners, be careful. These cameras offer virtually 100 percent viewing in the viewfinder; thus, some of your image will be lost under the edges of a normal slide mount. You can either remount your film into special full-frame mounts, or learn to crop a little looser. Don't compose extremely tight to the edges of the viewfinder.

Some cameras, such as the Canon EOS Elan, show 90 percent or less in the finder. Think about that—10 percent or more of what is going to be on film doesn't appear in the viewfinder! If you don't pay attention to what seems to be just outside your frame, you'll discover all sorts of things creeping into your picture: sections of fences, your car, other photographers, your camera bag. With a camera such as the Elan, you should learn to compose with subjects tightly touching the side of the viewfinder, because on film they will be farther from the edge.

Run a few test shots to determine what your camera does with the viewfinder image. Have someone position things so that you can just see the objects in each corner of the viewfinder, and take a picture. For example, shoot straight down at the floor in your office with a slide box visible in each viewfinder corner. Process the film, and check the location of those objects on film. Are they still in the exact corners? How do the viewfinder's "corners" compare with what you see on the slide? Finally, draw on the film with a felt-tip pen around the edge of the slide mount, remove the film from its mount, and evaluate the actual image area. You may be surprised by the differences between the viewfinder image, the slide-mount image, and the actual film image.

By the way, don't be afraid to remount your slides if necessary. Both heat-sealing and pressure-sensitive mounts are available through most large camera stores. Remounting lets you position the film within the mount exactly the way that you want it to fall, not as some automated mounting machine has arbitrarily done.

I wanted to test how the image in my viewfinder corresponded to the image recorded on film. With my camera on a tripod, I positioned a slide mount precisely in each corner visible through the viewfinder and snapped off a test shot. I was surprised at all the extra coverage of the image on film. The line superimposed on the image represents the area visible through a standard slide mount.

Two Lights in the Sky?

Once in a while, when you see a picture with the moon in it, something just seems wrong. Look carefully, and I'll bet that the problem arose from the moon being double exposed onto the film.

Why do I say this? There is certainly nothing wrong with shooting double exposures. The technique is quite simple: shoot a landscape with a very dark or black sky, then photograph the moon on the same frame but composed so that the moon is located in a black, unexposed area.

One of three things about double-exposed moons usually bothers viewers, even if they cannot articulate what is wrong with the picture. Often they will just say that something isn't right, something just doesn't seem correct. These three common problems are: 1) shooting the foreground and the moon with vastly different focal lengths; 2) placing the moon on top of a colored sky so that it takes on that color; and 3) ignoring that the light shining on the moon (from the sun) and the light falling on the landscape are coming from different directions.

The first problem normally occurs when you use a very wide-angle lens to photograph a landscape that includes a foreground object nearby and then use a long telephoto for the moon. The wide-angle lens decompresses the scene, making it appear to stretch out. This is very apparent in the size difference of any objects in the immediate foreground. Scale diminishes quickly when you use a 20mm or 24mm lens. When you add a moon shot with a 300mm lens, viewers instinctively recognize the size discrepancy. The solution here is to maintain the same focal length for both exposures.

The second problem arises when the sky in the first exposure is not black, such as at twilight. If you drop a moon into this section of the frame, it will pick up whatever color has already been recorded on the film. We all know that the moon is normally yellow or white. If a twilight sky is bleeding through a double-exposed moon, you may literally create a blue or purple moon. Not good.

The third problem is the most glaring and the most jarring. The moon and the earth are both lit by the same light source, our sun; therefore the direction of the light falling on both should be the same. However, I've seen pictures of full moons hanging over sidelit landscapes. Humm. The only natural explanation would be that they are landscapes shot from another planet where there are *two* light sources. Rule of thumb: If there is a full moon, the landscape must be frontlit, also.

Here is a tip for anytime you photograph the moon or the sun. They appear on film at roughly 1mm in diameter for every 100mm of focal length you use. For example, if you want a moon to be 3mm on the film, shoot with a 300mm lens; a 400mm lens gives you a 4mm diameter moon; a 500mm lens gives a 5mm image. This is true regardless of the film format you're using, whether 35mm, 2¼ x 2¼, or 4 x 5. A 4mm moon takes up a lot more of a 35mm camera's 24mm x 36mm dimensions than the same 4mm moon does on a sheet of 4 x 5 film. To make the moon fill half a slide—or 12mm—you would have to shoot with about a 1200mm lens. To obtain the same apparent image, half the frame, a 4 x 5 view-camera shooter would need about a 5000mm lens; not a picture likely to be taken soon.

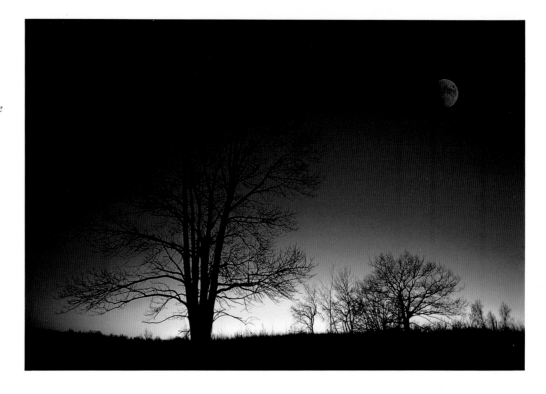

WHITE ASH AND MOON. Nikon F3, Kodachrome 25. Landscape exposed with 24mm lens, moon with 200mm lens.

Notice anything wrong with this photograph? Look at the twilight sky and tell me the location of the sun. It is coming from below the horizon, directly behind the ash tree. But now look at the moon. Where must the sun be to illuminate this half moon? Directly to the right of it. This is a poorly done double exposure, taken without thinking about the direction of the light.

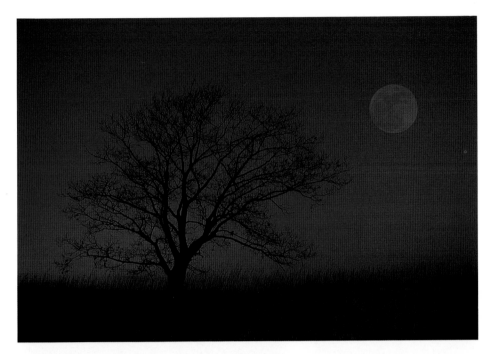

OAK TREE AND FULL MOON. Nikon F3, Kodachrome 25. Tree exposed with 24mm lens, moon with 400mm lens.

Here is a "blue moon" shot. I photographed the oak tree just at twilight when the sky was deep blue and then double exposed the moon into position with a long lens. But the background exposure has entirely tinted the moon. I trust this is not what you really see on "blue moon" nights.

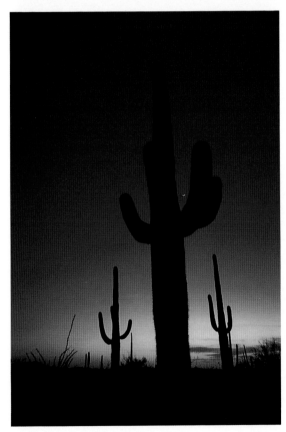

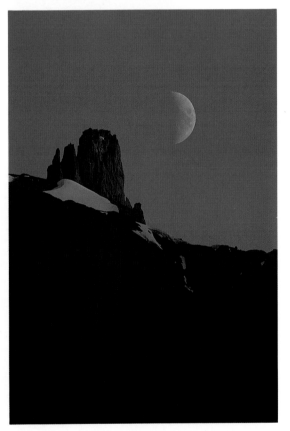

SAGUARO CACTI AND CRESCENT MOON, Arizona. Nikon F3, Nikon 24mm lens, Kodachrome 25.

I photographed these saguaros just at twilight, with the crescent moon positioned between the arms of the cactus in the foreground. Notice the size of the moon; this is how small it appears when photographed with a 24mm lens.

HALF MOON AND ROCK TOWER, Banff National Park, Canada. Nikon F4, Nikon 500mm lens, Fuji Velvia.

This is a single exposure taken with a very long lens. The light's direction is consistent on both the moon and the rock tower. Note also the size of the moon in the frame, a result of my shooting with a 500mm lens.

ON
LOCATION

POLAR BEAR, at edge of Hudson Bay, Canada.
Nikon F4, 300mm lens, Fujichrome 100.

PHOTOGRAPHING A THEME

Landscape photography can be as broad or narrow a subject as you wish to make it. You can specialize in the grand scenic or the intimate detail. Regardless of the scope of your vision, I urge you to work thematically and to build photographic motifs and variations of the same subject. Too often photographers have a one-approach viewpoint that limits photographic possibilities. Avoid falling into the rut of shooting all landscapes with the same formula—the same scale subject, using the same lens, from the same viewpoint (whether it be low or high)—in other words, a totally stale photographic approach.

This last section of the book is a record of several visual journeys I've taken, each focused on only a few subjects. On these first four pages I was working one theme, flowing water. When I'm shooting on location, I try to organize my work by jotting down ideas or concepts—such as "flowing water"—as reminders. These concepts, these little notes to myself, act as a passageway for my thoughts. While I'm searching for subjects, I often mull over these notes, letting my mind play to come up with new ways of thinking about them. I trust that this freedom will then be expressed in more open approaches to my photography.

On a very practical level, I make a conscious effort not to fall into the entanglement of always photographing in the same way. After I've shot a picture, I'll try to shoot it again but with a different lens from a different viewpoint. If I've used a 50mm lens, I'll try a 200mm shot. If a 300mm framing looked good, I'm curious to see what a 24mm lens does. If I shot from eyelevel, what about a very low viewpoint? After you think you're finished photographing a subject, a great exercise is to mount the lens you would be least likely to use for that scene on your camera and then force yourself to find a composition. You can teach yourself new ways of seeing.

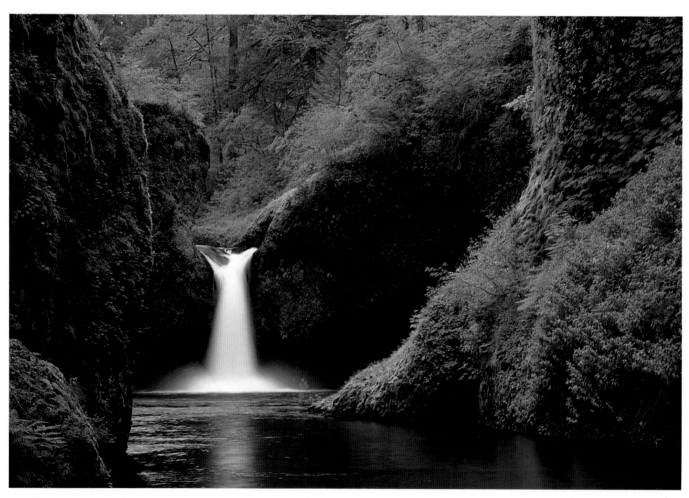

PUNCHBOWL FALLS, Columbia Gorge Scenic Area, Oregon. Nikon F4, Nikon 50–135mm zoom lens, Fuji Velvia, polarizer.

The light for this photograph was perfect: high overcast. If there had been any direct sun, the contrast would have far exceeded what the film could record. To make this straightforward shot of Punchbowl Falls, I used the long end of my zoom range to keep the bright sky area from creeping into the top of the frame. A long exposure, dictated by the small f-stop I wanted to use and the low light level, softened the appearance of the water.

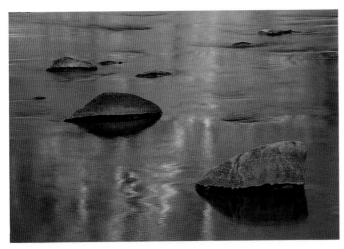

AUTUMN REFLECTION AROUND ROCKS, Vermont. Nikon F4, Nikon 200mm macro lens, Fuji Velvia, polarizer.

I photographed this quiet river, west of Woodstock, Vermont, just at sunset. U.S. Route 4 follows the Ottauquechee River, and as I was driving past, I noticed the brilliant autumn trees on the far side glowing in the late afternoon sunlight. By climbing down to water level and shooting with a long lens, I was able to surround the rocks with reflected color. I worked until sunset, when the warmest light yielded the most intense colors and this, my best picture.

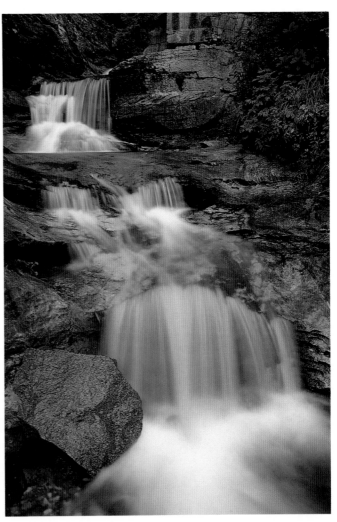

WATERFALL, San Juan National Forest, Colorado. Nikon F4, Nikon 24mm lens, Fuji Velvia, polarizer.

I climbed up this small cascading stream, crisscrossing it many times and getting my feet soaked in the process. I handheld my camera, framing different views, until finally I discovered the one I liked. Finding the exact spot from which to shoot takes some effort; too often photographers walk up to a scene and shoot without making any extra effort. Just because a location is easy to reach doesn't mean that it is the best place for your camera; on the other hand, the quality of a photograph is not proportional to the effort required to take it.

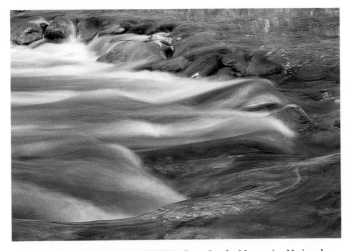

STREAM AND SPRING REFLECTION, Great Smoky Mountains National Park. Nikon F4, Nikon 105mm lens, Fuji 50, polarizer.

In this picture, I wanted to include the entire width of this small curving cascade as it dropped over the rocks. An eyelevel camera position and a short telephoto gave me just the framing I needed. The stream itself actually lay in the shade, which eliminated any contrast problems, while the reflection was of the sunlit hillside on the opposite bank.

FAST FLOWING STREAM, Alaska. Nikon F4, Nikon 50–135mm zoom lens, Fuji Velvia, polarizer.

The color of the water—a gray green caused by a heavy load of "rock flour," or glacial silt carried by this glacier-fed stream— intrigued me. I softened the water with a long exposure while sharply focusing on the large lichened rock; it repeats the same colors as the water. This very monochromatic photograph falls on the cool end of the spectrum, perfect for glacial streams.

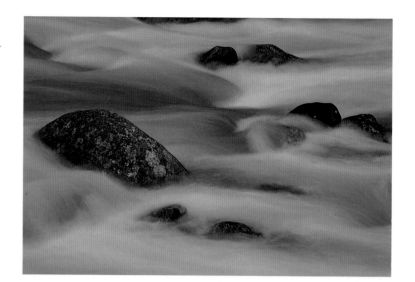

WATERFALL, Little Pigeon River, Great Smoky Mountains National Park. Nikon F4, Nikon 105mm lens, Fuji Velvia.

Here the water is dropping perhaps four feet, but there is no sense of scale, no surrounding hints about the subject. In fact, this is not so much a photograph of a waterfall as it is a picture reduced to the compositional elements of line and texture. To determine the exposure, I didn't meter the scene as you see it here. Instead, I swung the camera to the side and metered some rocks in the same even, overcast light. Working from that base exposure, I recomposed my picture and tripped the shutter.

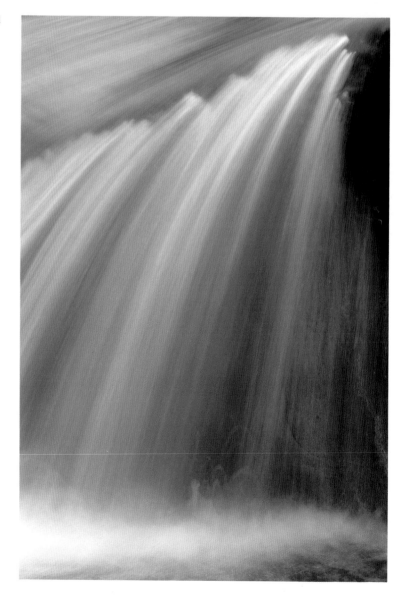

AUTUMN MAPLE LEAF IN SMALL CASCADE, Vermont. Nikon F4, Nikon 200mm macro lens, Fuji Velvia.

Only about a quarter inch of water was flowing over the lip of this black rock, making a shallow enough cascade so that a single maple leaf was momentarily caught before washing on downstream. Although I was working in deep shadows, I could see the silvery highlights on the water through my viewfinder. I carefully spotmetered the leaf, opened up about two-thirds of a stop to make it barely a shade darker than the palm of my hand, then recomposed and tripped the shutter.

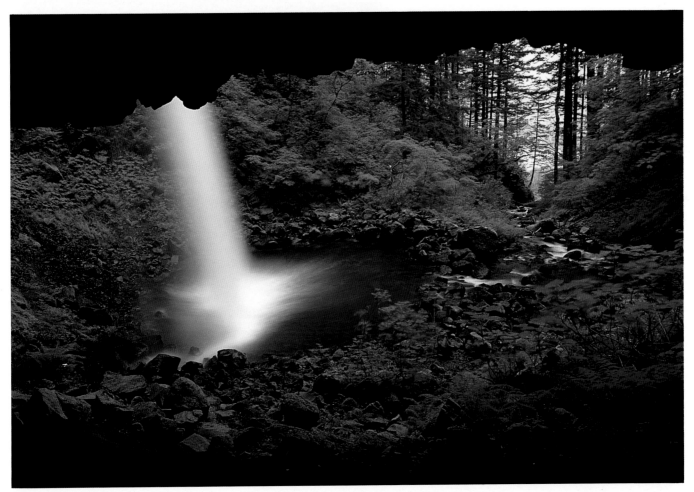

UPPER HORSETAIL FALLS, Columbia Gorge Scenic Area, Oregon. Nikon F4, Nikon 24mm lens, Fuji Velvia.

The trail to Upper Horsetail Falls follows a rock wall and actually passes right behind the falling water. For this photograph I stepped off the trail—visible at the extreme bottom of the frame—and wedged myself into the crevice under the overhang as far back as I could go. I determined my exposure by spotmetering the medium green on the other side of the pool, but the hot highlight area of sky bothered me. By jamming my camera against the roof of the overhang and shooting down, I was able to eliminate as much open sky in my frame as possible.

FOCUSING ON ONE AREA

If I had to choose one area to photograph for its graphic-design potential, somewhere not overworked by photographers, I would without hesitation choose the Palouse region of southeastern Washington State. This vast, almost treeless farming area of rolling low hills is planted with wheat, lentils, and peas. The variety of patterns formed by the farm fields is endless, and the hills yield good elevation for shooting photographs. Morning and

FIELDS AND STORAGE BINS. Nikon F4, Nikon 200mm macro lens, Fuji Velvia, polarizer.

evening sidelight delineates hillsides and barns, and the area is laced with roads. I've photographed this area on several trips, and I want to return as soon as possible. I've always been rushed in the Palouse, able to stay only a few days each time I've been there, but I would love to wander around it for a week or ten days.

I've based my trips out of Colfax, Washington, a small town with the necessary motels, gas stations, restaurants, and grocery stores. Farm roads, both paved and gravel, wander from it in all directions. For a radius of about 40 miles, it is almost impossible to get lost because Colfax is just south of Steptoe Butte, a hill that towers above the surrounding countryside. From any high spot along a road you can spot Steptoe, then simply find your way back to Colfax. A road leads to the top of the butte, and late afternoon along this road offers some incredible picture opportunities, especially if you bring a 100mm-or-longer telephoto lens to isolate sections of the fields below.

May is a great time in the Palouse to photograph green wheat fields broken by dark-brown plowed soil and brilliant yellow canola plantings. From then until late summer, you'll see an unending succession of ripening crops and harvested fields. With all of this going on before you, however, keep in mind that what you're really photographing are design elements: different textures, the lines of adjacent fields, the forms of the hills, and the light itself.

BARN IN WHEAT FIELD. Nikon F4, Nikon 50–135mm zoom lens, Fujichrome 50, polarizer.

BARN IN WHEAT FIELD. Nikon F4, Nikon 24mm lens, Fujichrome 50, polarizer.

PACIFIC WILLOW AND WHEAT
FIELDS. Nikon F4, Nikon 200mm macro
lens, Fuji Velvia, polarizer.

FIELDS. Nikon F4, Nikon 105mm lens, Fujichrome 50, polarizer.

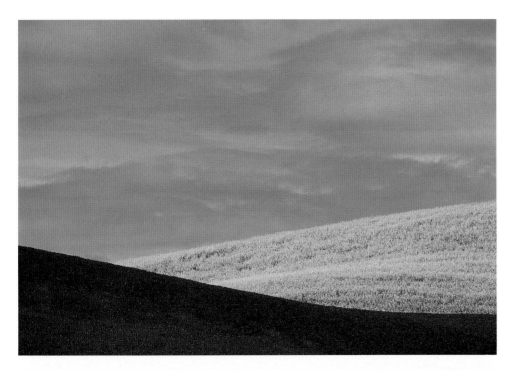

CANOLA, WHEAT, AND CLOUDS.
Nikon F4, Nikon 200mm macro lens,
Fujichrome 50, polarizer.

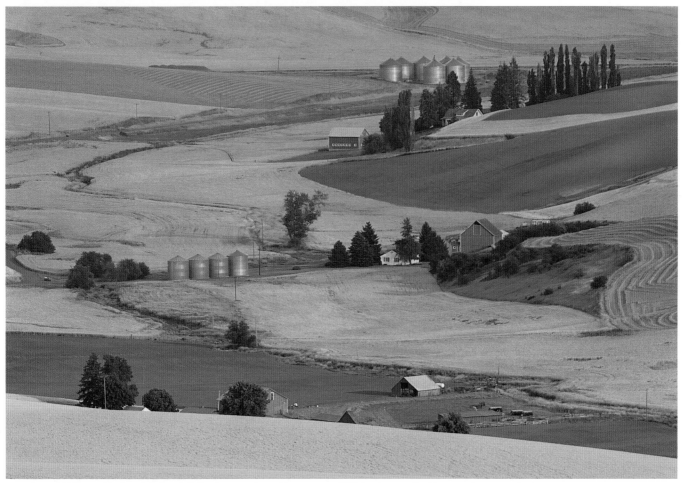

FARMS AND FIELD, from Steptoe Butte. Nikon F4, Nikon 105mm macro lens, Fujichrome 50, polarizer.

Being in the Right Place at the Right Time

So far in this section, I've explored how to take a thematic approach in various locales and how to focus on a specific area. Here I'm going to discuss how to photograph one particular place during its most photogenic season.

In April and early May, the roadsides and remnants of prairies in central Texas can be magnificent with wildflowers, a display unmatched anywhere else. I say "can be," as there is no guarantee from year to year that this phenomenal bloom will occur. It depends on a large variety of conditions: the spring weather, the amount of moisture dropped by winter rains, the previous year's seed production, temperature, and so on. One year the display may be spectacular; the next year, colorless. The same location can be crowded with flowers one spring and show not a single blossom the next.

In my estimation, the areas that bloom most consistently year after year are in an area known as the Hill Country, within a 100-mile radius around Austin. Many towns in this region sponsor "Bluebonnet Trails" at this time of year: drives through the countryside's best flower areas, marked by the local Chambers of Commerce. It is impossible, however, to pinpoint any exact spot where good flowers can always be found. The best thing to do is to pick up a Texas highway map, gas up your vehicle, and start wandering every side road you come across. When you find a good location, work it for all you can. Don't leave until you are satisfied that you've covered the subject every way it can possibly be seen.

That is how I stumbled across Lyndon Baines Johnson State Park several years ago. This park is directly across the Pedernales River from the LBJ Ranch, just east of Fredericksburg. One of the most dependable sites for Texas wildflowers that I know of, LBJ State Park maintains an extensive area just for the spring bloom. I've been to the Hill Country several times to photograph spring wildflowers, and even in mediocre years LBJ State Park hasn't disappointed me.

My last spring trip to Texas was during the second week in April. I carried lenses ranging from 24mm to 300mm and used all of them, although most of my pictures were taken with a 35mm, a 105mm, and a 200mm lens. I spent two mornings at LBJ State Park for a total of about eight hours working time. The following photographs were taken on those two mornings, all within a short walking distance from my car.

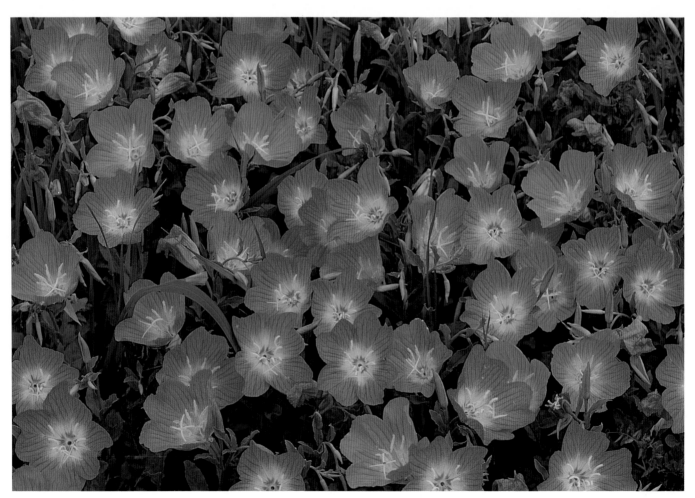

PINK EVENING PRIMROSE. Nikon F4, Nikon 105mm lens, Fuji Velvia.

PHLOX AND MESQUITE. Nikon F4, Nikon 105mm lens, Fuji Velvia.

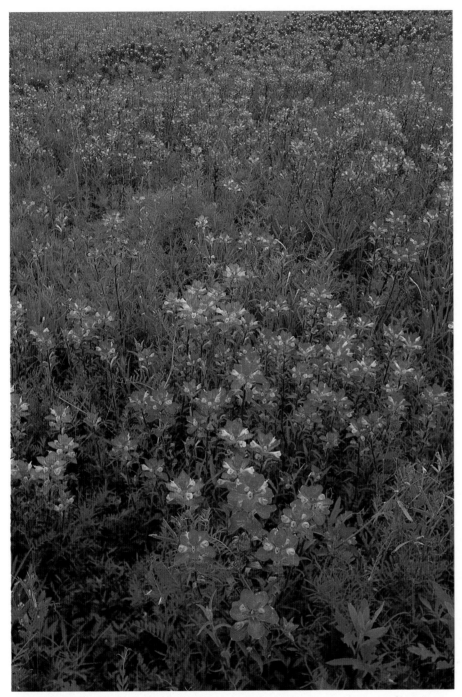

PAINTBRUSH. Nikon F4, modified Canon 35mm TS lens, Fuji Velvia.

BLUEBONNETS AND
PAINTBRUSH. Nikon
F4, Nikon 105mm lens,
Fuji Velvia.

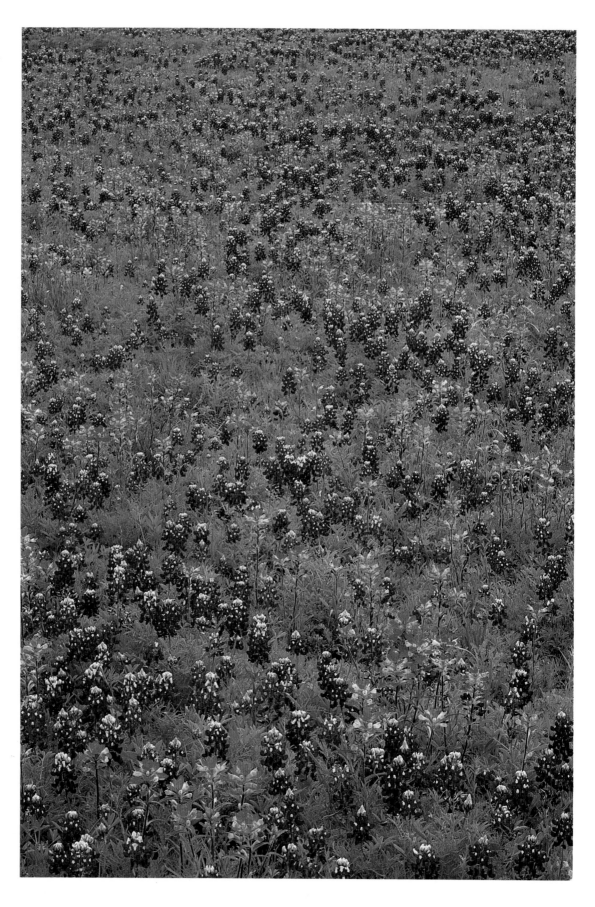

PHLOX, PAINTBRUSH, AND
BLUEBONNETS. Nikon F4, modified
Canon 35mm f/2.8 TS lens, Fuji Velvia.

WINE CUP MALLOWS, PHLOX, AND BLUEBONNETS. Nikon F4, Nikon
105mm lens, Fuji Velvia.

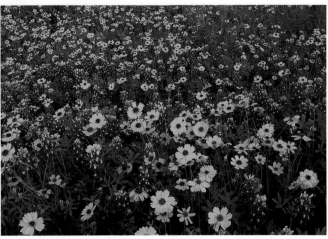

COREOPSIS AND BLUEBONNETS. Nikon F4, Nikon 35mm lens, Fuji Velvia.

THE ANIMATE LANDSCAPE

What? Animal pictures in a book on landscapes? Well, there is an aspect of landscape photography that is often overlooked: scenic views that include the creatures living in the landscape. Photographers tend to categorize their work arbitrarily, as if there were no overlap: here are landscape pictures, here are portraits, here are wildlife shots, here are closeups. Actually, these divisions are more like variations on a theme than distinct categories. After all, there is not much difference photographically between a portrait of a person and a portrait of a wild animal. A closeup of a flower and a closeup of a mountain are basically the same, except for the scale of the subject and the camera equipment used. Good technique, proper exposure, and pleasing composition are the same for all photographs, regardless of subject matter.

I'm not suggesting that you lump all images into one giant category of expression, and I'm certainly not suggesting that you stop photographing your preferred subjects in your favorite style. By all means, go ahead with what you're doing. All I'm suggesting is that you add another dimension to your vision of the world.

I want to encourage scenic specialists to include birds and mammals in their pictures. For example, show not only the desert sweep, but also the jack rabbit that lives in that desert. Add deer to your pictures of the autumn woods. At the same time, I think wildlife photographers should take environmental portraits in addition to head shots. Don't settle for only a tight shot of the moose and her calf, but pull back and include the whole pond where they are feeding. Show the bear within its habitat, and let the surroundings make a statement about the animal.

POLAR BEAR ON ICE, Churchill, Manitoba.
Nikon F4, Nikon 300mm lens, Kodachrome 200.

This may be my favorite picture that I've ever taken of a polar bear. I've certainly taken many pictures a lot closer to them, and pictures with more action. But as far as I'm concerned, this photograph says more specifically about the natural history of polar bears than any other in my file. They live in a cold, harsh environment that is windswept and exposed; they are solitary mammals; they stoically endure.

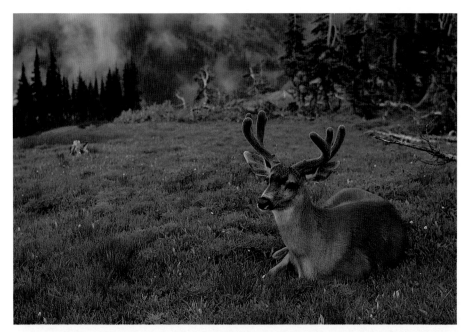

BLACKTAIL MULE DEER, Olympic National Park, Washington. Nikon F3, Nikon 55mm macro lens, Kodachrome 25.

I spent most of an afternoon with this mule deer. Not wanting to stress the animal, I started photographing it from some distance away with my 300mm lens. As it accepted my presence, I ever so slowly and ever so carefully eased closer and closer. Finally, I was able to use my 55mm lens. Its angle of view included quite a lot of background, portraying the deer within the context of its habitat.

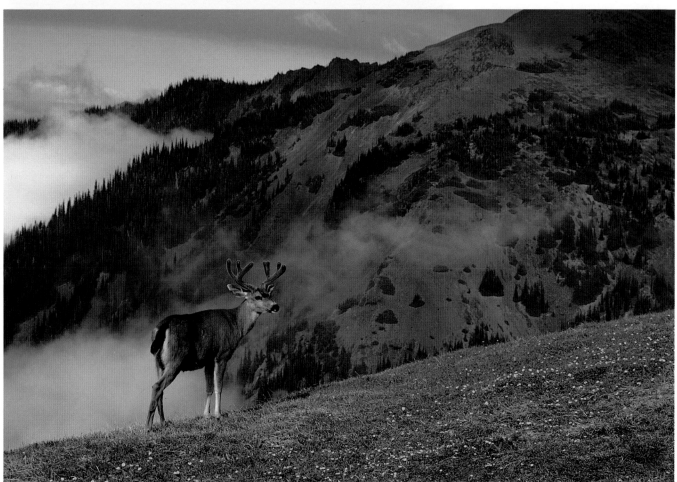

BLACKTAIL MULE DEER, Mount Rainier National Park, Washington. Nikon F3, Nikon 50–135mm zoom lens, Kodachrome 25.

I had hiked from the Sunrise Visitor Center to Berkeley Park and beyond, photographing the summer alpine meadows. A mule deer crossed my trail, so I followed it for awhile, photographing with my zoom. This picture was taken with the lens set at roughly 135mm.

ELK IN WINTER SNOWSTORM, Yellowstone National Park. Nikon F4, Nikon 400mm lens, Fujichrome 100.

I took this photograph only 30 feet from the north entrance station to Yellowstone, near Gardiner, Montana. It was a cold, blustery February day, with snow driven hard by the wind. This elk had bedded down for the afternoon in the midst of these large boulders. I stood above the elk on the road bank to photograph with my tripod extended no more than necessary in order to keep any wind movement to a minimum. What I liked about this situation is the way the elk blended into the scene. The snow on its back and the snow on the rocks look so similar that at first glance you don't realize exactly where the elk's body lies.

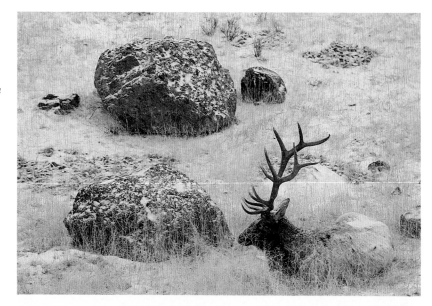

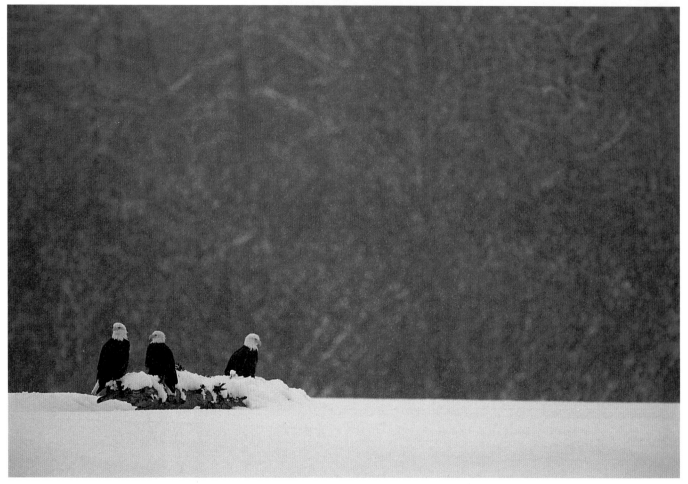

BALD EAGLES IN SNOWSTORM, Chilkat River Valley, Alaska. Nikon F4, Nikon 500mm lens with a 1.4x teleconverter, Kodachrome 200.

I purposely positioned my tripod quite low, near the edge of the river, so that I wasn't looking down at the eagles. Doing so would have placed them against the white snow on the river bed, and their white heads would have merged with the snowy background. By staying low, I was able to isolate the birds against the trees on the far side of the river. Fast film and the fastest shutter speed I could use froze some of the falling snow in mid-air.

Including new subjects—especially living, moving ones—in your pictures may mean making some technical changes. For example, you might discover you need to carry different or additional lenses. It is good to be prepared with a variety of focal lengths so that you can photograph the broadest range of subjects. When you're planning a wildlife shoot, add some short lenses to your pack in order to include more of the environment.

When you expect to shoot only landscapes, go the other direction and drop in an extremely long lens for any wildlife photo opportunities. A good starting point for either specialty would be the coverage provided in a range of focal lengths from a wide-angle 24mm to a telephoto 300mm lens. Add a 1.4X teleconverter and you can work almost any subject—from mammals to mountains—that you encounter.

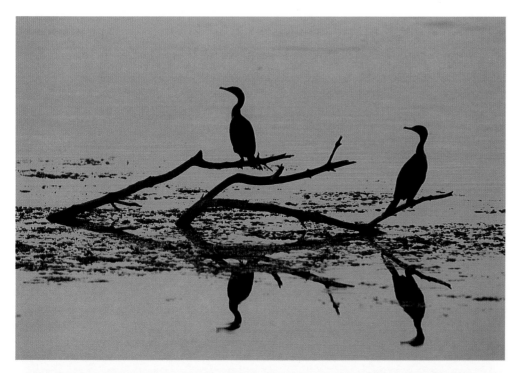

CORMORANTS AT SUNSET, Florida. Nikon F4, Nikon 300mm lens, Fujichrome 100.

This picture may tell you a little bit about a sunset and the surrounding habitat, but it really is a picture of silhouetted birds and logs. Notice that I carefully chose my camera position: the shapes of the birds and the logs don't merge together, but are separate and distinct. For my exposure, I opened up one stop from a meter reading of the water in the upper left. Then I waited until both birds were looking in the same direction, so that their bills were parallel with my film plane.

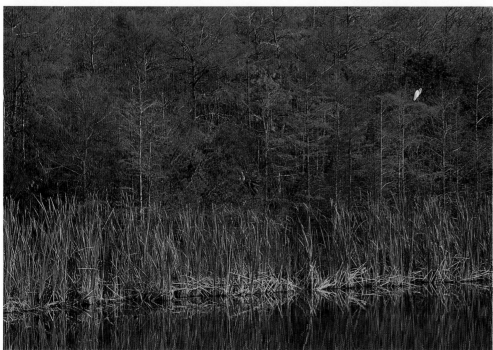

BIG CYPRESS NATIONAL PRESERVE, Florida. Nikon F4, Nikon 300mm lens, Fuji Velvia.

A landscape in transformation is pictured here, a distinct moment in the transition from winter to spring. There are old dry cattails, and there are new green ones. Some of the bald cypress trees—deciduous conifers— have the past year's brown needles still clinging to the branches, while others show this spring's pale, yellowish-green growth. Just edging into the frame is a great egret.

DECIDING WHERE AND WHEN TO GO, AND WHAT TO BRING

I've often said that anyplace in the world is beautiful if you're there at the right time. Indeed, landscape photography is far more time-dependent than place-dependent. A couple of years ago, I ran into a photographer in Great Smoky Mountains National Park who had come all the way from his home in Alaska to photograph the park at peak autumn color. Unfortunately, he hadn't bothered to call ahead, so not only was he two weeks too late, but he had also picked a color year that had been one of the worst in memory. He had taken a long, expensive trip with few results to show other than disappointment.

Being in the greatest location on earth at exactly the wrong time—the wrong time of day or the wrong season—is a far worse fate than being in a mediocre location at a wonderful time, when the sky is gorgeous and colors are saturated. The very best circumstances, however, are when you find yourself at an outstanding location at precisely the right time to be there. This takes some homework and preplanning but is well worth the effort.

My first choice of excellent places to photograph would be the national parks. The Park Service administers quite a number of areas including not only the parks, but also monuments, historical parks, lakeshores, and recreation areas. A brochure called "National Park System Map and Guide" is available from almost any national park facility. Its map locates every area administered by the Park Service, with a listing of each park's mailing address, facilities, and recreational information.

Of course, there are many great scenic locations not within the national park system. State tourist bureaus are a wonderful source of information, and most have toll-free 800 telephone numbers. Many states with special autumn-color displays also run seasonal color hotlines. A quick visit to any good library or bookstore will yield much information on places to go. There are travel guides for almost every region imaginable, and although most of these aren't specifically written for the nature photographer, you can still glean applicable information.

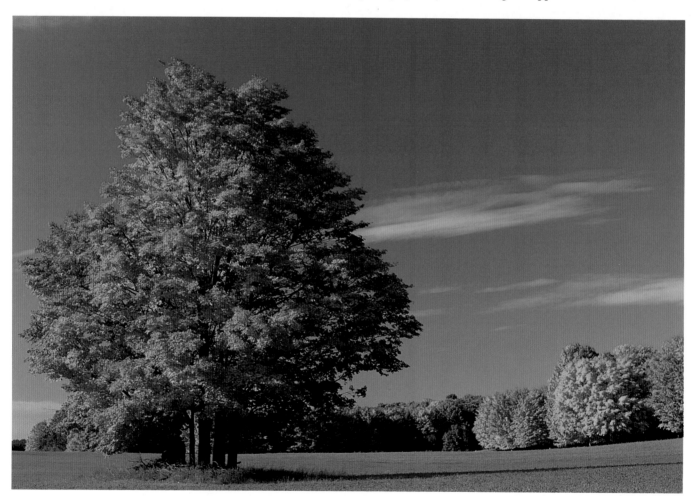

AUTUMN SUGAR MAPLE, Michigan. Nikon F4, Nikon 105mm macro lens, Fuji Velvia, polarizer.

SANDSTONE WALL DETAIL, Zion National Park, Utah. Nikon F3, Nikon 105mm macro lens, Fujichrome 50.

Here is a rundown of how I planned a recent spring trip to Utah. I knew I wanted to cover some of the national parks spread across the southern part of the state, plus any other good spots. First, I wrote a general letter to all the national parks in Utah—Zion, Bryce Canyon, Capitol Reef, Arches, and Canyonlands— explaining that I was planning a photographic trip and needed information as to the best time to be in each park. In this letter I asked for a park brochure, weather information, any general biological brochures available (plant and bird checklists, for example), and a list of any publications obtainable through the park's natural-history association (the people who usually run the visitor center bookstore). Within two weeks I had brochures, charts, maps, book lists, and camping information.

Then I called the Utah Travel Council and explained my planned trip to them. In response, they sent an 88-page state travel guide loaded with color photographs, brochures on designated scenic highways, a brochure describing suggested driving tours of the national parks and monuments, an accommodations listing by town, a listing of regional travel offices to contact, a state highway map, an index of large-scale state maps with marked geological and historical sites...in fact, far more information than I had ever imagined that Utah would send to me.

Before I left for my trip, I also checked my local library for any picture books covering southern Utah. I usually try to scout out a location ahead of time by letting someone else do the legwork—in this case, the other photographers who have worked the area. I do this when I arrive at my destination, too. For example, when I got to Zion National Park, the first place I went was to the Park Visitor Center to examine all the books, cards, and calendars. I scrutinized the published photographs of the park and asked myself questions: What is this formation? Where is this location? What time of day was this taken? How can I shoot this site differently?

I save all the brochures and maps I receive, plus all the information I pick up on my trips, and file it all by location for future reference. After all, I might want to return. In fact, I truly believe that you can't take your best pictures the first time you visit an area, especially one that is a totally different habitat from where you live. I'm usually too overwhelmed by a spectacular new location to do as well as I can on a second visit, when I can concentrate more on my photography.

FLEABANE AND
ARNICA MEADOW
WITH ASPEN TREES,
Colorado. Nikon F4,
Nikon 24mm lens,
Fuji Velvia.

I also keep a shooting log of all my trips. I always carry a small daily-appointment book and jot down lots of field notes: directions to specific locations, best times of day to shoot certain areas; what is blooming; good motels; names of prominent features not marked on my maps; and important phone numbers. In fact I now have logs going back almost 15 years, and they've proved invaluable many times in planning return trips.

Of course there are lots of other sources of information about good scenic areas to photograph. Several magazines are specifically aimed at the nature photographer:

Outdoor Photographer
12121 Wilshire Blvd., Suite 1220
Los Angeles, CA 90025

Nature Photographer
PO Box 2037
West Palm Beach, FL 33402

Outdoor and Travel Photography
1515 Broadway, 8th Floor
New York, NY 10010

There are at least two newsletters devoted to locations for photography:

Photograph America Newsletter
1333 Monte Maria Avenue
Novato, CA 94947

Photo Traveler
PO Box 39912
Los Angeles, CA 90039

There are also many tour companies that take care of structuring a trip for you. A word of caution here: many, if not most, of these tours are designed for casual tourists and non-photographers. A leisurely breakfast is followed by a 9:30 AM departure, while dinner runs from 4:30 PM until dark. Such tours are a guaranteed way to come home with no quality photographs, only midday snapshots at best. For a serious photographer, being trapped in a vehicle with people who don't want to stop for your once-in-a-lifetime shot will quickly turn any trip into the tour from hell. If you're considering a tour company—and a good tour company can arrange quality trips to prime locations at prime dates—pick a company that specializes in nature photography. Then check out their itineraries and leaders to make sure both meet your qualifications. I recommend a company for which I occasionally lead tours:

Joseph Van Os Photo Safaris
PO Box 655
Vashon Island, WA 98070
(206) 463–5383

If I'm driving to a location, my equipment philosophy is simple—I just take everything I own. After all, buying an expensive lens and then leaving it at home effectively turns it into an extravagant paperweight. I normally load my vehicle with camera gear, film in a small cooler, two tripods, assorted shoulder bags and backpacks, binoculars, field guides, and notebooks. If I'm going to be photographing around water, I'll add my hip boots and a couple of old towels to dry tripod legs. A folding rain umbrella, extra plastic garbage bags to cover equipment, a flashlight, and a spare cable release are always in my car anyway. Of course, I also take personal items: clothes, rain jacket and pants, hiking boots, and so on, including camping gear if needed.

Obviously, I have to cut this list down when I fly to a location. Then I try to make everything serve double-duty, both camera equipment and clothing, but still I pack personal gear as lightly as I can. I would much rather be shy on clothes than on camera equipment. On any trip where I'm primarily shooting scenics, whether I'm driving or flying, I would carry at least the following items:

- 24–300mm lenses, both fixed and zooms (shorter and longer as space available)

- two camera bodies

- a tripod and head with quick-release

- 1.4X teleconverter

- filters for all lenses: 81A and polarizer

- one-stop and two-stop graduated ND filters

- camera cleaning supplies (cleaning fluid, large air bulb, Kodak lens tissues, old toothbrush)

- hand meter (an old habit I can't seem to break)

- extension tubes for closeup possibilities

- Nikon 5T and 6T closeup lenses

- a jeweler's screwdriver set and needlenose pliers

- at least two cable releases

- aspirin, insect repellent, and sunscreen

- sunglasses, reading glasses

- a notebook, pen, Sharpie permanent marker

- a complicated Swiss army knife

- two or three plastic bags

- lots of film

All the equipment and as much film as possible go into a Tamrac #787 backpack or a Tamrac #623 shoulder bag. When traveling by air, I hand carry everything I can onto the plane, including my tripod if possible; otherwise it goes into a suitcase. I actually took my tripods, with heads removed, to my local luggage store and shopped for a large, rugged suitcase in which either tripod could

easily fit. During winter air travel I use a giant nylon duffel to carry my parka and insulated boots; my tripod, wrapped in dense, closed-cell foam padding for protection, is packed in the duffel.

If I also expect to photograph birds and mammals, or if I want a long focal length for isolating sections of the landscape, I take my 500mm with me. I carry this in a Domke model F–622 long lens bag, large enough so that I can carry the lens with a Nikon F4 body attached. For a little extra protection, I add an additional layer of closed-cell foam padding to the bag, a tube I taped together from Ensolite (I cut up a closed-cell foam sleeping mat, available from any backpacking shop).

When I'm flying, I remove all my film from the boxes, then put it in clear Fuji canisters and stack 10 rolls in a one-quart zip-lock bag, using as many bags as necessary. With the flap taped over, a bag makes a flat package that is easy to tuck into pockets on my camera bag and is extremely convenient for airport security personnel to inspect. In fact, while traveling within the United States, I haven't had any hassles with hand inspection of my film since I started using this method. Within the continental United States I also carry film-processing mailers, bubble-padded envelopes, and pre-addressed mailing labels so that I can Express Mail 30 or 40 rolls of film at a time to my lab while I'm on the road.

If I'm traveling to one of the states for which DeLorme maps are currently available (about half the states right now), I take the appropriate DeLorme map book, called the "Atlas and Gazetteer." These are the most practical, thoroughly detailed maps to the states that I've discovered; they cover not only all the roads—including dirt ones—but also mark out waterfalls, lighthouses, hiking trails, covered bridges, and more. Great maps! The ones I have are covered with my notes and comments. To order them, contact:

DeLorme Mapping
PO Box 298–5200
Freeport, ME 04032
(800) 227–1656

Here are a few of my favorite locations for landscape photography. This is by no means an exhaustive list:

Scenes with wildflowers

- southern Appalachians/Smoky Mountains in late April, early May

- Texas Hill Country around Austin/San Antonio during all of April

- Colorado alpine wildflowers, the high country around Ouray, from late June through July

- Mt. Rainier National Park in July, early August

Desert

- Saguaro National Monument, near Tucson, April or May

- Organ Pipe National Monument, Arizona-Mexico border, March

Eastern autumn color

- Vermont, late September through October

- Michigan, northwestern Lower Peninsula, and area near Munising in Upper Peninsula, late September, early October

- Canaan Valley/Blackwater Falls area, West Virginia, mid to late October (the Monongahela National Forest)

Spectacular landscapes

- anywhere in southern Utah for exposed rock formations

- Banff, Jasper, and Yoho National Parks in the Canadian Rockies

- Denali National Park, Alaska, autumn scenics in late August, early September

Don't think you need all the equipment that I listed earlier to take good landscape pictures. I carry a ton of gear because I make my living through my photography; essentially, I'm carrying part of my business with me. To shoot good pictures, all you really need is one lens, one camera body, one tripod, and good light. Too many photographers are equipment fanatics, always loading themselves down with additional lenses and the latest gadgets. It is just as bad to have too much equipment, and consequently become overloaded and immobile, as it is to have too little equipment to get the job done. On the other hand, I'm still waiting for that new 20–600mm *f*/2 close-focusing zoom lens with rotating tripod collar, no bigger than a current 28–80mm, razor sharp at all focal lengths, reasonably priced....well, you understand.

INDEX

aerial perspective, 98
Agfachrome, 38
angle of view
 and image size, 55
 See also focal length; lens(es)
animate landscapes, 134–137
aperture, 16, 20, 26, 29
 See also lens(es); light
Aperture Priority. *See* autoexposure
 modes
aperture ring, 20
Arca quick-release system, 43
Arca-Swiss B1, 43
autoexposure compensation
 control, 26, 34
autoexposure modes, 34
autofocus lenses, 37
 filters and, 116

backlighting, 74
ball head, 43
bellows, 68
Bogen heads, 43
Bogen tripods, 42–43
bubble level, 114

cable release, 36
camera
 in autoexposure mode, 17
 in cold weather, 84
 handholding, 41, 44, 110
 in manual-exposure mode, 20
 positioning, 41, 56, 96, 110
 rain cover for, 85
 selection criteria for, 34–37
 shutter speed on, 16–18, 20–22, 34, 41
 with TTL meters, 23, 25, 28
Canon
 macro lens, 62
 mirror lock, 36
 perspective-control (PC) lens, 69
 polarizer, 46
 short lens, 59
 600mm lens, 66
 300mm lens, 66
 tilt-and-swing system, 70
 viewfinder screen, 36, 117
catadioptric lens, 66
color saturation, and filters, 45
composition, 35, 44, 88–93, 96, 100
 design and, 88–89
 light and, 80
 long lenses and, 57, 63
 short lenses and, 57
 tilt lenses and, 69
 view camera and, 100
contrails, 113
contrast, 25, 40
 exposure and, 112
converges, 110
correct exposure, 16
cropping, 8, 112

DEET, 115
depth of field, 29–31, 36, 96
 aperture setting and, 18, 29, 31, 34, 82
 focal length and, 29, 31, 67
 hyperfocal distance and, 31, 96
 preview, 31, 34, 47, 50, 96
 Scheimpflug principle and, 68
depth-of-field scale, 31
design. *See* composition
diffraction, 67
diffusion, 45
diopter, 62
Domke lens bag, 142
double exposures, 118

Ektachrome, 20–22, 35, 83
enlarging lens, 70
environmental problems, 115
equipment
 cold-weather, 84
 protecting, 84–85
 See also specific type
exposure
 aperture and, 16
 auto- or programmed, 16–17, 20, 22, 26
 overriding, 26
 basic theory of, 16–21
 controlling, 16–17, 25, 34
 estimating, 22
 locking in, 27
 long, 34, 82–83
 in low light, 98, 108
 manual, 20, 22
 metering for, 18, 22–28, 37, 48, 80–81, 98
 proper, 16, 20, 22
 reciprocity and, 20
 shutter speed and, 16
 testing, 22–24
 vibration and, 29, 36
exposure meter, 16, 22, 24–26
 calibrating, 22–24
 reading, 25
 in low light, 81, 108–109
extension
 bellows, 70
 on short telephoto lens, 62

fast film, 20, 41
50mm lenses, 31, 41, 54, 64
 macro, 60
film
 choice of, 38–39, 82
 contrast range and, 48
 exposure and, 16
 longevity, 39
 in low light, 82
 rendition, 39–40
 sensitivity, 16, 20
 slide, 38
 speeds, 20–21, 38–39
 storage, 39
 testing, 38

filter(s), 45
 exposure and, 49
 flare and, 116
 graduated neutral-density (ND), 48–51, 112
 and composition, 48
 and contrast range, 48, 112
 positioning, 50
 holders, 48
 and long lenses, 64
 polarizing, 45–47, 65
 stacking, 47, 49, 116
 suppliers, 51
 ultraviolet, 116
500mm lens, 37, 41, 118
flare
 prevention, 116
 See also lens(es)
focal length
 and angle of view, 54
 and image size, 54
 and double exposures, 118
 and spotmetering, 37
focus, 29, 64, 68, 96–97, 126–129
focus indicator mark, 31
focusing collar, 31, 64
foreground/background relationship, 96–97
 See also lens(es), short, long
foreground drama, 96–97
400mm lens, 41, 62, 64, 118
framing subject, 84, 94–95
frontlighting, 74
f/stops, 16, 20, 22, 29, 31, 34, 55, 67, 82
Fujichrome, 20–22, 38–39, 34, 83
Fuji Velvia, 20–21, 24, 39, 69, 82–83, 112

Gitzo tripods, 41–42
glare, 45, 46
graduated filters, 48
gray card, 26
grid-focusing screen, 114

heads. *See* tripod(s)
horizontal format, 12, 94–95
hot shoe, 114
hyperfocal distance
 depth-of-field scale and, 31
 finding, 31
hyperfocal scale, 29

image size
 and angle of view, 55
 See also focal length; lens(es)
infinity mark, 31
intimate landscape, 8
ISO ratings, 16, 20–22

Kirk Enterprises, 44, 65
Kodachrome, 20–22, 38–39, 82–83

lens(es), 34
 aperture and, 54
 angle of view, 31, 54

auto-diaphragm, 70
 depth of field and, 29, 30, 31, 67
 distortion and, 59, 64
 extension on. *See* extension
 flare and, 59
 focal length and, 31, 35, 54–55
 image size and, 31, 55
 long, 37, 54, 63–66
 and aerial perspective, 98
 and condensing, 56
 and filters, 64, 65
 and vibration, 36, 41
 mirror, 66
 normal, 60
 perspective and, 31, 56
 short, 54–55, 57, 59, 96
 short-mount, 70
 short telephoto, 35, 62, 67
 speed, 35, 55
 tilting, 67–70
 vibration and, 29, 36, 37, 63
 See also macro lenses; zoom lenses
lens hood, 47, 115, 116
light
 ambient, 31
 aperture and, 20
 changes in, 76
 composition and, 80
 direction of, 74, 75
 effects of, 74
 exposure and, 22, 26, 74, 80–83
 f/stops and, 20
 low-contrast, 74
 and polarizer, 45
 measuring, 22
 overcast, 12, 41, 74
 problems with, 118
 properties of, 74
 shutter speed and, 20, 34

macro lenses, 56, 62
 benefits of, 60
 50mm, 60
magnification, and depth of field, 31
medium-toned subject, 22, 24, 26
merging
 camera position and, 110
 tonalities, 110
meter. *See* exposure meter
metering patterns. *See* through-the-lens
 (TTL) metering
Minolta
 polarizer, 46
 600mm lens, 66
 viewfinder screen, 36
mirror lock, 36
moisture, 84

National Park System Map and Guide, 138
neutral-density filter, 48
Nikkor
 500mm, 65
 large-format lenses, 67
Nikon
 bellows, 70

diopters, 62
 long lenses, 65
 macro lens, 62
 mirror lock, 36
 polarizer, 46, 65
 short lens, 59
 600mm lens, 66
 viewfinder screen, 35, 36, 117
 analog display and, 37
90mm lens, 67

100mm lens, 41
105mm lens, 29, 41, 70
opening up, 20, 29
overcast light, 12, 41, 74
overexposure, 16

pan/tilt head, 43
perspective-control (PC) lens, 69
planning and preparation, 80, 138–142
polarizer, 18, 35, 45–47, 65
pressure-sensitive mount, 117
Programmed Exposure. *See* autoexposure
 modes

quick-release systems, and heads, 43
 distributors, 44

reciprocity, 20
 failure, 81
recording motion
 blurring, 17, 18, 31
 freezing, 17, 29
reflected-light meter. *See* Through-the-lens
 (TTL) metering
remote release. *See* cable release
remounting, 117

Scheimpflug Principle, 68
Schneider large-format lenses, 67
seasonal photography, 102–105
shadow images, 115
shadows, 74
Shutter Priority. *See* autoexposure modes
shutter speed, 16–18, 20–22, 26, 31, 34, 36, 41
sidelighting, 74
silhouettes
 exposure and, 108
 wide-angles and, 108
skylight filter, 116
slide film, 26, 38, 116
slow film, 20
spotmeter, 28, 37, 98
stopping down, 20, 22, 29, 67
Studioball QR, 43
subjects
 animate, 134–137
 dark, 22
 defining, 100
 framing, 12, 94–95
 isolating, 37, 63, 126
 light-toned, 22
 medium-toned, 22, 24, 26
 placement of, 96
 seasonal progression and, 102–103

silhouetting, 108
 working distance from, 29, 134–137
sunny *f*/16 principle, 22
sunrises, 108
sunsets, 108
swing, 68

teleconverter, 70
telephoto compression, 56
telephoto lens, 55
 short, 62
thematic photography, 122, 122–125
300mm lens, 41, 63, 64, 65, 118
Through-the-lens (TTL) metering, 23, 25, 28
 in low light, 81
 and polarizer, 46
Tiffen polarizer, 65
tilt, 68
tilting horizon, 114
tonality, 16, 22, 24, 26, 37, 45
tripod(s)
 centerpost, 41
 as compositional aid, 44, 63, 83
 extension, 41
 head, 35, 43
 height, 41, 114
 legs, 41
 and long lenses, 63
 platform, 42
 positioning, 96, 110
 recommended, 41–43
 suppliers, 44
 with quick-release plate, 43
24mm lens, 29, 57
200mm lens, 29, 31, 41, 62
 macro, 62

ultraviolet (UV) filter, 116
underexposure, 16, 81, 108

vertical format, 35, 94–95
view camera, 31, 67, 69, 100
 and plane of focus, 68
 and, 35mm composition, 100
 tilt feature, 68
viewfinder, 34, 35, analog display in, 37
 coverage, 117
 depth of field and, 31
 light level and, 31
 screen, 36
vignetting, 47, 116

weather conditions
 compostion and, 84, 84–85
 equipment and, 84–85
white skies, 112
wide-angle lenses. *See* lens(es), short

Zoom lenses, 22, 35, 55, 57
 and composition, 57
 flare and, 116
 focusing, 59
 short, 62
 with diopter, 62
 with polarizer, 35